Things
Invisible
To See

Other Books by Lawrence Schimel
(a partial listing):

The Drag Queen of Elfland: Short Stories*

Switch Hitters: Lesbians Write Gay Male Erotica
and Gay Men Write Lesbian Erotica
(with Carol Queen)
PoMoSexuals: Challenging Assumptions
About Gender and Sexuality
(with Carol Queen)

Two Hearts Desire: Gay Couples On Their Love
(with Michael Lassell)

Boy Meets Boy
Food for Life and Other Dish

The Mammoth Book of Gay Erotica
The Erotic Writer's Market Guide 1999*

Tarot Fantastic
The Fortune Teller
Camelot Fantastic

The American Vampire Series:
Blood Lines: Vampire Stories from New England
Southern Blood: Vampire Stories from the American South
Streets of Blood: Vampire Stories from New York City
Fields of Blood: Vampire Stories from the Heartland

*published by Circlet Press

Things Invisible to See

Gay and Lesbian Tales of Magic Realism

edited by
Lawrence Schimel

Circlet Press, Inc.
Cambridge, MA

Things Invisible to See
edited by Lawrence Schimel

Circlet Press, Inc.
1770 Massachusetts Avenue, #278
Cambridge, MA 02140
circlet-info@circlet.com
http://www.circlet.com/circlet/home.html

PS
648
·SS
T44
1998

Printed in Canada

ISBN 1-885865-22-8

Publication Date: September 1998

First Printing

Circlet Press is distributed in the USA and Canada by the LPC Group.
Circlet Press is distributed in the UK and Europe by Turnaround Ltd.
Circlet Press is distributed in Australia by Bulldog Books.

For Gregory Maguire

Contents

Introduction

People regularly ask me, on hearing the title of this anthology: What is "magic realism?"

If you ask a dozen writers (or readers) this question, you're likely to get a dozen different explanations.

Colloquially, the term is used to describe a kind of literary fantasy that shows the contemporary world as we know it (this is the "Realism" half of the term) which verges off into the realms of supernatural or fable (the "Magic" half) when something inexplicable and fantastical happens: pigs not only talk but prophesy the future; a man wakes up one morning to discover he's become a cockroach; a metaphor becomes literal. Often these stories are about an emotion so strong it alters the shape of the world: a jealousy so fierce it sets things on fire; a girl feels so hollow and empty after the death of her lover that she begins to float uncontrollably; a man so happy in love he begins to glow with pleasure.

People seem to have little doubt about what "lesbian" or "gay" mean, even though to ask a dozen people—whether they identify with those labels or not—would likely result in a dozen different answers as well.

But many aspects would overlap in the answers, as well. For many of us, that moment of finding out we're not the only

one, of falling in love for the first time with someone of the same sex and finding that love miraculously, incredibly—when society tells us such passion is wrong and perverse—returned, can seem like a bright spot of magic in the drab, gray "real" world.

The title *Things Invisible to See* comes from the metaphysical poet John Donne's famous "Song" which begins with the line "Go and catch a falling star." Later on in the poem he writes:

> If thou beest borne to strange sights,
> things invisible to see...

Doesn't that describe our queer existence in so many ways? How is it that we manage to recognize that invisible spark inside us that signals our mutual attraction for our own gender? And despite all the gains lesbians and gay men have made in recent decades, our lives are still invisible in so many ways in this world.

The stories in this book are about looking for—or inadvertently finding—something more, exploring the many layers of life as we know it and the hidden realms of spirit that underlie our mundane experience, told through the lens of men and women who have already chosen to look beyond the heterosexual choices society offers and promotes, who live according to their true natures and desires. Comic situations, such as a lesbian who wakes up one morning to find she has a penis or a gay man who one day finds an angel tangled in his laundry line, alternate with poignant tales of loss and love, visions of the future or the past that have a solidity and realness all their own.

In the Middle Ages, these sorts of incredible, mystical occurrences described above indicated the presence and virtues of saints. In the worlds and words of magic realism, these wonders are more commonplace, miraculous events and

visions occurring in the ordinary lives of real people (just like you or I) in the recognizable contemporary world as we know it (that is, not in some made-up fantasy realm).

Originally used to describe the work of certain Latin American writers (most famously Gabriel García Marquez's novel *One Hundred Years of Solitude*), the term magic realism now applies to a broader range of work by writers of all different ethnicities and origins. Sometimes this work is considered to be outright genre fantasy if written by certain writers known for their science fiction, or it's simply "mainstream" fiction if written by authors who are accepted into that canon.

Examples of books of lesbian or gay magic realism would be the lyrical coming of age novel *In The Eyes of Mr. Fury* by Philip Ridley; the transformative, visionary episodes in Judith Katz' novel *Running Fiercly Toward A High Thin Sound*; the döppelgangers (what concept could be more homo) of Nancy Springer's gender-bending novel *Larque on theWing*; and some of the stories in Randall Kenan's collection of linked stories *Let The Dead Bury Their Dead*.

And, of course, the work of the writers in this collection.

Turn the page, and let them open your eyes to the hidden wonders in the world around us, to show you things— awesome, frightening, poignant, and joyous things—invisible to see.

Lawrence Schimel
New York, New York

The Story So Far
Martha Soukup

W e grew up in the same small town, in the same short story.

A first glimpse of classroom. Blinds raised, a sunny day. Mrs. Zelinski appears, short, gray, plump, pulling down a map with a stick with a hook at the end. In another moment she is wearing a plaid cotton dress, and it is ugly.

I am sitting at a desk among two dozen other murky students, but I do not know who I am yet. I only know Mrs. Zelinski, talking about Argentina, which hooks down to a point at the bottom of the map, and Dennis.

Then Dennis looks across at Sylvia, and I see her for the first time. Sylvia happens before I do, but only by an instant, because Dennis sees me sitting on the other side of her, so that I am there when we first see that she is beautiful.

Sylvia is beautiful. She is beautiful in the way few people are in their first rush of adolescence, which explains to me for the first time that that is how old we are. In this way I learn: Mrs. Zelinski's dress, tan and gray plaid, hitched up on the right where it catches in the belt, is ugly. Sylvia's blonde hair pushed over to one side, Sylvia's skin so fair it glows, with no trace of the acne I know now I have, Sylvia's soft blue dress gliding

down around her new breasts and her long legs crossed at the heels, under her chair—these are beautiful. There can be no doubt Dennis is struck with an awkward awe at the sight of her.

Dennis glances past her for a moment at me and I blush. I know he doesn't even see me (now I know my name is Emmy Cluff, and I am small and flat and forgettable) past the fleeting notice that I am a little pale mouse next to Sylvia. Still, Dennis has looked straight at me, and I blush and look down at the top of my desk. I do not care about Dennis, but I have to blush.

Mrs. Zelinski's stick crashes on her desk and Dennis is no longer looking at me. Now I don't have to look at my desk, so I look up, first to see Argentina, pale green on the map against the robin's-egg Atlantic Ocean. And then I look over at Sylvia.

She winks at me. Dennis is stammering at Mrs. Zelinski and doesn't see. Mrs. Zelinski says something and Dennis looks embarrassed. I am thinking, why do I have to have a dumb name like Emmy Cluff? I wish my name were Sylvia.

Mrs. Zelinski says something else, and that is the last I see of Mrs. Zelinski or the seventh-grade classroom.

It is a summer game of softball. I think more has happened between, but it is the next time I am in the story. I stand on the sidelines watching Dennis come to the plate. He is bigger now. While he hits his bat on the plate, I sneak a look down at myself. I am bigger too, but not much bigger in the place I am looking. I look around and see Sylvia, on the other sideline. She is wearing shorts that show how long and slim her legs are. I am in baggy blue jeans and a dull blue blouse.

There are other kids with names here, mostly on Dennis's team, but I can feel that they won't be very important to the story, and most of them don't even have names.

Dennis strikes out. He comes over to the side. Sylvia is laughing with another boy on the team. Dennis walks up to me.

"What are you doing Saturday?" It is the first time I really hear his voice, which is medium-deep and sounds like it's getting deeper. It is only the second scene that I have been alive.

"I have a clarinet lesson," I say. Do I play clarinet?

"No, I mean Saturday night," Dennis says.

I blush again, which is annoying. This story does not have much subtlety. "Nothing, I guess," I say.

Dennis glances over at Sylvia, who is laughing loudly enough to hear from here. If the look is meant to be surreptitious, it misses, so it probably isn't. "Want to go to a movie?"

I feel the blush burn harder. I want to shout Stop that! I say "Okay," which is all that's required of me, because there isn't a break, exactly, but the doorbell rings and I have parents, hovering over me in the front hall of our house.

My mother rushes to the front door and lets Dennis in. My dress is too tight in the ribcage and I guess too short, too. It shows I don't have many opportunities to dress up. As Dennis comes in I sneak a look at my parents. They are both short, plump, with brown hair the color of mine, my father's thinning and my mother's held round about her head with too much hair spray. They aren't much of a job of imagining parents.

As Dennis comes up to take my arm in an oddly courtly gesture, I wonder if he notices the gaps in the story, or if being the center of attention is enough to keep his mind occupied. I want to ask.

"Is the movie downtown okay?" he asks.

"Sure," I say. I walk to the door with him, feeling heavy. I must weigh twenty pounds more than I did in the first scene. My mother beams.

The movie playing is a second run of something. Of what, I'm not sure: I watch the screen but I see only random shapes, a shadow of something that is either a car chase or a dancing scene. Dennis cranes his neck over the balcony railing. I sit

back, squinting my eyes against the darkness. I'm still taller than he is. I can see where he's looking: down in the main section, in front, over to the left. She is with the boy from the softball game, and she is pulling his head over to kiss him.

I shake my head in admiration. Right in front of the theater like that. Anyone else would hide in back, in the balcony. The longer I am alive, the more of the story's assumptions I understand. Now I know that Sylvia does not have a good reputation, and that Dennis doesn't dare talk to her. I wonder why this story seems to define girls by what boys think of them.

Then I realize the only reason the story has Sylvia kissing the other boy in plain sight is for what Dennis will think about that. I worry: Does she want to kiss the boy? Does she understand it's a show for Dennis? Does she enjoy it anyway?

I'm thinking about that when Dennis puts his hand up my blouse, and I push it away once and then do not. I am not thinking about his hand. It's the way the story goes, his hand groping randomly over me, and I can't do anything about it but think. I wonder what Sylvia thinks as she puts her tongue in the softball boy's mouth. I wonder if anyone thinks besides me. I hope Sylvia does.

Now it's a dance. Banners over the gym floor say JUNIOR PROM. I'm in a different dress, but it still feels tight. I glance down to see that I'm straining at the front of it. Must be a recent development, har har.

I am far from the center again, standing by the bleachers. It's more focused in the center of the gym, and it takes me no time to pick out Dennis, dancing with Sylvia. Her hair is longer and ripples like a waterfall when she moves. The story is dim where I am, and I find I can ripple my fingers in imitation of

that watery shimmer, on purpose. I wonder if her hair feels like water. I run my fingers through my own hair.

Sylvia laughs. "What in the world are you doing?"

I drop my hands, startled. Dennis is still far away on the gym floor, arguing with some boys. Sylvia is grinning at me.

"Trying to make my hair like yours," I blurt.

The words come out exactly the way my thoughts are in my head. That's a surprise. I realize this isn't part of the story; the story continues with the boys slowly circling each other on the dance floor.

"It isn't, though," I say, a little more careful with these words, these words I am controlling myself. "It just hangs there." As long as Dennis doesn't see or hear us, I can really talk. "This is stupid, but—can I touch your hair?"

Sylvia looks slantwise at me. She doesn't say a word. I'm afraid she's really just a prop in the story after all, and I feel sadder than I'd learned how to feel before.

She takes my hand.

The argument across the gym is becoming more animated. I see one of the boys is the boy from the softball game and the movie. Sylvia's hand is warm and dry. Mine feels clammy. I am embarrassed, fascinated, as she raises my hand. I feel my pulse against the warmth of her skin.

The boy from the softball game is hitting Dennis in the face. The rest of the boys stand like statues.

Sylvia pulls my fingers through her hair. It is soft and smooth, but it isn't water and it isn't magic, it's hair, like mine. I like that.

I say, "I wish I could dance like you do."

"Oh, *dancing*," she says, dismissing it. "That's just for the story. What I *do* is think. You do that, too."

She smiles and I think she is going to touch my face when the boy from the softball game comes and takes her away, just like that. Dennis appears, a bruise around his mouth, his eye

beginning to swell. "Let's leave," he says, and I realize I came to the dance with him. I want to wave goodbye to Sylvia, but my fingers cannot move that way when Dennis is looking at me. Instead they go up to touch his mouth, gently. He winces.

"I'm sorry," my voice says. "I should have told you Ralph was looking for you."

"It's a free country," he grumbles. "People can dance, can't they? Can't people do what they want?"

I don't know, I want to say. Can I?

"Of course," I say. "Could you take me home now? This is a stupid dance anyhow." He takes my hand to lead me from the gym. His fingers trap mine. They do not pulse with possibility. I look for Sylvia in the parking lot as we get into the car and the scene ends, but she is nowhere to be seen.

I am driving down the central part of town. I see Dennis and Sylvia walking along the sidewalk. Dennis seems to catch a glimpse of the car I am driving. He pulls Sylvia into an ice-cream shop. I want to try out how fast the car can drive on the expressway but

I am crying on the front steps of my parents' house. "The scholarship didn't come through," I say. "You know my parents can't afford to send me to the school you're going to." Tears feel weird. There is a teasing little breeze: it catches them in cold stripes down both sides of my face.

"I won't go. I'll take classes with you at the community college." Dennis has a brave look on his face, but his eyes look trapped. Does he want to stop the plot to see what happens, too? I want to ask him. I try. I open my mouth.

"Don't be stupid," I say. "You have to go. You'll learn all sorts of things. You'll be an engineer. And you'll meet lots of girls as beautiful as—prettier than me. You'll probably end up

living in Paris or something, and I'll stay in the suburbs." I guess this is a fight. I don't like the way I fight. I don't seem to do it in a very straightforward manner.

"I won't," he says. "I'll come back."

"You won't," I say. If he doesn't, is the story over for me? I know this is Dennis's story, though I wish it were Sylvia's. But not mine. If the story's spotlight were on me all the time, I wouldn't have been able to say what I wanted to say to Sylvia in the gym. She liked that I thought my own thoughts.

"I will," he says. "I'll marry you, Emmy."

I cry harder, which seems pretty stupid. Then my face is dry and we're in a jewelry store and I say "It's the most beautiful ring I ever saw, Dennis!" He kisses me. I see Sylvia through the store window. She puckers up and squoonches her eyes shut, making fun of the way Dennis kisses. She winks at me and skips away.

Dennis didn't even see her.

That's interesting.

The long train of my dress catches and pulls on the red carpet. I am taller than my father now, walking beside me, but he doesn't look any different or more formed than he did last time.

"Dearly beloved," the minister says.

Dennis puts another ring on my finger. He kisses the bride.

I throw the bouquet at the reception. Sylvia catches it. I try to catch her eye but everything is moving too fast.

He is carrying me into a hotel room. I am in bed. My clothes are gone. He gets on top of me. His legs are heavy on mine and he smells of sweat. He murmurs unintelligibly.

The scene breaks.

Things Invisible to See

* * *

Dennis comes home. He's been doing things, but I don't know what, and I can't ask. I'm just in the apartment, which isn't much different from my parents' house except it's smaller.

"How was your day?" I ask. I know the story's been moving since the wedding. I can feel it. I wish I knew if Sylvia is still part of it.

"Fine," Dennis says. Then he makes a smile and says "Fine, honey." And he puts his mouth on top of mine and bends me back. That's that.

"The doctor said there's no reason I shouldn't have children," I'm telling Dennis. "He said just relax."

"Do you ever relax?" Dennis mutters. How would I know?

I bring him a dinner I must have cooked. Pot roast. I put it in front of him and he doesn't say anything. He just eats it. I don't say anything either. I don't think I like being married. My scenes are shorter and there's less for me to look at. I wonder if things will change, or the story will just end, or my part in it will end. I wonder if I'll know it when my part in the story is over, or if I'll just stop.

"A person can see who he wants to see, can't he? It's a free country, isn't it?" Dennis is shouting at me.

This marriage must not be very pleasant.

Sylvia walks by the front window and waves at me. I'm surprised she's there, and I want to go see her. But Dennis is still shouting.

"Don't let me stop you," I say in a low mean voice. Why

should I sound angry? What is Dennis to me? He has made me blush, and marry him, and he bent me back in bed, but that doesn't touch me. I just have to say the things I have to say. We have not been in groups of people, so I could think my thoughts in the background while he interacts with someone else, not since the wedding. It all moves too fast now. I have to try to figure things out in the little moments between shouting and tears.

"I won't!" Sylvia is back outside the window. She lifts her fingers and makes antennae behind the back of Dennis's head, where only I can see. She puts her hands on her hips, pretending to shout, and points and shakes her fist. I feel a huge laugh inside me, watching Sylvia clown out of the corner of my eye.

"That's fine. Don't expect me to hold dinner," I say in the same low voice. Dennis turns and Sylvia ducks instantly out of sight. He goes to the door. I stand frozen, scowling, laughter trying to explode out of me.

He slams the door and laughter does explode from me. I choke and shriek with it. Tears run down my face. I lean against the window, gasping for breath, watching Dennis sneak into a little red sports car. Sylvia sits behind the steering wheel. Dennis doesn't look back, but Sylvia turns and raises her eyebrows at me. I wave with both hands at her and dance around like a maniac. The car drives away, and I laugh for another minute, standing in the living room without Dennis there or anywhere around, just laughing, alone, laughing so hard that for several moments I don't stop being there, even without Dennis, his needs, his story.

That is the only time I laugh for a long time. My scenes stay short and angry. I suspect most of Dennis's story is somewhere else. Maybe with Sylvia. I am happy to think she's out there,

somewhere, maybe clowning behind his back, but I never catch a glimpse of her. Fighting with Dennis was tedious the first time, but it's all that happens for me.

And I can't steal any more time for myself. When Dennis goes, I try to hang on. I promise myself a reward if I can do it. The problem is, I can't think what I could give myself. I think Sylvia must know something I don't. She was there that time, when Dennis didn't know it. How did she do that?

Somewhere within a scene break we have moved to a house, but it's the only thing that's changed. Dennis may be a little older. I probably am, too, but there are no mirrors in the rooms in which we fight.

This is the best I can do:

"You are a shrew," Dennis says.

My hands are wrapped loosely inside a big dish towel. "Who made me one?" I say. Inside the towel, I dance my fingers around crazily. He doesn't know I'm doing it.

Dennis is stomping away to the door, and I have seen this before, and before, and before.

When his back is to me I drop the dish towel and twirl around three times on my toes—in the few moments before he gets to the door and it's over again.

"I called her," I say to him. I called someone? I want to cheer. It's different. I have an active role in this fight.

"Who?"

"Your tramp," I say. I think that means Sylvia. I wish it hadn't happened off scene. I wish it was something I had done, rather than something I tell Dennis about. "I invited her for dinner."

"My god, Emmy, you didn't. There's nothing going on between us and you know it, and you're going to throw some kind of hysterical scene!"

"I don't see how you can have any objection to inviting one of your friends for dinner. I'm always alone and starved for company in this house." I wish this were true. I am always with Dennis, only with Dennis. I don't exist alone. "Maybe now you'll stay home for dinner one time."

"You're not going to do this," he says.

"She said she'd come, and she'll be here in half an hour. I have to finish making the gravy," I say. I go to the kitchen and stir brown stuff in a long flat pan on the stove. There is a heavy silence from the living room. It's very much like being alone. I like the feel of the wooden spoon in my hand. It feels more and more real as I move it through the thick brown sauce. I can feel the wood grain against my palm. I hold it firmly, its growing reality, thinking about nothing but the spoon.

I take the gravy off the stove when the doorbell rings and go to join Dennis, greeting Sylvia at the door. I can tell when I see her that we are all older. Maybe ten, maybe fifteen years older. She's beautiful.

"Hello, Emmy," says Sylvia. Her voice is a little lower than it was in the gym.

She hands me her coat. Her dress looks like one of the ones in the lingerie catalog I was shouting at Dennis about many scenes back. Then I don't look at her. I want to, but my face turns away. "Hello, Sylvia," I say flatly. "Dinner's almost ready."

"Maybe we can catch up on old times while it finishes," she says in a voice just as flat. Dennis looks upset. Sylvia and I walk back in the house to the den.

My heart is beating hard as I shut the door behind us. I am afraid the scene will break. My hands lock the door and it makes a loud click, loud enough to be heard down the hall. I can hear the floor creak from Dennis's step. He often paces when we're about to argue.

I turn to Sylvia. She whoops a whispered whoop and

throws her arms around me in a hug that knocks my feet off the floor. "Time!" she whispers, picking me up. "We have time!"

"How much time?" I whisper, rubbing my sore bottom, a part of myself I think I've never felt before. "How long can this scene last until we have to go out there again?" Then, "Slut!" I shout. I pick up a lamp and throw it at the wall. It shatters loudly.

Sylvia giggles. Her high cheeks flush with merriment. "We're having a fight in here," she whispers. "How ridiculous! —Do you know the trick?"

"The trick?" I say, confused.

"To make time last."

I don't know what she's talking about.

"When he's not paying close attention to you, when the story's not paying close attention to you—when he's not looking at you, it doesn't matter what you're doing," she says. I make shapes with my fingers, remembering. "So it doesn't matter how much time you think is passing. You can decide for yourself how much time it is."

She grins. "Once when he went to the bathroom, I took the whole stereo apart. To see how it worked. When I decided I was finished and he came out, it all went back together again. I took a bicycle apart once too. It was easier to figure out." She's talking very fast, like she's stored things up to tell me. "I think I stole an hour, or two hours, just while he was taking a leak. I probably could have taken more, but there just wasn't anything to do once I had all those pieces laid out. Hotel rooms are boring. Haven't you done anything like that?"

"I'm never alone in a room," I say. "It's a fight, and another fight, and another fight. Nothing in between."

"No. Not even once?"

"Once I laughed, all by myself," I say, remembering.

"Tell me what you've done. Tell me what you've thought."

I tell her about my part of the story, what it's like to be the shrewish wife to a person I don't really know, how I've tried to fit the story together from the little pieces I've seen and decided it wasn't good or fair. I am too embarrassed to tell her how often I think about her.

"Excuse me a second," whispers Sylvia. She knocks over a leather chair and squeals a loud outraged squeal: "You——!" The floor creaks again outside.

I sit on the floor against the overturned chair. I clutch my knees and start to cry. The tears feel natural, and bitter.

"Hush," says Sylvia. "Hush." She kneels down next to me. She puts her arms around me. "Hush, honey, hush." She brushes my hair back with her fingers. I reach out to feel her own long, gold hair. It is soft and heavy. She kisses a tear off my cheek. I reach my hand down behind her neck.

Sylvia is so strong, the sort of person you know you can only admire. I start to pull away. She catches my hand.

"You're real," she whispers. "You see things. You think things. You're so beautiful." She brings my hand up and kisses my fingers. She kisses me on the lips. I find the way her dress unfastens, and I pull it away to see what all of her looks like. I run my hand from her neck down to her hip, along the warm curves of her side. She moves her arms gracefully, pulling my blouse up.

I want to tell everything and leave nothing out. I do not mean to leave anything out when I say: I do not now do anything that I have not thought to do. What Sylvia does is what she thinks of herself. It feels beautiful. It feels real. And I stop waiting for another creak outside the room. I forget for a long time that there is an outside the room.

We lie there together a long time, breathing quietly and not having to do anything we don't want to, most of the time. Once I have to slap my hands together hard, and Sylvia has to cry out. Her eye swells and starts to turn dark underneath.

"I wish I got hurt instead of you," I whisper.

"It doesn't hurt."

Finally I start to drowse, and that must be when time starts fast again. Dennis has forced the door open, and I am standing with my hand raised to Sylvia. There is a smirk on her mouth, but her eyes are kind and searching. She looks like she wants to tell me something. Dennis shoves me and takes Sylvia out of the room. I don't think he's coming back in this scene. I will myself not to go away. I will being alone in this room.

I sit beside the overturned leather chair and feel it, its grain different from the wooden spoon, different from Sylvia's skin. I compare the feeling of all three textures, wood and leather and skin, and I love them all. I stroke the chair and

Dennis doesn't talk to me now. There are no fights. There is silence. Bits of silence in fast patches, as he enters and leaves, enters and leaves, once or twice glowers through breakfast or dinner. In the silences, I think about my memories, and at the moments of his leaving I practice making time for myself out of his inattention.

I learn how. I make a lot of time.

I duck into the room in which Sylvia and I were together when we had the fight for his benefit, and I fix it up. I take the curtains off the windows so all the sun comes in. I don't worry about privacy, because there is never anyone outside the window, though I keep looking. I put the leather chair in the middle of the sunlight, so that it is warmer than a person, soft in the sun. I take books off the shelves to read them, but there are no words inside; so I take their bright jackets off and put them on the walls. Later I sneak in the kitchen scissors and cut the jackets into colorful shapes, flowers and birds and bright red mouths. I cover the walls with paper kisses.

I'd like to write in the empty books, but all I know is the

story I am in, and I don't even know most of it. Just what I see from where I am.

The parts of the story I am in become more fractioned, more disjointed. Dennis walks into the room, throws his jacket on a chair, and walks out. Dennis shouts at me that he cannot take off work for a vacation. Dennis comes home late, drunk, and does not say a word. Dennis ages faster, scene by scene. The story must end when he dies, if not before that. Time is precious. I make my own hours for every few seconds of time with him.

In my time, I cut the curtains in my room into long shreds and sew them together to make a huge floral robe that swirls around me when I move. I exercise my memory: I remember seeing a boy sail a paper airplane in the first moments of my life, and I tear pages out of books and fold them until I get something that flies. The failed shapes I hang by thread from the ceiling so they won't have to be failures. When the weather is warm so I can open the window (one day it will be spring, the next winter, the next summer) they swing against each other, rustling.

Always I tire, lose my concentration and find myself in another fragmentary moment with Dennis.

He is reading the paper one time when I see a little red car drive by. It has dents and rust on it. I see Dennis see the car, too; his eyes flick up, and then he looks back down at the paper. Dennis shows no emotion now.

The instant he looks down I run into the kitchen and out the back door, where I've never been before. The back yard is an expanse of hazy green, without detail. I run around the house and wave frantically at the back of the car.

Sylvia pulls over, out of the view of our front window. I

27

climb in. She is wide and round now, her hair more gray than gold. She looks good. I hug her.

"I've missed you," I say. "I've taken a lot of time for myself. I've fixed up the room. You'll think it's silly. Come and see."

"I've had no time since I saw you," she says. "One little bit with Dennis telling me it was over, but that was it—that was the one moment I've had since I was here last. I think I'm out of the story."

"I thought you *were* the story! I thought that was it— Dennis going back and forth between the two of us."

She shakes her head. There is a little gray curling around one ear. I want to touch it, so I do. "I don't think it has anything much to do with either of us. I think it has more to do with his job, now, and I'd bet he's selling secrets. Now that he doesn't have a home life or a mistress, I think he'll go further and further until he's caught."

"His job? I don't know anything about it! What could be interesting about that?"

"Who knows? We're just peripheral to it all."

I am angry. "All this mucking about to make a life for him, and it doesn't even have anything to do with us!"

"Poor Dennis," says Sylvia.

"Poor Dennis?"

She shakes her head. "He's so trapped."

"So are—"

She puts both arms around me and holds me, her breath in my hair. "We have room to make up parts of ourself. Room to live, in the cracks of this story. What does he have? Does he get to wonder? We can't even ask him. He can't even tell us." Her voice is rich with sympathy. I remember all over again how fine a person she is. I snuggle against her, feeling peaceful.

Later, when I ask, she gets out of the car and dances with me. There is no one on the street, no one on the sidewalk. She dances barefoot on the featureless grass, bending and reaching,

slowly, with a kind of dignity that is new. Her body is mature, full, now. We dance to no music with the wind in our faces. Then we lie on the grass and look up. "I never saw clouds before," I say.

"Look closely," she says. "I think the story's almost over. You may never see them again." I turn on my elbow to her, but she is looking up at the sky. "You may never see me again, either."

"No!" I cry. "That can't happen—I've hardly seen you!"

"Things end." Blue sky reflects in her eyes. "This has been the best part. With you."

"Stories can be told again." If I say it firmly, I might believe it.

She smiles with her mouth and glances at me. "This isn't our story. We stole what we have." Her mouth quirks sideways and she looks back up. "When this story gets told again it's just Dennis's sad little life, starting high and selling out until he ruins himself. No happy ending. If he doesn't get one, why should we expect to?"

I want to cry, but I can tell she is close to it herself, and Sylvia is not a person who likes to cry. I lean over her and kiss her neck, in her favorite spot.

Time does not stretch forever. In the end Sylvia is back in the car driving out of sight, and I go back to the living room behind Dennis's back. I think I see a flash of light from her bumper as I hear the sound of her engine fade away. There has been no goodbye. She never saw my room.

Dennis folds his paper. "I have to go to the office."

"On a Sunday?" my voice says. None of the loss of Sylvia I feel in it: the tired resignation of a wife nagging her husband for the thousandth time.

"Things are complicated, all right?" he snaps. Suddenly I know it is almost over. Shaken, I forget to steal time.

* * *

Dennis is home, ashen, something terrible happening he won't talk about. I know Sylvia was right and I will never see her again. She is gone. Soon I will be too.

The phone rings and Dennis answers it, panic and wheedling, not words, audible in his muttering. I leave him on the phone and go back into my room. Lopsided paper birds fly under the ceiling. My robe is spread across the chair. If Dennis came into this room, would everything that is mine in it vanish?

It will all vanish soon anyway.

I look out the window, wanting to see her car. The road is not visible from here.

Now I cry, the first time I have ever really cried, myself, not Dennis's little wife Emmy in the story. I pull my flower robe up around my face and sob, silently. Dennis must not hear me. It could break the last time I can make my own time.

I cry until I get angry. I did not decide on my life. I did not write it. I tear off the robe and start yanking hangings from the ceiling, furious that they are all I have done with my life, furious that Sylvia never even saw them, furious that they are foolish. I think if she did see them, she'd laugh at them. I can hear her laughter in my mind.

But my mind can't make it mocking. Even when she made fun of Dennis, there was nothing hurtful in it.

I think of Sylvia, laughing. I'm the only one who knew her, and soon I will be gone. The story could be told again with nowhere any trace of me, of Sylvia. Only Dennis and the fleeting images of women in his life. Only Dennis's story.

I barely knew Sylvia, but knowing her made her more real, as her knowing me freed me. My anger falls away. My

frustration falls away. Sylvia found ways around the limitations. I remember her laugh.

I push the leather chair over to the writing desk. My body has gotten older and the chair is heavy; I sweat doing it, and like the feel of my sweat. I open the drawer and find some pens. I take down two books and open the first one to a fresh, white piece of paper, clean, like Sylvia's grin. I gather my memories around me, with the cutouts and the hangings and my tattered funny robe. They all belong to me.

I write on the cloth cover of the first book, "The Story So Far." I write on the cover of the second, "The Further Adventures of Sylvia and Emmy." In the first book, I begin:

"We grew up in the same small town, in the same short story"

When I finish this story, I will start the new one.

The River of Time
Lawrence Schimel

I placed Eric's ashes on the seat beside me. I wasn't expecting to feel such relief to let go of them, which made me realize it was the right thing to do. I'd been carrying them around for so long, it seemed, walking through this last request he'd made to me: to scatter his ashes from the Christopher Street Pier into the Hudson River. I knew I was having trouble letting go of him. I'd kept putting off the day of scattering his remains with excuses: the weather wasn't right for how I thought his last moment (as if he hadn't already had it) should be or my work schedule meant I couldn't do it at the "right" time of day for such an occasion, whatever it took to convince myself of the need to delay.

Now that my hands were free, I rubbed my shoulders, which ached from the weight of carrying him around. The urn with his ashes was nothing, really, compared to what his physical presence had been. I was amazed that an entire human body could become so insubstantial.

"We're mostly water," Eric had said, the first time he'd gotten really sick, when he was telling me what he wanted me to do. "They'll just be taking all the water out. I'll be like that

freeze-dried food they give astronauts. Just add water and it pops back to life."

I didn't say anything. There was nothing I could say that would change anything, make a difference. He'd put his hand on mine and continued. "That's why I want you to dump me in the river. I know I won't pop back to life, not like that astronaut food. But it'll be like mixing me up into a sort of clay and giving me a new start. Who knows where I'll wind up? I want to go all over the world, at last get to visit all those places I never could afford to go to! And I will; I'll be like a drop of ink falling into a cup and, over time, it colors the entire glass. You'll never be able to see water, drink water, even be water, since that's what you mostly are—anywhere there's water, I'll be there, too."

I'd started to cry, and he stopped talking to stare at me. I'd laughed at myself then, I'm not sure why, the look on his face or my lack of control or both, and he'd reached out with one arm to wipe a tear from my cheek. "Anywhere," he said, holding the salty tear on his finger.

He'd gotten better, only got that sick once more. But he never let it stop him; he was always living grandly, by the seat of his pants, getting into scrapes, having adventures—even those two times he was confined to a hospital bed. That first time, when he spent a week in St. Vincent's, he'd seduced one of the male nurses, who'd broken all sorts of rules and regulations to finger-fuck him and jerk him off. There were boxes of safety rubber gloves everywhere, and medicinal lubricants. He'd claimed it was some of the best sex he'd ever had, as he gleefully told us the details one night at the restaurant.

Eric had been one of the protease success stories. He'd seemed invulnerable—except for those two hospitalizations—as he confronted elemental forces of nature: he went white water rafting, climbed mountains, went deep water scuba

diving, anything and everything that would give him that terrifying, exuberating thrill. We'd all gotten used to the idea that this disease would kill him in the end, despite the drugs, as the promise of a cure kept slipping further and further back. But it had been such a shock for him to die as he had, a freak accident in his own home where he'd tripped getting out of the bathtub and cracked his skull, something having nothing to do with his HIV.

We felt cheated, I guess. At least I did. We'd always thought there'd be time to say goodbye, a long slow descent. His friend Liza had asked him once, when a group of us were getting stoned at her apartment late at night, how he felt about suicide, if he thought there might be a point when he'd want it for himself.

He hadn't answered right away. Sitting up, he looked around, took another hit. "I'm too much of an overacheiver ever to give up," he'd said. "By the time I got so bad that I'd want suicide, I wouldn't be able to do it myself." He'd smiled then. "I'd feel like such a failure if I had to have someone help me, I'd never be able to live with myself."

I wasn't sure why he'd picked me. We were friends, but in a casual sort of way. We were never lovers, though sometimes we flirted so madly that our acquaintances were sure we were getting it on with one another. I met him one night when I was working as a waiter at Stingy LuLu's and he'd come in and just struck up a conversation with me every time I walked past, not hitting on me, just talk.

He became a "regular" and somehow that evolved into a friendship where we'd see each other outside the restaurant. And whenever I quit and started working elsewhere, he'd become a regular over there. He had an amazing appetite and would try anything you put in front of him, which made sense given how adventuresome he was in other parts of his life.

"Why the Hudson?" I'd asked him one time.

"Exactly!" he'd replied, and I knew there was a doozy of an explanation coming. Eric was always enthusiastic when he was telling of his exploits, and this, to him, was just one more adventure. "Who'd even notice me in there, what with all the pollution and stuff? It's someplace I've always been too afraid to go swimming, but when I'm dead I won't be so afraid. It beats getting flushed down the toilet like an alligator.

"Besides, I think it's the perfect place for my ashes to be dumped, because whenever I got dumped, that's where I always went: down to the piers, to drown my sorrows and the memory of my now-ex-boyfriend in the sticky, blissful forgetting of anonymous sex."

So he and I were on our last excursion together, taking the subway downtown to go dump him in the river like he wanted.

Walking through the street with his ashes had felt uncomfortable at first, like when I had just realized I was gay and was afraid that everyone else could tell, too, like it was written on my face the way some of the kids at school would write signs saying KICK ME and tape them on my back when I wasn't looking. I walked around with this awkward burden that was all that remained of my friend as if it were some secret shame; everyone who passed me stared at it, recognized what it was. When they looked at me, it was as if they thought I had murdered him, as if I were holding his dripping severed head in my hands. They wouldn't meet my eyes.

But as I kept walking, there began to be something liberating about carrying Eric's ashes, as if I were showing him one last good time. It was the in-your-face, I'm out and proud defiance of being queer, and it felt right. People still looked at me, but now they were the ones to look away, and I knew they were thinking about their own mortality, or of family or friends. I know that seeing me carrying Eric's ashes had changed them—or at least some of them. So many New Yorkers have blinders on when they walk the streets: don't look, don't

get involved. I wanted to go up to them and shake the urn of ashes in their face—but I felt that wouldn't be right to do to Eric. I was acutely aware of what I held, careful to not jostle the contents of the container I carried, even though I felt pretty sure Eric didn't mind, or didn't care, or wouldn't even notice.

Trying to maneuver through the subway turnstile had been tricky, dropping the token in the slot with one hand while trying hard to not bang Eric against the metal and rattle him. As we passed through, I couldn't help silently wondering if I should use two tokens. I smiled at my joke, despite the macabre humor of it, then felt guilty for smiling. I tried to reason that this was exactly the kind of humor Eric had liked and used himself, but I felt like I was trying to convince myself. I wasn't Eric, and just to have had the thought made me blush.

I'd kept the urn on my lap when I first sat down, since I felt guilty taking up two seats on the subway. But this was Eric's last chance, really, to take up space in this world. Now Eric sat beside me as if he and I were going downtown to shop or cruise, any ordinary Sunday afternoon.

"When my husband passed away, I had him cremated," the woman across the aisle from me said. I felt like everyone on the car turned to stare at me, and what I held. Why didn't they look at her, I wondered, this middle-aged white woman who sat opposite me; she was the one speaking, making noise, attracting attention. I looked away from her, hoping she'd stop talking to me, I didn't want to hear, didn't want everyone else to hear. But she continued. "They put him in a little box, nothing so fancy as that. I didn't believe he was really all in there, it was such a tiny thing. So I looked inside, and there was a plastic baggie in there! With all the ashes inside the little Ziploc baggie."

I'd wanted to peek inside, too, to make sure the ashes were really in there. But I'd resisted. It seemed only bad things could come of such mistrust. I thought of all the stories of men

who'd looked too soon, and lived to regret it: Lot, looking back and turning his wife into a pillar of salt; Orpheus, fearing she wasn't following him from the underworld, and then losing her forever.

I grabbed the urn and stood up even though the train hadn't stopped, anticipating my exit. I felt guilty at turning my back on her—the opposite of those stories from the Bible and myth—but I just couldn't deal with this right now. The subway pulled to a stop. The doors opened and I leapt through them, brushing past the people waiting to board.

On the street, I slowed down, took a deep breath. This was Eric's last trip down this historic gay street, I realized, and I wanted him to get a good last look. I held the urn up in front of me as I walked past St. John's Church in the Village. Again passersby looked at us. Some looked away when they realized what I held, others smiled. I didn't really care what either set thought, I did this for Eric.

We crossed Bleecker Street. There, across the street, was the Village Army Navy, the Potbelly Stove Cafe, Don't Panic; we passed McNulty's Rare Teas Choice Coffees Since 1895, The Leatherman, the Hangar bar, the Lucille Lortel Theater; at the corner of Hudson, the infamous Christopher Street Bookshop. I wondered briefly if I should walk inside, realized how foolish I'd feel going in there holding a funerary urn filled with ashes. In so many ways, this entire nostalgia inventory felt forced, as if I were making a ritual of this all because I, too, was losing these places, as if I couldn't visit or enjoy them after this last journey because Eric was no longer alive to share them with me. As if he'd ever been such a large part of my life; dead, he took up more of my time and thoughts than he had when he was alive!

I continued on toward the water, past the homeboys sitting on the steps at the PATH entrance, past the other erotic video stores and bars, across the highway and onto the piers at

last. Lots of men were just hanging around, their shirts off, some smoking weed, listening to boomboxes. Men and women on rollerblades skated past people out jogging or walking their dogs. I walked down to the end, climbed through a hole in the chain link that stretched up over the protective concrete partition. There were a handful of us out on this "forbidden" zone of the pier, no barrier between us and the crumbling edge that led to the water.

This was it. The moment of truth.

I looked down at the urn's closed lid. Eric had chosen and paid for it when he first got sick, so even though he hadn't expected to trip and die in his bathtub, he'd been prepared. An only son, his parents having predeceased him, and without a longterm lover, he had wanted to make sure his remains were taken care of.

"I want an urn fit for a queen!" he'd declared, when the salesman showed him the possibilities. He chose a Grecian-styled urn with a simple geometric design around it.

"I'd wanted one of the naughty ones," he'd confided to me, later, when he showed me the pictures. "You know, like they have at the Met, in that wing where you walk about in between sucking men off in the lavatory." He'd smiled lasciviously and sighed, "Ah, culture!"

I took the lid off. The inside was filled with a pale gray powder, finer than sand. It wasn't what I'd been expecting, which was flakier, more like charred paper, the way a book or log that had been burned looked, still having the semblance of form but crumbling at a touch.

It wasn't in a baggie, just loose ash inside the jar. I reached in, stood like that for a moment, my hand deep inside the remains of my friend. Then I pulled back, scooping up some ash, and held my hand out before me.

The fine powder drifted from my fingers, down to the choppy waves which looked, because of the light, like a

hammered sheet of metal, solid, even though it was in constant motion, flux. I felt like I was adding powdered sugar to the top of an obsidian cake. Or more like adding salt to a soup, since the ash was sucked up greedily by the water, leaving no trace of itself on that restless surface. Handful after handful, I let go of the gray powder, as if I were desperate for seasoning, for flavor, for taste.

The ashes were not all thin powder. Sometimes there were larger chunks, like hard white pebbles, the kind that always get in your shoes when you walk on the beach or along a riverbank. I tried not to look at them. My hand moved mechanically between the urn's mouth and the sea, my eyes fixed on the point where the ash disappeared into the water.

A sudden gust of wind blew one handful back at me. I was blinded by the white flash of ash in my eyes, sputtered against the taste of it in my mouth. Frantically, I rubbed at my face with my hand, before I realized that it, too, was covered in ash, even the back. I put the urn down and rubbed at my eyes with the back of my left hand, wondering if I could catch HIV because I'd gotten ash in my eyes—a mucous membrane—the way semen in your eye could infect you. I hated myself for having the thought, knowing there was nothing of the virus that could survive the cremation, but I couldn't stop thinking it.

I remembered Eric, that afternoon when he first told me what he wanted me to do, brushing away one of my tears with his fingertip.

Now, for some reason, I couldn't cry. Even despite the ash in my eyes.

The noise and life of everyone around me came crashing back in on me, reminding me I wasn't alone, that life still went on—for me, for them, for us.

I stood and again picked up the urn. I reached inside; it was more than half empty now. Slowly, handful by handful, I

released Eric's ashes into the Hudson River. I was never tempted to just overturn the urn I held and plop them all in at once.

As I scattered his remains, I remembered the good times we'd had together—a cliché, perhaps, but something I felt obliged to do: to think about him, us, what I'd miss about him. It wasn't difficult to remember happy moments; we didn't have many bad times together. I didn't see all that much of him, and he was always so good-natured and happy-go-lucky, it was hard to find him in a mood where he rubbed you the wrong way.

When the urn was empty, I stood there for a long while, just lost in thought, letting it sink in that he was finally gone.

I looked down at the empty urn, wondering what I should do with it. This was something that never got mentioned when people talked about scattering someone's ashes. It didn't feel right to just throw it out, especially since Eric had picked it out specifically. I turned my back on the water and climbed over the barricade and started walking down the pier again toward the city. I took the urn with me; I didn't know what else to do with it.

The entire trip back I was afraid to touch anything, afraid of leaving behind some trace of Eric like fingerprints lingering after a crime. I held the emptied urn in my right hand; since it was already filled with a trace of ash coating its insides, it wouldn't matter if some got on the outside, too.

If the pier hadn't been so high up from the water, I'd have knelt down and dipped my hand in the water, drawn up water into the urn to empty its clay belly, so all of Eric's ash was dumped in the Hudson as he'd wanted. I felt strange that I still carried some of him with me, as if I'd somehow failed in completing his final request. All I wanted now that I'd done the deed was to get home.

Things Invisible to See

I got off the subway at Times Square, climbed upstairs, and started walking west. The urn seemed heavier than when it had been filled with ashes. I wanted to switch hands; my right arm was aching from carrying it for so long, supporting its weight without the help of my other arm. I rested the urn against my hip, or stopped and set it down on top of a trash can, but I didn't touch it with my other hand, as if it were now tainted. Ridiculous thoughts, I knew, but it was as if an immutable superstition had sprung up and I had to obey it.

I didn't know what I planned to do when I got home, how that would change things somehow, but I felt that once I got there everything would be OK. I'd be safe.

I lived in a fifth floor walkup in Hell's Kitchen, between Ninth and Tenth Avenues. It was a one-bedroom apartment, an illegal sublet from my downstairs neighbor, George, who was a painter. Evidently, he was a good enough painter that he could afford to own two apartments, or more likely he'd been something before he became a painter—an investment banker or lawyer—and earned enough to let him follow such rarely-lucrative pursuits as fine art painting. Whichever it was, I didn't care; the rent I paid was dirt cheap because I let him use my apartment as storage for his works. He hung his paintings—enormous abstracts with words hidden in them—on every wall, making my apartment a sort of mini-gallery dedicated to him. Except no one but me and my friends ever saw it; he never asked to bring anyone up and show them the paintings. And in the two years I'd been living there, he'd only once sold one of the paintings in my apartment. It was strange for the first month, to be staring at a new word—DISINTERESTED—above the television, day in and day out; I kept looking for the old word hidden somewhere in the painting, but of course never found it.

I fished my keys out of my pocket with my left hand, and opened the three sets of locks on the door. When the door had

closed behind me, I put the chain on and went directly into the bathroom. I placed the urn in the tub, as I would with anything dirty I brought into the apartment and meant to clean before I set it down on my own furniture or stuff.

This wasn't something dirty. This was my friend, the last bit of him I still had, except for my memories, already beginning to fade as if my trying to recall them, my going over them again and again as I emptied the urn, had worn them out.

I sat down on the tub's cold rim and thought of how Eric had tripped and fallen, wondering what his last thoughts might have been, if he regretted dying in such an awkward, tawdry fashion instead of doing something daring and exciting. Shallow thoughts for someone to have while dying, perhaps, but they seemed appropriate somehow.

I leaned forward and turned the faucet on, with my left hand so as not to smudge ash everywhere. I stared at the burst of water, letting the rust run out. When it was rushing clear and cold, I ran my hand under it, washing the gray-white dust from my skin. I remembered letting my friend Phillip, an avant-garde sculptor I met when I was living in the East Village, take a plaster of paris cast of my hand for a project he was doing. I imagined Eric's ashes becoming sticky substance like that, mixing to form a clay—like he had said would happen, that day he first asked me to be responsible for scattering his ashes into the river. He said he'd become clay when he hit the water, so he could be shaped into a mannikin again and have life breathed back into him.

I picked up the clay urn he had chosen as his penultimate resting place. What would I do with it now? I set its lid beside me on the rim of the tub and held its wide mouth under the faucet. The urn was becoming Eric in my mind, my refusal to let go of it, as if it still held his ash inside. But why was it so important for me to keep it? His ash had never been him, even if it was the stuff that had once made up his body; the Eric I

missed was something more, something ineffable and indescribable, something irrevocably lost.

As I was about to pour out the urn's contents, I was struck by the face reflected in the water of its mouth: it wasn't my own.

I looked more closely, and sure enough, Eric looked back at me, just as if I were Eric, staring down into the water. Eric was young again, maybe ten years old. Something moved in the water, above the reflection: the shadow of a bird flying overhead. We were on a riverbank, looking into the water; I could see trees reflected behind us. I could feel the sun shining warmly on our back as we leaned over the river. Dark shapes flitted beneath the surface, and our eyes shifted from the reflection on the surface to what lay beneath. Fat little tadpoles bumped among the rocks on the riverbottom.

Where were we? How could this be real? Was this Eric's past? How was I here?

I reached out, in wonder, to touch his face, reflected in the water's mirror.

But as my fingers touched the reflection, the spell was broken, and I was in my bathroom in my apartment in Hell's Kitchen in New York City, sitting on the edge of my bathtub, staring down at the urn which had held Eric's ashes, now filled with a mix of water and the last traces of his gray remains that I'd been about to pour away.

I remembered Eric saying, "It beats getting flushed down the toilet like an alligator," and suddenly I couldn't just pour out this last bit of him down the drain.

What just happened? I wondered. What did this mean?

I wanted him back so badly I was hallucinating.

I wanted to hold onto him, this one little piece of him that was all I had left of him. Suddenly I wanted to hold him, like I'd never actually held him in life, though we'd always joked that one day we would have sex with one another, some night

when we were drunk or stoned or just plain horny and happy and falling into one another's arms.

I turned off the faucet, which had been running all this time, however long I'd been lost in my daydreams of Eric. I lifted the urn from the tub and set it on the foot towel, to dry off its bottom and sides. I carried it out into the living room and set it on the small endtable, so it was sort of under both the window and the orange painting above the couch with the word INVINCIBLE hidden within its swirls of color.

I left the urn and went into my bedroom. I flopped down on the bed, wondering what was going on. Why was I feeling such strong emotion for Eric? Why now, when it was too late? Was it only because it was too late? Was this some expression of all my stored up grief, about everything, finding an outlet at last?

I felt worn out, drained, even though I'd only been up for a few hours. I sat up, looked at the clock, then reached over and set it to wake me up in an hour. I lay down again, thinking over the events of the past few hours, and especially the past few moments. I tried to match the place in my vision with some story Eric might've told me one night, but I couldn't figure out where it was, what adventure took place in that setting.

I must've fallen asleep, because I woke again when the alarm went off. It was time to head back downtown. I had to work dinner tonight at Pad Thai, the chic Chelsea restaurant on Eight Avenue. "Cute Boys and Asian Noodles" Liza always referred to it, teasingly, but with affection.

If I had dreamed, during my brief nap, I didn't remember anything from them. I felt a little disappointed, after the vivid images I'd seen while still awake.

I glanced at the urn on my way out of the apartment, but I didn't look inside it. I was too afraid of what I might see. And I was half-afraid that I wouldn't see anything.

All night long, I kept expecting Eric to come into the

restaurant—alone, or with some friends, with a trick, it didn't matter. I just had a feeling that he'd stop by.

He didn't, of course. He was dead. I had held his ashes in my hands. But my mind refused to admit it; I hadn't seen the body before it was cremated, didn't really have proof that he was forever gone, and not simply out of town on one of his wilderness excursions.

I was in a fog at work, messing up people's orders, making the wrong change. I stumbled home, wearily unlocked the three locks, looked at the urn from across the room, then went into my bedroom and shut the door.

The alarm went off. I woke with a piss boner, and as ever I wondered if there had been some sort of mental erotic stimulation in my unremembered dreams, or if it was merely a quirk of bodily function. As I lay in bed, feeling my hard on begin to subside a little and the pressure on my bladder increase, I felt like everything was back to normal again. That somehow, despite having finally let go of Eric's ashes, despite that strange episode last night where it had seemed like I saw his ghost—or his past—life would now go on as ordinarily as ever.

And, just like ever, if I didn't get out of bed and showered I was going to be late for class. I was studying intermediate German at Baruch College, and even though I was taking the course through their Adult Education division, because of my schedule they let me take the regular undergrad class which met first thing in the morning. Last year I had fallen in love with this boy from Berlin who was visiting New York for a week. He'd given me his address, in case I ever came to Germany, and in the weeks after he left I looked around desperately for a course in basic German, thinking I would move there to be with him, I could work in a hotel, they always

had a need for English-speakers, I would figure it out later, all that mattered was that I be with him. He never answered my letters, but by then I was already beginning to learn the language, and decided to stick with it to spite him. Maybe one day I would go to Germany anyway, and work in a hotel, and fall in love with someone.

At least, it had seemed like a good idea at the time, but now, if I didn't wake up, I'd be late to class. I took a piss, and turned the water in the shower on. While waiting for the water to heat up, I went into the kitchen and put on a pot of coffee. On my way back through the living room, I looked inside the water-filled urn.

There was motion on the bottom, and I thought at first that it must be a swirl of ash floating inside the urn. But it was black, not gray. I thought this might be another vision, like the one last night. But I was still aware of myself—standing in my boxers, my early-morning breath—staring down at the urn.

The black shape moved, and I realized it was a fish. It swam around in circles. No shit, Sherlock, I told myself, realizing there was nothing else for it do given the shape of where it was swimming. I'm always something of a bitch before I've had my coffee. Especially when I'm hallucinating against my will and without the aid of drugs.

I reached out and touched the surface of the water, expecting the vision to vanish as the one last night had done. It didn't. The little fish swam up toward my finger, and I pulled back before I got bitten. Not that such a tiny fish—smaller than my pinkie—could've done much damage.

It swam to the surface, as if to beg for food, and I realized it was a tadpole, not a fish, like the ones Eric had been staring at last night in the vision.

What did it mean? I didn't have the inkling of an idea, certainly not when it was still so early in the morning.

I wondered what human foods tadpoles could eat, and

remembered throwing stale bread and crackers to fish at ponds when I was younger. But looking down at it, swimming in circles, I also remembered that tadpoles didn't eat, they just digested their own tails, transforming themselves into frogs that way.

In German class, we'd been reading some of the Grimm fairy tales in German, including "The Frog Prince," where a frog gets transformed into a prince. In the version I knew from my childhood, this magical transformation was because of a kiss, but in the story we read the frog was thrown against the princess' wall, after eating from her plate and drinking from her cup, which turned him back into human form.

Had Eric been transformed into this tadpole, who'd grow up to be a frog—and perhaps, if kissed by a boy who loved him, into a human prince?

What had Eric been doing by that riverside, in the vision I'd had of him? Had he been looking to catch a frog to kiss?

It was too early for me to be thinking, let alone trying to puzzle out such strange mysterious things as unasked for visions and the sudden appearance of this tadpole from one of them.

I went into the bathroom and took a shower, constantly aware of the fact that Eric, when last he was in his bathroom, had tripped getting out of the tub and cracked his skull. My heart raced when shampoo dripped in my eyes and I was suddenly blinded, feeling off-balance as I turned to hold my face up to the falling water.

I didn't slip, didn't die. I dried off, got dressed, drank my coffee. I looked at the urn on the table under the painting, and tried not to puzzle over what was going on; perhaps if I just let things happen, it would all become clear soon enough. That's how I'd first learned to find the words hidden in George's paintings, to just look at them until eventually, suddenly, they made sense.

I left for class, thinking about Uwe from Berlin, who I hadn't thought about in a long time.

The tadpole was still there, swimming in circles inside the urn that had held Eric's ashes, after class. Fraulein Staudacher had been impressed by my sudden leap of fluency this morning, which had come upon me without warning. It was as if a switch had been thrown inside my brain; I didn't need to think about the individual words, just listened for—or spoke—the sentence as a whole, and somehow it all made sense. I think it was because I was in such a fog, I wound up inadvertently practicing that same philosophy I'd used to understand George's paintings. If I'd been more awake or aware, I'd have been too surprised by my ability to speak this strange tongue I didn't really know yet, and I'd have stumbled over my own tongue trying to figure out how and why I was talking so well this morning.

Maybe whatever magic had made this tadpole appear had given me the gift of tongues as well.

I had no idea why any of this was happening—the German, the tadpole, the visions—and I wondered: Why me?

It had something to do with Eric, that seemed to be obvious from the way everything had happened only after I'd scattered his ashes. Was there some curse haunting the urn, still—that bit of bad karma that had made him trip? Should I get rid of it before something untoward happened?

I looked down at the tadpole, trying to figure out what this all meant, if there was a purpose to my having these strange visions, which were leaking into the real world.

Or was it all a figment of my grief-stricken imagination? I reached toward the water, touched its surface, waiting for the tadpole to disappear as if it had never existed, a phantom trick of light on water. But beyond my fingers I could see it,

swimming as if unconcerned by the presence of my hand in its bowl, the possibility of my grasping hold of it. I reached for the tadpole, but it managed to elude me, despite the tiny confines of the urn. I was determined to prove once and for all whether or not it was real by holding it in my hand. I reached and reached into the water, until my arm was deeper inside the urn than it could possibly be.

And suddenly I couldn't pull back. The water was pulling me onward, like a fierce undertow or a whirlpool dragging me into its depths, into the urn.

My hand closed about the tadpole at last.

Triumphant I lifted it above my head. I could feel it squirming inside my hand. Water dripped from my fingers, back into the river, rippling my reflection.

"What have you got, Eric?" a voice behind us asked.

It was Tom, Eric's camp counselor. He was older, maybe sixteen, seventeen. The other kids had gone with Jamie, the other counselor, to explore a cave that was nearby, but Eric had wanted to stay by the river. He couldn't be here alone, so Tom had stayed with him.

Our eyes were drawn to his crotch. He wore bright blue Speedos, and the thick bulge of his cock was visible beneath the thin fabric. Tom rubbed his hand across the bulge with one hand.

"It's a tadpole," Eric said at last.

"Come here and show it to me," Tom said. He smiled, friendly, as we walked over to where he was sitting on a nearby rock. He took our closed fist in his big palm, and placed it in his lap. The bulge underneath his bathing suit pressed against the back of our hand.

Eric looked into Tom's eyes, over his shoulder, anywhere but into Tom's lap.

Tom slowly pried Eric's fingers open. Cool water dripped

onto his lap, soaking into his bathing suit. The tadpole squirmed free and dropped into the space between Tom's legs.

Eric still wouldn't look into Tom's lap, and our heartbeat was thundering in our ears, suddenly audible.

Tom kept uncurling Eric's fingers, then turned Eric's hand over in his lap, until we were pressing against Tom's hard dick.

Tom was still smiling.

He held Eric's wrist, and slowly moved our arm back and forth, so we were rubbing against his dick.

"You want to see what I have?" Tom asked.

Eric didn't say anything. We couldn't speak. Our mouth was dry, as if we'd been bitten by a watersnake. Cottonmouth.

Tom hooked one hand under the brim of his bathing suit, and began to tug it down, still holding our hand pressed against his cock.

I leapt into the water to get away, diving into my reflection.

I was drenched.

What had just happened? I wondered, as I stood in my living room, one hand held just above the urn of water.

What had I just seen? Why was I having these visions of Eric's past—if it truly was his past, and not simply my subconscious in denial over his death, conjuring him again through these hallucinatory episodes.

How could any of this be real?

And how could I deny that it was real? My clothes were soaked through, I was dripping water onto the rug.

Where were these visions coming from, and why? Eric had never told me anything about camp, and I was afraid to continue having this vision, to follow it through to its painfully obvious and inevitable climax.

I walked into the bathroom, stripping off my wet clothes and leaving them in a pile on the tiled floor. To my surprise and chagrin, I had an erection from the strange rape-fantasy vision

I'd just had. I felt myself blush with shame, even though there was no one who knew, no one there to witness my sexual excitement from something I found so morally unpleasant. But I felt like my body had betrayed me.

I turned the shower on, but sat on the rim of the tub, waiting for my hard on to go down. I didn't trust myself right now, I didn't know what my body did when I had these visions, was afraid of falling while I was in the tub as Eric had. And everything was all happening so quickly, so strangely, I felt bewildered. And resentful.

I stalked back into the other room, leaving the shower running. I was determined to throw the urn out, at the very least pour off the water. I never asked for these intrusions into my life.

But when I picked it up, stared down at the tadpole, still swimming in circles, innocent and unaware, I knew that I couldn't bring myself to pour it down the drain and kill it. Even while I seethed with rage at the things it was doing to my mind.

My skin felt sticky, the riverwater—or vision-water, whatever it was that had drenched me while I was in Eric's past—having dried in the warm Spring air.

I put the urn back on the endtable and went back into the bathroom. I stood under the showerhead for a long time, letting the hot water relax the tension from my back, trying not to think about anything except the fact that I was determinedly not thinking about anything. I couldn't help occasionally thinking about falling in the tub and cracking my skull, quick flashes of what it would be like, the dizzy tilting forward as the world, and my feet, slipped away.

I dried off, put on clean clothes. I sat on my bed, growing angry again by the thought that I was afraid to go into my own living room because of the urn and hating the feeling of being

trapped, feeling like I had nowhere to go except in circles like that stupid tadpole.

I left early for work, locking the door behind me as if I could seal off this strange influence and abandon it here, in my home, the one place where I should feel safe from the rest of the world.

Michael kept trying to convince me to come out drinking with him after work, but I just didn't have the energy. I felt like I should go with him, do something with people, get my mind off Eric. But I just felt so drained, I wanted nothing but to finish work and go home and go to bed.

As a waiter, you get used to looking up whenever the door opens, to see how big a party it was, if nothing else, and make sure someone was there to seat them—preferably in your section if it was a party of four or more. But even though I'd mostly had tables of ones and twos tonight, I was glad when Tina sat this new group in Michael's section. As they were standing there, waiting for someone to help them, I couldn't help admiring the stunning black man with a shaved head, who noticed my attention and smiled. I didn't know what the arrangements were among the three of them: two women—one Asian and one white—and another black man, who could all just be friends, or possible partners, in whatever combinations. I couldn't even be sure he was gay, or at least bisexual, but I was pretty sure he was interested in me: there was that spark of interest there, that had me suddenly full of energy and excitement.

Michael noticed my revived spirits, and again asked me to come to Barracuda with him after work, but I put him off. He hadn't noticed why I was suddenly so alert, and I was content to let things remain that way. I knew they'd be teasing me for

weeks if they saw me pick up one of the customers; that's what happened to any of us who got lucky while we were working.

I always find it tacky to try and pick up customers, or for people to try and pick up their waiter. It's an awkward situation, because you can't get out of it—from either side—until the meal's through. As a waiter, you try to be friendly, and even a little flirtatious for the sake of a tip. And because you're accessible to the public, it's best not to mix work with your personal life, because if things go sour, your ex can always track you down, cause a scene. Make things messy.

But this one was just too good to let slip away, and he seemed to feel the same way about me. All while they ate he kept watching me, and I was happy to stare back at him, smiling, waiting. Which of us would make the first move?

I liked watching him move. He had a languid grace—even just while eating and talking—that kept catching my eye, the way he held himself as he sat, how his body unfolded itself along the bench. I wondered what he'd look like doing other things, imagined how his body would look without clothes. He wore comfortable, loose clothes, but I could tell he had a fine body underneath it, not overdeveloped like many of the men in Chelsea, but firm and taut. You could tell just from the way he held himself that he had muscles many of us only dreamed about, and he knew how to use them and keep them in shape.

I was glad for my apron hiding the hard on I was getting, fantasizing about him when I wasn't busy tending the needs of the customers at my few tables. I thought about going into the john and jerking off, but decided against it, enjoying the pleasurable tension of wanting release.

Thinking about going to the bathroom, however, made me recognize the growing pressure on my bladder.

"Cover for me," I told Tina, heading toward the back of the restaurant.

"Don't forget to wash up!" Michael called. I felt as if the entire restaurant turned to look at me.

I took a piss. I flushed. I washed my hands, wondering if I could get away with bringing a wet paper towel out and slapping it on Michael's arm, an innocent prank.

When I opened the door, the man was there, waiting as the next in line. I was surprised—and also pleased.

"Hey," he said.

"Hi."

We stood just looking at each other for a moment, and I snorted a little at the absurdity of breaking the ice, especially standing in the doorway to a lavatory.

"I know this sounds like a line," he said, "but you've got the most beautiful eyes."

I grinned, feeling good, one of those rare moments when the guy you want wants you back. I was so relieved he was willing to make the first moves. "Thanks," I said. "What if I hope that was a line?"

He smiled, too. "When do you get off work?"

I told him. He arranged to meet me at the Big Cup later tonight.

"I really do have to use the bathroom," he said, smiling again.

I laughed, and let him pass.

Marvin pinched my butt as we climbed the stairs to my apartment. "Stop that!" I cried, brushing the air behind me. He'd already let his hands drop to his side, all innocence.

I stopped on the landing and waited to ambush him, as he followed a few steps behind me. "You silly," I said. He was still one step below me, but our bodies felt so close together. I couldn't resist touching him, having wanted to do so all evening but feeling self conscious because we were in public. I

leaned forward and our breaths mingled; I could smell the sweet spice of cinnamon and cappuccino on his breath.

And then our lips met, our first kiss, soft and exploratory, then growing bolder, stronger.

"Mmmmm," he replied, his tongue lost inside my mouth.

I pulled him closer, no longer caring who might see us— even my neighbors, who I'd have to see again in the morning, and for months to come. "You sexy silly," I said, running my hands from his shoulders down his back. His body felt as fine as I'd imagined it; he was a dancer, getting an MFA at Tisch, and his studies and practicing had paid off.

It felt so deliciously naughty to be so frisky with each other out here, with the chance of discovery by the neighbors, but there were things I wanted to do with him that I didn't want to be standing (in a stairwell no less) for, so we continued climbing to the top floor.

The door to my apartment opened when I leaned against it, preparing to put the first key into the hole.

Could George have, finally, decided to show off some of his paintings? Had he sold one, and needed to collect it immediately?

I pushed the door fully open, turned the light on, and looked cautiously inside.

"Shit!"

I'd been robbed. I could tell in an instant that they'd taken the easy stuff: TV, VCR, stereo. Items they could pawn easily on the street.

They'd left George's paintings.

I wondered if, perhaps, George had been the thief, unlikely though that seemed. The thought made me feel less violated, as if there might be some understandable (if not quite rational) explanation for all this.

But this had been a true break-in, out of the blue.

Almost literally. The kitchen window was wide open. They'd come down from the roof.

I'd thought I was safe up here, as opposed to the ground floor, say; there were bars over the bedroom window that led to the fire escape. Who knew they'd think my place was worth the effort of swinging down off the roof on a rope, so easily noticed by a neighbor or someone on the street, but no one ever looked up this high, not in this area. Tourists maybe, but they wouldn't be here.

"Shit," I said again.

They'd used my own garbage bags to carry the stuff out, so no one would know what it was. Even if you didn't know someone in your building, you wouldn't really look twice at someone taking out the trash. And they'd probably gone up on the roof, climbed across to one of the other buildings who all shared the same tar beach, and gone down that stairwell.

I paced from room to room, furious at this invasion, cataloguing in my mind what had been taken.

"They killed your fish," Marvin said.

I turned to look at him, surprised to find him kneeling on the floor of my living room, by the couch, this stranger I'd met tonight and brought home with me.

I'd forgotten about him.

I'd forgotten, too, about the urn.

Marvin was holding up the tadpole, dead and stiff, having drowned in air when the intruders knocked over the urn and spilled its contents onto the rug.

I wondered, for a moment, if the water had dripped through to George's apartment, if it had damaged any of his paintings. Implausible imaginings, the rational part of my brain knew: there wasn't enough water in the urn to soak all the way through the thick floors of this building.

But there'd been water enough to drench me completely,

and still leave the urn filled to its wide brim, I remembered with a chill.

What was going on here? What was happening to me, because of this urn, because I'd kept this one piece of Eric? First the visions, then the tadpole, and now this theft and violation.

I picked up the urn. It was all because of this, I felt certain; this haunted, cursed receptacle.

It felt good to have something to blame. I carried it into the kitchen, wondering if I really dared throw it out the window, if that could truly dispel the bad karma that had been emanating from it ever since I'd emptied it of Eric's ashes.

I didn't understand why these things were happening. Was it because I kept the urn in the first place? Had I committed some celestial faux pas I wasn't aware of? Was I bringing this on myself by not letting go of Eric fully, leaving his spirit free to move on to its next adventure?

The burglary was so sudden and unexpected—like Eric's death had been. I wondered if this all had meaning; if I was supposed to learn something from all this.

It helped, somehow, to think that someone was putting me through this torture for a purpose. As if, having run this emotional gamut, I would be transformed. Like a frog, being kissed, turning into a prince.

"I'll understand if you want me to leave," Marvin said, following me into the kitchen. "It sort of kills the mood to come home and find this, doesn't it?"

I turned to look at him. Again, I'd forgotten he was there, even though I so wanted him to be here with me. I remembered how genuinely concerned he'd looked as he held up the dead tadpole, told me it was dead. It would never grow up and be transformed into a frog now, never have the chance to be kissed and feel like a prince, the way I'd felt in the stairwell with Marvin, as if we'd already found our happily ever after.

What was it about the blush of first intoxication that made it so sweet?

I didn't know if we'd see each other again, if we'd spend more than this one night together. If we'd even spend this night together.

I hoped we would.

Marvin seemed to be so much of what I'd been looking for. It was amazing to me that he could drop right into my life like this, even if for just a brief while. That connection, no matter how long, held power.

And I realized suddenly that not only bad things had happened because of the urn. What if my finding Marvin had also been caused by its strange mystical powers?

What if none of this had any connection to anything whatsoever? Just the random nature of the universe. A man falls in his bathtub. An apartment that's hardly worth the trouble gets burgled. A prince walks into my life.

Maybe this is what I was supposed to learn: that life doesn't make sense, you just have to make the best of it, and create the meaning from it that you want or need.

Marvin stood there, waiting for an answer. He was being so understanding, giving me space, but trying to be supportive. He looked so sexy, and also so warm and solid and real, an anchor in all this chaos.

A reminder that I was still alive.

"Please stay," I said, putting the urn down on the stove and walking over to him. I touched his shoulder, his cheek. "I don't want to be alone."

Thursday night, Marvin rang the street buzzer and I pressed the button to let him in. I grinned, eager to see him again; our first "date" even though we'd already had sex the night we met: exuberant uninhibited sex that made me feel I was reclaiming

my apartment as my own space after the robbery, made me forget there was anything bad or ugly in the world. I imagined him climbing all those flights of steps, and wondered if he asked himself if the climb was worth it. It must've been, because he kept climbing. At last, I heard his footsteps growing nearer, and opened the door to greet him.

His face lit up when he saw me, which made me smile back as broadly. He stopped where he was, still a few steps shy of the landing, and let his tongue loll from his mouth as if he were a dog. He panted exaggeratedly, and said, "You, my friend, need an elevator."

I walked toward him, until we were in the position we'd been in when we'd first kissed, he a step below me. He put his arms around my waist, as I wrapped mine around his shoulders. His soft thick lips met mine, and I felt sexy and desired and magical.

He was carrying a bouquet of flowers, which he handed to me: bright tiger lilies, just beginning to unfurl. I blushed, a happy warmth. I always feel shy when people give me flowers. I don't care if it's so traditionally heterosexual; I find it romantic.

He kissed me again, a longer kiss with tongue this time.

"I thought you could put them in that urn," Marvin said, following me inside, "since they killed your tadpole." I marveled that he was so comfortable with me already that he didn't feel awkward or self-conscious to refer casually to such a painful and awkward subject. I took a deep breath to calm the panic and anger that always wanted to overwhelm me at the thought of the robbery, that violation and disruption in my life. It felt so mature to be able to not get hysterical, and it was somewhat strange to realize that, of course I was mature, I was an adult; I still thought of myself as a teenager, just getting my feet wet in terms of accepting responsibility for my actions and

such. I was still waiting tables, as if I were just out of college; what kind of a life was that?

I longed for the centeredness, the sense of having found yourself, which Marvin exuded. That was one of the things that made him so attractive; whether or not he actually felt that way, he acted as if he was always sure of himself, as if he had his feet planted squarely on the ground. While it all looked casual, you also got the feeling that nothing could knock him out of that stance easily. Some of it may have simply been his familiarity with his own body, its dancer's strength that left him feeling secure in what it could do.

I wasn't anywhere near that stable yet—physically or emotionally—but I felt like I was finally beginning to get there. Whether or not there was some celestial force testing me, the robbery was like a rite of passage—even if it had seemed like a baptism by fire at the time. I'd learned how to live with loss that night. Not just the loss of my stuff, but the loss of my friend, Eric. Even the loss of my magical tadpole, which I'd resented while it was impossibly manifesting itself in my life, unbidden and strange.

Now they were all gone, and I wasn't in a hurry to replace any of them, to go back to that state I'd been in before. As if earlier I'd been trying to regain the innocence—or ignorance—one lived in before death entered your life, like the time before losing your virginity, when even though you're constantly aware of sex, you don't know what it is actually like until you've had it, and then—whether the experience was good or bad—you're never the same again.

While I'd known people who were sick or dying before—relatives, acquaintances, whoever—Eric was the first of my peers that I'd actually lost. For a while, after he'd died, I'd been trying to live Eric's life in a way, to go on living it since he was no longer around to live it.

Somehow, like what had happened with George's

paintings—or my German class—I'd learned to sit back and just accept everything until suddenly something went click in my head and it all made sense.

I did miss having my music, and I would get a new stereo. I didn't intend to deprive myself unduly to make some spiritual point that no one but me cared about or even knew was being made; I just hadn't gotten around to going shopping, too caught up in other aspects and details of my life.

"I've already found other uses for the urn," I said, leading Marvin into the kitchen.

I'd decided, in the end, to keep it. Not as some replacement or substitute for Eric, just as a sort of mnemonic, like keeping snapshots in a photo album.

Before work one evening, I'd bought soil from one of the gardening stores in Chelsea, then planted tomato seeds in the urn when I got home. The first tiny white roots had begun to emerge already, a rapidity of growth I attributed to Eric's influence.

Every time I watered them, I thought of Eric, that afternoon when he'd wiped a tear from my cheek and said, "Anywhere there's water, I'll be there, too. Anywhere."

And he was. In my memories of him. In the water.

And who knew, maybe one day it would feel right to fill the urn with water and find out what had happened to him that day at the river. Maybe that was why he'd asked me to be the one to scatter his ashes, knowing somehow—with the prescience of the dying?—that I'd thereby learn this story about his life that he couldn't tell me himself while he was alive. For all I knew, that moment in the vision might have a happy ending: his discovery that he was gay, that others had these same desires. Something I'd never considered while I was caught up in the visions themselves. I'd find out, one way or the other, if and when that day came.

In the meantime, the urn of future tomato plants sat on

the kitchen windowsill. They would guard me against unwanted intruders, as best as they were able. That's all one could expect.

I set the bouquet of tiger lilies on the counter, then turned and gave my full attention to a welcome visitor to my home.

Elvis Lives
Nancy Springer

The night I walked out, the night I finally got it through my head that Howard honest to God really just did not love me, was the night I saw the Elvis impersonator.

"Elvis Emulator" was what he called himself on the sign. There was this hole-in-the-pavement basement bar, and the sign on the easel, ELVIS LIVES, and I was strolling along, admiring the night—if I must tell the truth, I was crying; no idea where I was gonna go or what I was gonna do now, Howard had called me a fat ugly cow. He'd said no man was gonna want me—and then I heard "Heartbreak Hotel" floating to me like a black butterfly, and it was like I, Giddy Stump, was a dog under the table of fate and they'd thrown me a bone. Like love and Elvis were dead, so they were giving me a scrap of what was left, but I didn't have enough pride to say no thank you. So I went in.

I don't want you thinking that I worship Elvis. The last thing I want to be is one of those sincere big-haired polyester cowgirls in tight jeans and high heels with a light-up black velvet Elvis shrine in the rec room. I've never teased my hair in my life and I've only been to Graceland twice and I only have a few Elvis things around the house, like a porcelain statuette of

Things Invisible to See

Elvis riding a unicorn on the living room mantelpiece—well, I did have it, until Howard smashed it. What I want to say is, I am not freaky about Elvis. But if you want to think that I adore Elvis, that's all right, because I do. Not some of the things he did; I just adore him. That bruised-looking mouth and those bedroom eyes. That little-boy shyness. The sweet way he treated his mama. The shiver in his voice. The way he let the music whip him crazy. Everything.

The impersonator wasn't wearing a white sequined jumpsuit or a cape or silver sunglasses or gobs of rings. I stared at him for a minute when I walked in—let me tell you, he knew how to emulate Elvis with his hips—then I sat as close as I could get, which was pretty close; it wasn't that big of a bar. He wasn't wearing gobs of Brut either. He was dressed like the early Elvis, in chinos and a sport coat and white socks and penny loafers.

And then he began to sing, and I had to close my eyes to hold back the tears. His voice—it was Elvis.

His face wasn't quite right—not enough bone. He had the shadowy eyes and that sweet roundness in the cheeks, he even had that curling mouth, like one of them pagan gods, but there was something not quite Elvis about the chin and nose—but heck, it didn't matter. When I closed my eyes, it was like magic. Like Elvis, the real Elvis, was right there and he was singing straight to me. No so-called emulator should ever have been that good.

"Are you lonesome tonight ..."

Yes, damn it, yes, I was lonesome.

Nearly fifty years old. Only us old women care about Elvis anymore. Nearly fifty, and who the heck was ever going to give a damn about me? Not Elvis. I'd never seen him in real life. I'd picked what might have been one of his toenail clippings out of the shag rug in the Jungle Room in Graceland, but Harold had sold it to some collector for seven hundred dollars.

"Love me tender ..."

Tears ran down my face. I did, I loved him, but he was dead—I'm not one of those Elvis wackos, I knew he was dead—and who was ever going to love me?

"I'm caught in a trap, I can't get out ..."

It was when Harold threw my porcelain Elvis to the floor and smashed it that I walked out. He could keep me penned in the house, he could cut me off so I didn't have any friends, he could bust on me—in fact he did most of the time. He had smashed my face a time or two, and I could deal with it. But he better not smash my dreams.

"Thankyou. Thankyou ver' much," the fake Elvis mumbled into the mike. "Thankyou. G'night." Hardly anybody applauded except me. Elvis had left the auditorium. But they didn't care.

I left, too, because if anybody tried to pick me up, I was likely to bawl on their shoulder. No, that's a lie. I left because I knew nobody would try.

I strode out onto the dark, empty street, trying to look like I was going somewhere.

Somebody else was striding along ahead of me. Elvis.

Carrying a purse.

At that moment things started happening so fast that I didn't have the chance to think, Huh? A purse? There were shadows moving. Two guys lunged out of an alley. One of them hit the Elvis emulator on the back of the head with a brick. The other one tried to grab his purse. Elvis fell, but he held onto his handbag, he was wrestling the guy for it, and the guy with the brick lifted it to smash him in the face—

I screeched like a steam whistle and ran toward them, and I pulled my can of pepper spray out of my own purse and let the guy with the brick have it right in the face.

More like the ear, actually. But he howled anyway, dropped the brick, and ran. The other guy kicked Elvis, then ran before I could blast him.

"Are you all right?" I got down on my knees beside the Elvis emulator, who was sitting on the sidewalk holding the back of his head with one hand and his ribs where the guy had kicked him with the other. He still had his purse, but it had come open and his stuff was scattered all over the sidewalk. Typical woman, I started to pick it up.

He had a deck of weird cards in there, and it had gone all over the place. Thick pasteboard cards with lots of gold on them—they glittered in the street lamp light—and pictures of people in fancy clothes. I was gathering them together when it happened.

From one of the cards, Elvis Presley was looking back at me.

Not just a picture of Elvis. It was him. Real.

Stone bone real. Alive. Moving. His blue-black hair lifting back from his forehead, feathering in some breeze I could not feel. He blinked. His coal-dark eyes gazed into my soul.

"Elvis!" I squeaked.

"For God's sake," the impersonator said in her own natural voice, which sounded pissed off and like she wanted to cry, "I'm not Elvis, and I'm getting blood all over my suit. Does anybody have a Kleenex?" Like there was anybody there but me, which there was not.

Realizing that the fake Elvis was a woman startled me almost as bad as seeing the real Elvis looking back at me from the card. Plus, like she said, she was getting blood all over her suit. Her head was bleeding like a sonuvabitch, like conked heads always do. Put everything together and I was so rattled that I jammed all the cards back into her purse without thinking about it.

I started digging in my own purse for a hankie. "No," I babbled, "on the card. Elvis was looking at me on the card."

The Elvis-girl who had been mugged just stared at me. I kept babbling. "Um, are you okay, honey? Do you need a

doctor?" I gave her a wad of nose tissue. She pressed it to her head and stared at me some more and didn't answer my question.

She said, "You saw Elvis?"

I nodded.

"Which card?"

"One of those cards you got in your purse."

"Yes, but which one?"

I just knelt there like a dummy. Now, maybe you can't believe I got to age almost-fifty and never seen a deck of tarot cards before, but what can I say? I was raised Baptist. Ain't been to church since I met Howard, but the way a person was raised is like a habit they don't even think about. I just never been noplace or around no people where I might see no weird things like them cards.

Ms. Elvis was still staring at me. "Who are you?"

"Um, Giddy." My real name is Gladys, but I hate it. Anyway, I didn't feel like she really cared about my name. The question seemed to mean something else, somehow.

"Where do you live?"

"I—noplace." I thought I was done crying, but my voice came apart, damn it.

She looked at me some more. Then she nodded like she knew all about it. She stood up, threw the bloody wad of Kleenex on the ground, hefted her purse, and said, "C'mon."

"Huh?"

"C'mon."

She took me home with her. She lived in a back-alley, third-floor apartment by herself, her name was Lisa, and when I washed the blood off her head for her, the black hair dye came off with it. Her hair was a nice tawny tabby-cat color. Her head didn't look like it would need stitches, but I put Bactine on it and made her take a few aspirin. She washed out the rest of the dye and pulled off her fake sideburns while I worked on getting

the blood out of her jacket. There's nothing like cold water and ordinary hand soap for lifting bloodstains. I should know.

Lisa watched me. "You're a good mom," she said.

I shook my head; I had never had any kids. I watched Lisa. She looked pretty, sitting at the kitchen table in her underwear. She wore one of those sports bras to flatten her breasts, though she didn't have much there to start with. Boyish. I asked her, "Are you a lesbian?"

She just laughed. "Are you going to run for the hills if I am?"

"No." I didn't know much about lesbians, and like I said, I was raised to stay away from anything weird—but no, I was staying. I told myself, what could she do to me that Howard hadn't done already? But the truth was, I looked at her and I kept seeing Elvis.

I slept on her sofa that night.

In the morning while we had our coffee, she laid the four kings from her deck of fancy cards in front of me. "Which one was it?"

I blinked, fuzzy-eyed; it always takes me till noon to wake up in the morning. Which was a good thing, because if I hadn't been so sleepy, the cards would have scared me. Weird. A king in black armor hefted a sword. Another king sat on his throne with a big ugly club tucked between his legs. Another one looked like a drunk carrying a monster goblet. The fourth one was—well, the fourth one had this big gold circle like a gold record, with a star on it like on a dressing room door, and he was moon-walking. It didn't scare me because I didn't care about Michael Jackson one way or another.

"That one's Michael Jackson," I told Lisa, pointing.

"Oh, really?" She looked at him, and I could see her

starting to see him, and her lip curled. She didn't like him. "That's groovy. Which one's Elvis?"

"They're your cards. You don't know?"

"Would I be asking you if I did? But he's got to be one of the kings." She peered at me with her eyebrows worried. "Doesn't he?"

I shook my head. Michael Jackson was groping himself, but none of the other kings were doing a thing.

"Huh." Lisa pulled another card and showed it to me. "That's The Boss," I told her. The card said, "The Chariot," but it was a picture of a big old Cadillac and Springsteen was driving it.

"Oh, God, no, I don't want to sing like him." Lisa shoved it to the bottom of the deck and showed me some more. The Emperor was nobody, just a card. The Hierophant was nobody. She was showing me mostly cards with male royalty on them, but I caught a glimpse of a card that showed a woman in a cone bra patting a lion, and I told her, "That's Madonna."

"Jesus." She blinked at it. "Christ, you're right. You see twice as much as I can." She put Madonna away, and hesitantly she pulled out a card labeled "the Devil."

"Sinatra."

She slapped it to the bottom of the deck. "Damn it! Which one is Elvis?"

Right then I started to rebel. The coffee was waking me up. I was getting nervous and the next thing Lisa would want me to go through the whole freaky deck with her, and I wanted no part of it. I did want to see Elvis, but not like that. Those cards frightened me. I reared back in my chair. "How come you want to know?"

She cocked her chin up and gave me a hard stare. She didn't look much like Elvis when she did that. I'm no fool, that glare said. Whatever it was the Elvis card could give to her, she thought I meant to take it away.

"Who are you?" she demanded.

She made me mad, not trusting me. "I am ugly, overweight, middle-aged woman," I told her, flat and loud, "with bad teeth and no job and nobody—" I stopped short. If I admitted that nobody cared about me, I might as well give up.

Lisa was giving me one of them long, thoughtful looks. You could tell, being around her, that she did a lot of thinking. Maybe too much. "You're a clairvoyant," she said, quiet and gentle now.

"Well, who or what the heck are you?"

She didn't answer. Nothing about her answered to nobody. She wore her tabby-cat hair flopped over her forehead, and she had a gold ring in one nostril. She wore what looked like a man's undershirt dyed black, one of them stiff stick-out ballerina skirts that should have been pink but it was dyed black, black tights, black Army boots. She didn't look a thing like Elvis. She said, "Stay here if you got noplace to go," and she got up and went out. I noticed she took her cards with her.

I stayed.

I did things for Lisa. I sorted through her clothes and mended some torn seams and sewed on some buttons. I cleaned mold off the inside of her refrigerator. She wasn't a slob, just a normal person who didn't have time. Not like me— I got nothing but time. I cleaned her apartment. I made tuna casserole, spaghetti, chicken corn soup.

Lisa did things for me. She listened to me when I talked about Howard and how he'd beat me. She ate the food I fixed and she liked it. She gave me money for clothes and groceries. She took me out for Chinese buffet. She bought me a little statuette of Elvis riding on a unicorn.

She didn't collect Elvis porcelain, but she did have Elvis

books. A whole shelf of books about Elvis. I looked at the pictures, but I didn't read them. I don't read much.

"How'd you get such a feeling for Elvis?" I asked her. She was so young. No more than thirty. She never told me much about herself but she did say she didn't have no family. No mama.

Eating the apple crisp I'd made for dessert, she shrugged her bare shoulders. She wore tank tops a lot, and her shoulders were strong, like a boy's. "I dunno. How did you?"

"I fell in love with him, that was all. I was a young girl. I saw him on television. I went to see all his movies."

"I think. . ." She gave me a shadowy sideward look. I could see Elvis in that look. "He's the King, that's the thing. The way he sang—the way he put his heart in his voice—"

"Yes," I said.

"He's the greatest there ever was," Lisa said. "Isn't that what you'd want to be? The greatest ever?"

Days, Lisa worked as a part-time package gorilla at RPS. It kept her in shape, she said. Nights, she did Elvis gigs. I always came along to watch her and listen to her sing. It was magic, the way she could turn herself into Elvis. I closed my eyes and I cried every time. Every single time.

Who can explain why people start to love each other or how it happens?

I didn't say nothing to Lisa about the way I felt. I wasn't no lesbian. Besides, I was too old for anybody to love me. Lisa was just being a nice person, keeping me around.

I began to worry a lot. I knew I ought to get out of there. But, I didn't have noplace to go.

"Lisa," I said, "what the heck am I going to do with what's left of my life?"

She was stretched out on the floor with her headphones on, listening to Nirvana—I can't stand Nirvana—but she took the headphones off and rolled her eyes to look at me upside

down. Then she got up and said, "C'mere," and when I turned around there she was sitting at the table with the tarot cards.

"C'mere, what?"

"C'mere, I'll do a reading for you."

Lisa always had those tarot cards with her wherever she went. Especially when she went on an Elvis Emulator gig. They helped her sing, she said. They gave her luck. But they didn't feel lucky to me. She had stopped trying to show me the cards and get me to pick up the Elvis one because one time I started screaming, I just started screaming and crying and I couldn't stop. It was because of the Death card, but I didn't know how to explain what I saw.

"C'mon, Giddy."

I sat across from her and she made me shuffle the cards till I felt like they knew me. Then she made me give her ten cards, and she laid them out face up in a kind of diamond-and-pillar pattern. No Death card, thank goodness.

"Five major arcana," she said, like that meant something.

I wasn't listening because I knew which card was Elvis. I saw him—he was looking at me with them shadowy eyes and dancing in his blue suede shoes—it made me hot and bothered just to watch him. But, I didn't say a word because I wasn't sure I should tell Lisa. Them cards scared me. And she never would say why she wanted to know which one was the Elvis one.

"And what's not trumps is almost all cups and wands," she added. "You're a very nurturing person." She started at the center card of the diamond. "This card's you," she said. "The Fool." I could see her thinking of something kind to say. Lisa had a mind as sharp as swords, which made it hard for her to be kind, but she tried. "That means, sort of a drifter," she said. "Living for the day. Chasing butterflies. There's a lot of child in you. And see the playful little dog? That means animal nature, like, you're cute and cuddly, like a pet. You're crossed by—" She pointed to the card lying across the Fool. "The Emperor."

"I thought Howard was out of the picture," I grumbled.

"You haven't got him out of your head yet. But there's love in your future." Her hand moved to the next card. "Two of Cups."

She went on like that. A lot of it I don't remember. My unconscious foundation of being was Ace of Cups, which made me kind of a fertility mother, and my outlook was the Wheel of Fortune, which meant everything was changing for me and I had a great chance to make an ass of myself. This was nothing I did not already know. The way I was perceived by other people was as the Queen of Wands, which was the same as my foundation, fertility mother.

"But I never had any kids." Meanwhile, Elvis was giving me his slow smile, and I was trying to keep my eyes off him.

"Well, maybe you should." Lisa was looking puzzled at the next card. "What's this?"

Page of Coins. My secret desire, Lisa said, but she had no idea what it meant. Then there were a couple of other cards I forget. And then the be-all and end-all of my life was World. A naked young woman dancing in an oval made by flowers and planets and beasts. Except she wasn't just a young woman. She had broad shoulders like a man. She—I blinked and stared; she was Elvis, doing the jailhouse rock. But no, she wasn't just Elvis. She was Michael Jackson, too. And Jimi Hendrix, dancing like a guitar afire. And Buddy Holly in the plane going down, and John Lennon, and Morrison from the Doors, and even that idiot Kurt Cobain—

Seeing me staring, Lisa demanded, "Is that Elvis? Is that the Elvis card?"

"What would you do if it was?"

"Look, tell me. Listen, Giddy, if I could just see—if all the cards rocked, then that would be, like, peace on Earth. The end of the world as we know it."

I sat up straight like she'd jabbed me with a pin. I yipped, "Where did you get these cards?"

But she didn't answer me, because at that moment somebody started pounding on the door and yelling, "Gladys!" I knew that voice, and my bowels clenched, and I started to sweat.

"Oh, God," I whimpered, "don't let him get me." It was Howard, of course. I should have known he wouldn't just let me go.

"Go shut yourself in the bedroom." Lisa gave me a shove that way.

"Gladys! I know you're in there. You open this door, or I'll bust it down."

He would, too. Years ago I would have called that love, I would have thought, Oh, Howie, my Howie, he loves me so much, breaking down doors so he can slap me around. Now I knew better. I wasn't someone he loved. I was just something he thought he owned.

But his old habits are so strong. I felt like I should open the door. There'd be less trouble if I did.

"Giddy," Lisa told me between her teeth, "go in the bedroom and lock the door. Now."

I did what she said. I scuttled toward the bedroom, but I didn't quite make it before Howard kicked down the apartment door. He came toppling in, and he saw me. Lisa stood between him and me. "Out of my way, dyke!" He swore at her and tried to swat her to one side.

She karate-kicked him.

Or maybe it wasn't karate, maybe it was one of them other fancy Oriental ways of fighting, how would I know. I never even knew Lisa was a fighter. If she'd had her combat boots on, she would have broken Howard in half, but she'd been hanging around the apartment, she was barefoot, so all she did was make him howl and make him mad.

And Howard was a big man.

I don't know how many times he hit her. She fought back, she fought hard, brave, God, she was brave as I stood there screaming, but he beat her back, and all the time he was swearing about what he was going to do to her and to me, and he beat her down to the floor—

Something snapped or clicked inside my head, and I moved. I grabbed the nearest thing, a lava lamp, and as he crouched over her, I swung it high and hit him on the back of the head just as hard as I could.

The lamp broke all over him and Lisa, and he flattened like cookie dough. I didn't know whether I'd knocked him out or killed him, and I didn't care. I flopped down beside Lisa and pulled her into my arms and cuddled here against my chest and bawled. I cried and cried.

"Hey," she said gently, nestled against my breast, "I'm okay."

She wasn't okay; her face was all bloody. I lifted her in my arms and kissed her on her bloodied lips. Her bruised eyes widened.

"Okay," she whispered, "so you do love me a little."

I loved her a lot, and my heart was beating like dove wings because she loved me, she loved me, I knew she loved me, the way she sang to me, the way she had fought for me. "The Fool," I told her.

"Hm?"

"The Fool card is Elvis."

"God." She started to grin. "You're right. I am a fool. Nothing but a hound dog." She heaved herself out of my arms and stood up, tottering. I scrambled up to help her, but she was already staggering toward the tarot cards.

Lying on the floor amid broken glass and whatever that gook is they put inside lava lamps, Howard groaned. He wasn't dead, damn it.

"Never mind him." Lisa reached with shaky hands for the tarot deck and started looking for the Fool card. I saw blood in her hair.

"Lisa, honey, put those down, let me see if he hurt your head—"

"Never mind that." Her hands still fumbled with the deck, but her mind started working again and she focused on the Fool, which was lying right in plain sight on the table, where she'd been telling my fortune. "Of course," she whispered. "He's you, Giddy. The male side of you." Her eyes shone, and I could tell she was seeing Elvis. "The way he kind of stumbled backward into being who he was. The way he danced on the edge of the cliff and sang. Of course you're in love with him." A slow, boyish smile turned her hurt face beautiful. She picked up the card. She kissed it, then pressed it against her cheek, wet with blood.

I'll never know whether she intended this to happen or not. My feeling is, maybe not that way, but some way. She knew if she could find the Elvis card, she could find a way to make it happen.

It doesn't matter what she meant to happen. It happened.

The wetness of her blood soaked into the card. And the goldness of the card softened and mingled into her.

Howard, struggling up off the floor, saw the change coming over her, and it freaked him so bad that he yowled and scrambled out for the broken down door like he might wet his pants. I heard him thudding down the stairs and out of there. Bye, bye, Howard.

Me—I couldn't run away. I couldn't run away from anything in my life anymore. "Lisa," I cried, "no!" Tears stung my eyes.

Elvis Presley looked back at me with those coal-dark eyes. "What's the matter, Mama?"

Oh, that love-me-tender voice. That little-boy charm. It

should have been the butterflies-and-rainbows moment of my life, right? There he stood in his gold lame suit, Elvis, blue-black unruly hair that needed to be smoothed, velvet glance resting on me. It was Elvis, I was living with Elvis, his soft mouth flexing into a hint of pout, don't be cruel, his forever-young face not quite sure as he approached me with the respect and affection a good boy shows for his mama.

I stepped back from him. "Lisa," I begged, "you think I love you better this way? You're crazy!"

Why did she want to be someone other than who she was? Because her mother didn't want a dyke for a daughter? Because being Page of Coins wasn't as good as being the King? Why?

But she did want this. Since I'd known her she wanted to be—him.

"Mama, it's all right." Gently he put his arms around me.

His embrace felt like soup; I tore loose from it. "Lisa," I yelled, sobbing. "I want Lisa!" I stamped at him. "Is she in you? Don't you remember her?"

He watched me with sweet bewilderment. Elvis, and he was just a stupid dream, damn it, a fool's dream. In real life he'd fart and belch and get fat like any other man, and hump bimbos, down in the Jungle Room, and—and he wouldn't know a real woman if you hit him over the head with one.

Lisa ...

The tarot cards—maybe they could somehow help me get her back? But where were they? They should have been right there on the table. Had she—oh, God, had she taken them with her, the way she always did?

On the floor, facedown, lay a single gold-backed card. I picked it up and turned it over.

Smiling, innocent, and covered with Lisa's blood already turning brown, the Fool gazed back at me with sweet shadowy eyes. As I looked, the card crumbled to glittering dust in my hand.

The Pearl
Rand B. Lee

On a Friday evening near the end of May, at twenty minutes past eleven, Joe Cantrell was putting the finishing touches on his suicide outfit. His apartment was a third-floor walk-up right above the Mary Street Bar and Grill, which had always suited Joe fine, since it made a convenient place to interview his clients. Until recently. Recently, his luck having rather spectacularly run out, he had decided to call everything quits. From the first he had known he would wear black. He considered it the most tasteful color to be found dead in. But he had dismissed black leather as too obvious. He had settled on a recycled ribbed tire-rubber bodysuit set off by very dark green hip-waders, fancied up with a few dangly marital aids and a bright scarlet bandana knotted at the neck, where the needles would go in. Dressed, he observed his reflection admiringly in the second of his three full-length bathroom mirrors, flexing, posing, readjusting his basket, flexing and posing again. Music and laughter from the downstairs bar accompanied the routine.

It's not, he thought to himself, *as though I wouldn't have had a few good years left in me.* He was a muscular black-haired man in his early thirties, of medium height, skin medium-white (grimed

rather than tanned), jaw medium-weak, shadowed by a dark beard kept meticulously trimmed. His deep, warm eyes were all in all his best feature, unless you counted what he called his DNA delivery system, which he possessed in lavish proportions

The other thing Joe Cantrell possessed in lavish proportions was the latest strain of human immuno-deficiency virus, copulating merrily within his blood. That he had known for some time. But several weeks back Joe had noticed his first sarcomas: several livid pseudobruises on his upper inner thigh, where (considering his line of work) he could not afford them to be and could not cover them with make-up. He had had their nature confirmed: the report-sheet from the local free clinic lay on the kitchenette table where he had placed it carefully that morning before shooting up and going to bed.

When the overworked clinician had told him the news, the first words out of Joe's mouth had been, "Minnie, Minnie, tickle a parson," one of the many biblical references with which Joe's childhood was weighted. The clinician gave him a talk on the treatments available, but by that time Joe had made up his mind.

"Let's roll!" announced Joe to the mirror, like the man in *All That Jazz.* Shouldering a drug-stuffed overnight bag and jiggling his marital aids, he took a last look around the apartment. Except for the bathroom mirrors and a Divine poster, it was almost militarily spare of furnishings. He wondered who would live here after he was gone, and if his ghost would haunt them. "Please, Lord, may it be a couple of Mormon missionary youths," he quipped, then he kissed his reflection goodbye and shut the door behind him without locking it.

Down the stairs he bounced, feeling almost free, down the stairs and to the right and down the stairs again. The bar music got louder as he descended. No looking back for Joe Cantrell. He had not looked back when he left his parents' house at

fifteen and he did not look back now. He wondered how his sister Delsie was; he would have liked to have seen her again. But she had wed and bred dutifully within the faith, pleasing their parents, and though she had tried keeping track of him through his moves (Salt Lake City, Chicago, Philadelphia, New York, Key West, San Francisco) the letters had finally stopped coming. *Like me*, thought Joe.

Walking out of the building, he was lashed by noise from the open door of the bar. The front windows were gridded; Joe liked to tell his clients it was to protect the street gangs from the customers. Joe was known for his ability to put his customers at ease. He wondered briefly if he should go inside and say goodbye to some of his acquaintances, who had always seemed to him like characters in a 1969 urban losers movie. Big ugly kind Eubie would be bouncer tonight; big handsome vicious Sam would be tending bar; big motherly corroded Alexandra Marie would be waiting tables. Joe felt as close to Alexandra Marie as he did to anybody. They had shared needles and broken like-affairs. He wondered if she had given AIDS to him, or if he had given it to her; then he considered his sexual history and broke into a disgusted guffaw. No matter now. He had begged her repeatedly to change her name, which had always sounded to him like a drag queen's stage monicker.

Some sailors lounging at the entrance to the bar sent whistles his way, but he ignored them. It was his night; no time for business.

He knew where he would do it. He turned left onto Fifth, where the street hustlers hung out. They called to him from their stations: "Yo, Joe." "Hey, *pobrecito*." Mocking: "Howzaboutafreebee, Joe?" He knew them all: Dolores and Bobby and Cowboy and Gino Mongo. They liked him because he shared drugs with them; they envied him because he had a Protector (Maurice Callander himself, the sadistic little fat bastard) and worked off the Escort Line in his own apartment.

He supposed there was something picturesque about the street boys' despair, and he wished now he had given that interview to the silly cow from WAXL. "The Dark Side of the Street," the series had been called; very daring. "Hey, Cowboy," he replied. "Hey, DeeDee, looking good tonight."

"Where you off to in such a hurry, Josephina?" This was Gino Mongo. "And what you got in that there bag?" He loomed up out of the shadow, all six feet seven of him.

Joe did not break his stride. "Paytime for Mister Maurice, Ginny," he called to him. "We can't keep the old fart waiting, can we?" Gino barked humorlessly, but stepped back. Maurice's name was still good for something. *That's all I need*, thought Joe as he moved away. *To get stabbed to death on the way to my own suicide.*

Resisting every impulse to clutch his bag closer, Joe Cantrell moved on down Fifth, past all the whores, south to Arcady where the pool halls clustered, west to bombed-out Nolan and south again to Magister. There were a lot of people on the street, enjoying the brief spring cool; in two weeks it would feel like the height of summer. Halfway down Magister, he caught his first sour whiff of water and, almost simultaneously, a quick muted burst of small-arms fire. People scurried and ducked, but the trouble was some blocks away, back in the direction from which he had come. In a moment the normal pace of the night resumed. Suddenly Joe found his heart racing and his breath laboring. He was anxious, now, to get it over with.

One block west again to Riverside, a quick detour down an alley to avoid a gang parley, and he was upon the entrance to the cul-de-sac almost before he realized it. Brownstones looked down on him from all sides, like bystanders at an accident site. The Church Of Our Lady Of Perpetual Mercy lay at the end of the little street, its stone walls overshadowed with massive arbor-vitae, its wrought iron gate gaping. In the neighborhood it was called "The Church Of Our Lady Of

Perpetual Misery," or just, "Perp Miz," as in, "You look like Perp Miz warmed over, girl." Joe sidled through the gate and picked his way across the rubble-strewn yard. It was very dark, the street-lamps in the neighborhood having taken wing, and twice he stumbled. By the time he rounded the corner of the church and barked his shins on the first of the gravestones, he was weeping uncontrollably.

He had not expected this. He paused to wipe his face. *Come on, Josephina,* he thought. His tears stopped and his vision unfogged. The gravestones leaned like drunks. What moon there was barely limned the marble of the dry fountain, but it was enough for Joe to avoid running into it. He set his bag at its foot and looked up at the church wall.

The Virgin was there. Somehow, the folds of Her veil had gathered up the moonlight. He could see Her clearly: the tip of Her excessively Caucasian nose, the slight smile on Her untroubled Caucasian lips, the pale Caucasian eyelids downturned, watching the Caucasian Babe at Her Caucasian breast. The muscles at the base of his spine started to relax. He nodded to himself. This was how he had always wanted it: a white death, white as snow, while dressed in black.

He sat down at the base of the fountain beside his bag and opened it. From it he extracted the drugs and the syringes. He loaded the hypodermics and lined them up on his black-rubber lap. There was a cricket somewhere; otherwise the graveyard was still. He picked up the first needle.

When he had completed the injections, he put the syringes back in the back, put the bag down on the ground, lay back against the fountain, put his hands in his lap, and looked up at the Virgin. Having been raised Mormon, he had never had any particular feeling for the Mother of Christ beyond the vague feeling that she was the epitome of the good obedient Mormon mom, keeping herself pure so that the little incipient godlings of this world might take inspiration from the little

godling to be born through her. Then he thought of Brother Oral, the Stake President, preaching in front of the auditorium at the Saints Alive! Conference when he was nine. As a child he had worshiped the ground Brother Oral walked on. Brother Oral had taken kindly note of this, and had made the best of it. He had never tried to tell his parents. He had not even thought to.

He could no longer feel his feet. His legs were gone, a melting dream. He was cold. He could not raise his arms to hug himself, so he kept his eyes on the Virgin, who smiled down at him unceasingly, or maybe just at the noshing Baby. He was beginning to fade into her face when the pain began.

It took him by surprise. He had thought he would be too out of it to feel any pain. But it stabbed so fiercely up from the left side of his chest that it made him gag, filled his mouth with the vomit taste of fear, stabbed out from someplace in the center of his heart, squeezing his lungs flat, popping his eyes. His sole goal became to get a breath, get a breath, get a breath. *This is ridiculous,* he thought. *I'm a suicide. What am I trying to breathe for?* He found he could not stop trying. Dimly he became aware that he had slipped from sitting position and was lying on his right side in his black rubber suit at the base of the fountain. He realized with a small cold clarity that he was having a heart attack, and that the drugs were paralyzing his respiratory system. *Please God Mary Christ finish it oh God don't let them find me like this!* It also seemed to be getting darker, which he assumed was because he was going blind. He tried to remember what he had loaded the syringes with.

And then the pain stopped, as though someone had flipped a switch. He opened his mouth and breathed, full breaths. It was wonderful. He felt wonderful. He sat up. Everything was still dark, but he could breathe and laugh and move, and he felt wonderful, though it was awfully hot. He had not noticed how hot it was getting. It was unbearable. He got

to his feet and began unzipping his outfit. He found that he could unzip himself from head to foot, unzip the whole thing, head and neck and torso and marital aids and hips and hip-waders and feet, everything, unzip the whole thing and toss it aside so that it fell, dead mouth open and white face staring, at the foot of the silent fountain beneath the Virgin's silent gaze. It was not as dark as before, either. There was a light coming from somewhere above, not from Mary and her sucking Babe, but from higher up, gentle, watery, nacreous.

He began to see, very clearly, the outlines of the gravestones. They were glowing slightly under the watery light. DEUSDEIT JONES, REQUIESCAT IN PACEM. 1899. MARY ARBUTHNOT JONES, BELOVED WIFE AND DEVOTED MOTHER, LAID TO REST APRIL 17TH, 1920. He could read every word. Stepping lightly from gravestone to gravestone, he traced the carvings with cool, deft fingers. ADDISON ENGLISH, DEACON OF THIS PARISH. MOTHER OF ANGELS PROTECT US. MARY MINOR. SARAH MINOR. GEORGE MINOR. VIRTUE MINOR. "That makes two of us, Honey," he exclaimed, and burst out laughing again.

He wandered away from the church, out of the cul-de-sac and onto the street. It was deserted. He wondered what time it was. He felt lighter than he had felt in years. The glow seemed stronger over the river, so he headed that way. This end of Riverside was mostly warehouses, row after row of them: Acme Fisheries, Dolan Packing Company, Stateline Lumber. Between the hulks of them he spied dark water glimmering. He kept walking, the wind blowing sweetly, coolly through him.

The night after Oral had informed him he was getting too old, Joe had turned his first trick, as much for solace as anything else, but the man had insisted upon paying and that had felt good to Joe. After Oral, he felt he had it coming. Five weeks later he celebrated his fifteenth birthday and the next day he

was on a bus to Albuquerque. He scored in the bus station, and later in some bars. Soon he was robbed, then beaten up, then arrested. It was the first time he had ever been arrested and they sent him to a juvenile holding facility. Because he was beautiful, he was raped and beaten, then pitied, befriended, and protected. There he learned to rape, beat, befriend, and protect in his turn, but he never did learn pity. The police eventually found out who he was and they contacted his parents. "We are going to contact your parents today," said the man who came to talk with him once a week. The next day the man was back with a funny look on his face, and Joe knew he would never be going home again.

From Albuquerque he went to Denver, where a whore named Joepye took him under her wing and explained to him the benefits of professional patronage. Her boyfriend Beau taught him about free weights and cocaine. He tried to land some legitimate work, but he was too young and the pay was lousy. In Denver he spent his first birthday away from home. He went into a church and sat there in the dark; then he went out again. At a bar he met Jerry, Jerry The Wig Guy the whores called him, because he owned a bunch of wig factories and boasted that in some distant past he had been Wigmaker To The Stars. Jerry fell madly in love with him and asked him to move in. Joe agreed.

Jerry had a lover already, a black queen named Maxx ("With two exes, Honey, and more to come"). Joe acted as their houseboy. He had real duties other than sex and (to his immense surprise) a real salary, which Jerry paid him in cash, most of which he blew on coke. He found Jerry sweet and sad and undemanding, but he developed a huge crush on Maxx, whom he found utterly unsentimental, utterly unjealous, and utterly without shame of any kind. Maxx liked straight razors, not to hurt people with, just to collect and polish and hold up to the light and occasionally wear. During his stay with Maxx

and Jerry, Joe learned to cook, clean, and chauffeur. At Jerry's frequent glittering parties he learned silent smiling politeness. He learned to answer the telephone:

"Sinkevich residence." He learned massage. When he asked Jerry idly if he could open a bank account in his own name, Jerry said, "You need a residence to do that and you cannot use any of my addresses or someone will find out and I will lose everything." So one thing Joe did not learn was how to save money.

Joe was with Henry and Maxx for two years. He did everything he could to please them, since he could not open his own bank account, and by the second Christmas had begun to feel they were family. His real family he had not seen or spoken to for over three years. He had gotten permission from Jerry to write them from his post office box, and he had done so, saying only that he was okay and had a job and that they shouldn't worry about him. It was his sister Delsie who had finally answered, four months later, her letter opening with, "Why did you run away?" and closing with, "I am praying for you." He wrote back after a few months more, and they began their half-hearted correspondence, she far more faithful to it in the end than he, during all the years of which, by unspoken mutual agreement, they never once alluded to their parents even indirectly.

Three weeks after his eighteenth birthday, he came home from shopping for one of Jerry's parties to find an uncharacteristically empty townhouse. In the foyer were stacked three large new suitcases and two new garment-bags of soft scarlet Italian glove-leather. When he opened them, he found them packed with the clothing and jewelry Jerry and Maxx had given him. On top of the top bag was a thick envelope. Inside it was a bundle of American Express traveler's cheques, a one-way bus ticket to Salt Lake City, and a note in

Maxx's hand: "Kansas calls, Dorothy." There was no note from Jerry.

He did not go back to Salt Lake City. He left all the bags, clothing, and jewelry where they were and, pocketing the cheques and one of Maxx's straight razors, walked out of the townhouse without looking back. At the bus station he bought a ticket for New York, where Jerry and Maxx had taken him many times nightclubbing and theater-hopping. When he got to New York, he went straight to Washington Square Park in the Village. There he began his career in the Big Apple by scoring some coke, getting robbed, chasing, catching, and cutting the kid who robbed him, running from the kid's buddies, and ducking into an exceptionally sleazy jazz club ("clubette," Maxx would have called it). Eventually he ended up sharing a loft with a bunch of musicians who had what they called a "classic retro" band named Rat Fink.

He walked north on Riverside to the old pier. The wind was cool; it was nice not to be so hot. Lights were shining from the Stateline Lumber building, a boating party, very swank, slim women with their bangs and jeweled headbands and cigarette holders, slim men in dark suits and stiff collars topped with round-brimmed straw hats. The pier was hung with Chinese lanterns; punts bobbed on the water. A bar had been set up. Corks popped; people chattered high and chuckled low. A very young woman in a green fringed dress weaved over to him, her cigarette making firefly tracks in the night air. "Hey, Charley," she said. She was very drunk.

"I'm not Charley, Honey," said Joe Cantrell. She had on a lot of makeup. A tall man with a vulturine face shadowed her abruptly; she rolled her eyes up at him and gave an exasperated sigh. "There you are, Charley. Be a pal and get me a drink, will you?"

"You've had enough, darling."

The young woman pulled away. "I should think a girl would know when she'd had enough."

"Come along." Blinking, she went with him, stumbling slightly on the champagne-slick wood of the pier. Not once did the vulturine man glance in Joe's direction. Joe stood watching them go. He thought of the parties at Jerry's. He had seen people like that there. He felt a peculiar rush of love for her, almost acid in its urgency. He wanted to follow them, knock him aside, take her arm, sit her down, put his arm around her, hold her until her dead docility passed and her defiance returned. Someone coughed politely. He turned. An old lady in a turban and Japanese kimono was regarding him shrewdly through a lorgnette. She said, "Unless I miss my guess, you shouldn't be here."

"It was the water," Joe said. She was beautiful. Light flowered from the red silk space between her sagging breasts and vined through every pore of her. "I was hot."

"Of course you were." She nodded, her turban bobbing. "But you're going in the wrong direction. You're going back. You need to go forward."

"Forward?" Joe said.

"Toward the light, young man. Always toward the light." She gestured with her lorgnette, north and east over Riverside. He saw that the glow from the sky now seemed slightly stronger there, in the direction of Mary Street and Fifth Avenue. "That's where I came from," he said.

"Of course it is."

She melted back into the crowd of revelers. Three cops staggered by, red-nosed and merry, in dark blue dress uniforms with big brass buttons. Nobody seemed alarmed. The boats on the water moved silently, like sharks.

He walked away from the river back up the pier. Riverside was busy: lots of cars with small windows and running boards,

theatergoers in furs; the Odeon; the Vanity. Now Appearing In Limited Engagement Miss Fanny Brice. On the corner of Riverside and Arcady, the Riverside Hotel was awash in limousines. He passed a newsboy hawking a stack of thick, oversized papers. He glanced at a headline: Paris Fetes Lindbergh. He turned up Arcady heading east.

There was snow on the street. Dark men in shabby coats, mufflers, and hats huddled in doorways for warmth. One of them, bareheaded, about twenty-five, stared at Joe as he passed; otherwise, he was ignored. At Arcady and Eighth, a WPA crew was hoisting a statue onto a pedestal in front of the Crews-Butler Building. A little farther on, two black women in starched maids' uniforms came out of an apartment building by a side entrance and nearly ran him over. He heard one say, "That Martian nonsense nearly scared me half to death." At Seventh Avenue, he passed a construction site where women in work uniforms walked to and fro, bandanas around their heads. A sour-faced burly man stood with a pad and pencil giving gruff orders. Younger men in uniforms passed up and down the street, grinning at the women's whistles and catcalls. We Can Do It! declared Rosie from her poster. Buy War Bonds! said Uncle Sam from his.

At Sixth, there was only fire. He could not feel it, but he could see it, and what was worse, he could hear it roaring, like a beast of endless appetite. The whole block was burning. Fire engines, truncated, absurdly small, sprayed water ineffectually from heavy fabric hoses. People screamed, ran, fell, burned. A cat jumped nearly into his face. He reached out by reflex, and caught it. It dug claws into him and clung shivering. People got up from where they were burning and wandered away, naked and glowing, while their remains thrashed and crisped. There was a pork rind smell in the air.

Carrying the cat, Joe kept walking. Sixth was behind him. The sky cleared of smoke and flame until only the pale mother-

of-pearl glow remained. Big-moustached immigrant men and their plump, over-rouged wives strolled along behind baby carriages. I LIKE IKE, said lapel buttons. The cat purred and chewed his bearded chin; he held his face to its belly and its warm heart thudded against his jaw. The buildings grew shabbier, the passersby darker of complexion. At a storefront chapel, an African man in a suit cut the crowd with a voice like a saw. Farther on, a tight knot of mourners had gathered in front of a TV store to watch the solemn cortege move up Pennsylvania Avenue. Street vendors with long hair sold love beads and bagged herbs to young people like themselves. He reached Fifth and turned left, where the pool parlors jumped and hummed like new. He reached Fifth and turned left, where the pool parlors jumped and hummed like new.

Different whores were there, in silly clothes, all of them women. The cat wriggled free of his arms and padded amongst them without fear, leaking a faint light. There was no sign of Dolores or Bobby or Cowboy or Gino Mongo. A pair of scared-looking, neatly dressed men handed out tracts to the whores, who tore them up without reading them, making crude remarks. "You tell 'em, girls!" called out Joe. He walked up to one of the men. "Hey!" he yelled at the man. "Hey! I'm talking to you!" The man paid no attention, bent low to his fellow, who with pursed lips and sidelong glances at the prostitutes hurried him along down the street.

Joe considered following them, but the sky was darker in the direction they were heading, and the Mary Street Bar and Grill was before him. Lights were on inside, and music, old stuff, loud but not strident. The paint on the sign was fresh; so were the bars on the windows. He glanced up at his apartment window; red-and-white-checked curtains fluttered at it, forming a backdrop to a window-box of red and white geraniums. He remembered Alexandra Marie once telling him that the first owner had lived above the place with his mother.

Working girls around the corner and Mama in the attic, thought Joe. He wondered why he felt so sad.

As he stood bemused, a group of sailors reeled out of the bar and headed straight toward him. There was no time to move out of their way. He cried out, but they moved through him, and in that instant he felt their bodies around his: their sweat, their tight muscles, the beat of their hot blood, the heavy race of the alcohol through their veins, the clench of their thighs. They moved through and beyond him. He stood gasping; it was like being born again. He blinked down at the cat, who was sitting on her haunches blinking up at him with wide owl eyes.

"Far out," he said.

He walked into the bar.

Alexandra Marie Schenk bumped open the kitchen door with her butt, hoisting her heavy tray. "Hot stuff coming through!" she hollered, as Joe has taught her, and several sailors laughed, as somebody nearly always did. She was still feeling the buzz from the cocaine she and Eubie the bouncer had shared. Good buddy, she thought. Joe was a good buddy, too, although it was too bad that he was a fag. She wondered why he hadn't come by tonight. It seemed to her that he had looked a little peaked recently.

She moved around the room, flirting with a few customers, fending off others, grinning and wiseassing, keeping the mood easy and fun. Everybody was tense tonight because of the shootings on Delmar. It wasn't helping that Sam the Bartender was looking grimmer than usual in his Army camouflage muscle shirt and mirrored aviator sunglasses, speaking only in monosyllables, refusing to banter. His tattoos were the friendliest thing about him. They wiggled and winked with every move of his massive shoulders and arms. Alexandra

Marie had a tattoo also: an ankh, way down on her left ankle. She had hoped it would be a sort of bond between Sam and her.

But she and Sam were not good buddies. Sam was not good buddies with anybody. He liked his girl friends much younger than the law allowed. Rumor had it that he got them mostly used up from Maurice Callander's and when he was done with them they disappeared. Sometimes Alexandra Marie fantasized about it, the way somebody who loathes and despises snakes will stand in the snake house at the zoo and stare.

The door opened and Maurice Callander came in, flanked by a pair of matched gumbies, one black, one white. Conversation did not still, the way conversations do in Westerns when the Bad Guy enters the saloon, but anuses in the know clenched all over the room. Maurice was skinny, child-faced, and dead-eyed; he looked sick. Eubie the Bouncer clenched his jaw and nodded professionally at the gumbies, who did not return his nod, which made his nostrils dilate. Alexandra Marie approached Maurice, smiling. "Good evening, Mister Callander," she said. "Would you like me to clear a booth for you?"

"No, thank you," replied Maurice in his bookie's voice. "I will need to speak to Samuel, however." The words had scarcely left his mouth when Sam the Bartender appeared, as though the words had become Sam, as though he had coalesced out of them. Sam looked at Eubie and jerked his thumb barward. Eubie did a fade. "Mister Callander," Sam said, nodding. The two men, followed by the gumbies, strolled like old friends around the bar and disappeared through the swinging door in the back.

Immediately some local patrons floated from their stools, paid their tabs, and drifted toward the door. Most returned to their drinks as though nothing had happened (Well, nothing has, reasoned Alexandra Marie). The atmosphere of the bar was

much subdued for the next hour or so, despite Alexandra Marie's attempts to work the room, smoothing things over and cheering things up. Then Sam returned from the back. He went to work as though he had just stepped out for five minutes to take a piss. Alexandra Marie knew better than to question his carefully blank face.

A little past one, the after-dance cruising crowd started filling the place again. Whores, both male and female, mixed with the patrons, looking if anything better-dressed. Alexandra Marie wondered again where Joe Cantrell was. He had usually dropped down by this time to check out the action. Out of the corner of her eye she noticed Ricky and Mickey come in. They were drag queens, semi-regulars from the Ritz Cabaret on Belmont. The Ritz Cabaret was owned by Maurice Callander, like everything else in this neighborhood. They were well known to Eubie the bouncer, who would have protected them from the other patrons if they had needed protection, but they never did, partly because they were experts with the switchblade and everyone knew it, and partly because Ricky was the grandson of a well-known local mob figure, not Maurice Callander. Music and cigarette smoke swirled around them.

Normally they both looked very, very cool, very vigilant, very competent. But tonight when finally Alexandra Marie got a second and bustled up to them to say hi (Ricky was an excellent tipper), she took one look, then pulled them each by a sleeve around the side of the room to the hall where the public telephone was. "What in God's name is wrong with you two?" she demanded.

"Nothing," said Ricky, shakily. His voice was theatrical and womanish. He was the elegant one, small and light-boned, with soft cascades of undyed silver hair and creamy translucent skin. Tonight he was dressed in a pale blue silk crepe de chine evening sheath which Alexandra Marie would have killed to fit

into, and his face bore a stunned expression that made him look ten years younger. Mickey was the trashy one, Irish-red hair buzz-cut, cute freckles, multiple nose-rings, studded low-cut scarlet leather, tiny boobs, tattoos, and fishnet stockings. Oddly, he had always seemed to Alexandra Marie to be the more successfully female of the two. Mickey had once belonged to an all-pseudogirl group called the Whipettes. He was rumored to have a humongous penis. Tonight he looked thoughtful, which was so unusual for him that Eubie the Bouncer, on his way to something else, did a double-take. "What's the story?" he rumbled.

"It's Joe," said Ricky.

"He's dead," said Mickey.

"Oh my God," said Alexandra Marie. She put a scarred hand to her mouth, and sorrow burst in her heart like a water balloon.

"Ginny caught some kid with what looked like Joe's bag," growled Mickey. "Ginny made the kid tell him where he found it. The kid said he got it off some stiff." He shrugged.

"But why?" said Alexandra Marie. The silliness of the question struck her instantaneously.

"Where'd they find him?" asked Eubie. He did not bother to ask "How did it happen?" If there had been something left near the body for the child to steal, then it had not been murder, which left only two other avenues for a junkie: accidental O.D. or suicide.

"Perp Miz," breathed Ricky. "Under the Virgin."

"Did anyone call the police?" asked Alexandra. The three men looked at her with identical expressions, like a sister act. She said helplessly, "He might still be alive. He might be in a coma."

"He was dead, Alexandra Marie," said Mickey harshly.

She turned to Eubie. "Call them, for Christ's sake!" The big man rolled his eyes to heaven and reached for the telephone,

holding out his pale palm for a quarter. She dug in her apron and slapped one down against his fingers, so angry she could not see. It did not seem right to let Joe just lie there in the dark.

A shout from the bar summoned her back into the evening's fray. There was no question of disobedience; there was nothing she could do for Joe, not now, not ever. As she hurried off, she heard Eubie suggesting politely to the queens that they not spread the Good News too vociferously in this particular establishment on this particular evening. A leisurely time later, an ambulance wailed past, heading south and east. When she turned around again at the next lull, the queens were gone and Eubie was busy hanging some drunks out to dry. It was nearly three in the morning, closing time, before she was able to think of Joe again.

Accompanied by Eubie, she climbed the stairs to Joe's apartment, wondering what they will find there. They found the door unlocked. Inside, Divine stared down at them from the wall with a challenging expression on his alien face. All of Joe's things were there. Eubie did a quick search of the rooms for abandoned pharmaceuticals, which, he pointed out logically, an ascended Joe Cantrell could not possibly need. He was disappointed to find only a little pot, which he pocketed, offering to divide it with Alexandra Marie, who declined. In Joe's bedroom, she poked through an opened dresser drawer and found a book. She pulled it out. It was small and slim and bound in leather. In the front of it, on the blank page before the title page, someone had written in a childish scrawl JOSEPH SMITH CANTRELL. Many of the pages were marked, passages underlined, YES! written in the margins by some of them in the same young hand. She turned back to the title page. *The Pearl of Great Price*, it said. She put the book back in the drawer.

In the end she took only a little china figurine, a pretend Irish house with a green shamrock on the side which she had found in a secondhand shop and given Joe one Christmas as a

gag, "for good luck." Eubie kept taking things out of closets and putting them in stacks. "I'm going," she said to him. He grunted and kept rummaging. She left the apartment and walked downstairs. Outside, it was the grey place between night and morning.

The first two things Joe noticed when he entered the Mary Street Bar were that it seemed larger inside than he remembered it, and that the glow he had been tracking was here as well, hovering somewhere near the ceiling. Cigarette smoke billowed through it in innocent white clouds. The jukebox was jumping and the place was packed. Uniformed servicemen rubbed shoulders with bikers, drag queens with stevedores, immaculate clean-shaven men in dark glasses with map-faced grizzled winos, and nobody was fighting; there was laughter and good-natured swearing, backslaps, table-pounding, but nothing ugly; a holiday mood. When was Mary's ever like this? he thought. He saw nobody he knew. The cat rubbed against his leg and he picked it up again.

There were two new bartenders on duty, white guys, working like dogs. The glow from the ceiling lit up the tiers of liquor bottles, striking sparks from their dim interiors. He moved slowly toward the counter. A Marine lumbered through him, shouting beerily; then a pale junkie clinging with a silly smile on her face to her silent beau-of-the-moment; then a tray-hoisting waitress breathing tobacco and perfume. For Joe each contact was a lyrical shock of flesh and blood and bursting sensual vitality, in and through and gone in a flash. *Even the sick ones are so damn alive,* he thought. He looked for the wall clock he was used to; it was not in its accustomed location over the bar and he could not find another. It had to be late. Where was Alexandra Marie?

He turned his back to the bar just as the street door

opened. Two men came in. One was Maurice Callander, looking robust and tanned. His companion was in his late twenties, ruggedly built, black-haired and black-moustached, with a more than slightly worn street beauty, a rather weak chin, and quick, observant eyes. He was wearing a tight tee-shirt, fatigue trousers, and dog-tags. His nipples showed through his tee-shirt. Joe found himself assessing the youth from a professional standpoint. He was obviously trade; he had good chest, good arms with no obvious track marks, good thighs; probably a good basket, though with the fatigues it was a little tough to be sure; and he would not be young much longer.

The cat stirred in Joe's grip, kneaded his right wrist with its right paw. With a start he realized where and when he was. It was the night the Mary Street Bar and Grill had reopened under new management, the management of local entrepreneur Maurice Callander. And it was the night he, Joe Cantrell, had come to what would prove to be his final place of residence. No wonder everybody was happy: drinks had been on the house that night. The arrival of Alexandra Marie was a year or so in the future; Eubie would not sign on for three, Sam the Bartender for four or five. Remembering, Joe stared afresh at his younger self, standing polite and attentive at Callander's side. They would go upstairs soon, to what would be Joe's apartment for the final ten years of his life. Afterwards, Callander would say he had "class" and "would make a mint in skinflicks" and, after introducing him around at various parties, set him up in business. Joe felt himself gripped with a fierce pride. *Go for it, kiddo,* he thought. *Show 'em what a talented Utah boy can do!* Because he needed to kiss somebody, he kissed the cat on the top of its furry head.

And felt a tap on his right shoulder.

He turned. It was Maxx. He was dressed in a brilliant gold-lamé sheath and shoulder-length Marilyn Monroe blonde wig. His lipstick and nail polish were violent purple. He was not

wearing any razors. He waved a hand in the smoky air. "So what do you think, Honey?" he yelled over the music. "Isn't it a riot? I always did love a party."

"Is that really you, Maxx?" asked Joe. "You look like a Supreme on acid."

"Define 'really' in this context, Chicken," drawled Maxx from beneath heavy purpled lids. "And that's *three* x's now, puh-*leeze*." A whore staggered through him and away. Maxxx watched her go and shook his head. "Honestly, these *styles!* You have to love the Eighties. Who's your friend?" He indicated the cat.

"He was in a fire," said Joe. The cat matched Maxxx's lidded stare with one of its own. "Maxxx, are you—if you can see me, I mean touch me, then you must be—"

"*Dead?*" Maxxx put his palms to his cheeks and made a violet moue of mock horror. "Sugar, it's all right. You can say the word; it won't kill you. Of course I'm dead. We're all dead. That's why we came. To see you off."

"'We?'" said Joe. "The Gang. Come on over and say hidy." Maxxx took him by the left arm and propelled him through shifting waves of patrons to a clear space at one end of the room, where a couple of round tables had been set up next to each other. At one table sat the turbanned old woman with the lorgnette who had steered him toward the light. She had a large piece of chocolate-frosted chocolate layer cake in front of her, a third consumed, and she was gazing upon the others indulgently. Next to her slouched Beau, Joepye's bi boyfriend, who had introduced Joe to coke and free weights. He was looking shy but happy; *perhaps*, thought Joe, *he was shy about being happy*. Next to him, flirting madly in drunken monologue, sat the girl in the green fringed dress. She was evidently free of her vulturine companion and enjoying it, throwing back her head with an open-throated laugh as she gestured wildly with her cigarette-holder. Next to her, contemplatively slugging Jim

Beam out of a bottle, was Dolph Klegg, the drummer from Rat Fink. Dolph had liked water sports and had been the one who'd pressured the others to let Joe share their Village loft with them. He was tapping his fingers on the tabletop to the music from the jukebox. Joe wondered how he'd died. Next to him was an empty chair.

At the second table sat the bare-headed man from the winter Depression street, nursing a beer and talking quietly with a thin-boned, big-nosed, kind-faced woman who looked as out of place in this raucous dream of a bar as anyone could have looked. She appeared to be drinking seltzer, and she listened to the quiet man with evident pleasure. She was, Joe realized with a start, his second grade teacher, Miss Arquette, whom he had not thought of in over twenty years. Next to her was Tarantula, the gorilla-like bouncer from Thrash, the place in Key West Joe had hung out a lot. 'Rant, Joe recalled, had been into breath suppression scenes, and Joe knew very well how he'd died: a shot to the head during a midnight drug run off Islamorada. He was playing placid poker with a big man whose face was turned into his cards so that Joe could not make out his features. Next to him was another empty chair. "Hey, everybody!" Maxxx cried. "See who I found wandering around like a lost soul!"

They looked up at his hail, their cheeks flushed with talk and booze, looked up and called and waved in surprise and glad pleasure. The turbanned lady said, "Well, at last, at last!" Beau said, "Hey, José," their little joke. The sequined girl said, "Welcome to the party, darling!" Dolph said, "Yo, Joey; how's it hangin', bro'?" The street guy raised his beer bottle in toast. Miss Arquette said, "Joseph, you are a *picture*." Tarantula rumbled something inaudible, flashing a gold-toothed grin. And the man on the end turned around and looked up, and it was Brother Oral.

Joe stood where he was. The cat squirmed and dropped

out of his arms. Maxxx put an arm around his waist, kissed him on the left cheek, and patted his ass. "Come on, Joe. It's your party."

"Come on, Joe!" "Hey, buddy, get over here!" "Joseph?" But he could not move. Oral was exactly the way Joe remembered him: big-shouldered, round-faced, dove-eyed, in a grey polyester suit with a white shirt and a burgundy tie. He met Joe's gaze steadily, with a kind, wise affection that Joe knew only too well.

Joe took a step backward. Maxxx let go of him. "Okay," Joe said. "I get it now. I get it."

"Hush," said the old woman with the lorgnette to the others. "Let him speak." They fell silent, watching him, merry no longer. "Okay, Maxxx," Joe said to his friend. "I think I get what's going on now. This is it. The end of the line. The buck stops here. This is where fags and other sinners go when they die, or the prelude to it. Our last chance to howl, right? And then what? Limbo for suicides? Weeping and wailing and teeth-gnashing for working boys? Or just a repentant reincarnation as a missionary sister in West Hollywood?"

"No, Honey."

The jukebox sounded as loud as ever, but the drag queen's gravity was louder. Joe gritted his teeth and spun around, looking for somebody to take it out on. He took in the Mary Street Bar: patrons, whores, staff, junkies, cigarette and reefer smoke, the odd glow from the rafters. "If this isn't," he said desperately, and stopped. He turned back to the waiting, watchful group. "If this isn't the gate to Hell. And if you aren't—" He stopped again. The cat had jumped up on the table next to Brother Oral and was observing him mildly. Its eyes were green; he had not noticed that before. He realized that he was crying, and he was not sure why. It was not shame; not shame, at least, for what he was or had become. It was something else he did not have a name for. *"If this is heaven,"* he

managed through chattering teeth, "*then what the fuck is that goddamn fucking child molester doing here?*"

"Oh, honey," said Maxxx. He held out a purple-nailed hand, palm up. There was a spot of blood in the center of the palm, and as Joe watched, it welled up larger and larger until it spilled and dropped down over his fingers and onto the floor of the bar. Joe looked past him to the others. They were holding their palms up, too: the turbanned lady, Beau, the flapper, Dolph the drummer, the street guy, the teacher, even Oral. And in the center of each palm, male or female or slender or broad or gay or straight or bi or white or brown or black, the stigmata welled and flowed. He raised his own hands. They felt normal, and they looked fine from the back: big knuckles, strong veins ("Nothing like good old junkie venation!" somebody had said to him once), black hairs like wires, thick wrists. He had never been good at fisting; his hands were too big. He turned them over. Two bright eyes of blood winked back at him, dripping.

"Welcome to the family, Joe," said Maxxx.

And heaven, like a pearl, descended.

The Penis Story
Sarah Schulman

The night before they sat in their usual spots. Jesse's hair was like torrents of black oil plunging into the sea. Ann watched her, remembering standing in the butcher shop looking at smoked meat, smelling the grease, imagining Jesse's tongue on her labia. She was starving.

"I'm just waiting for a man to rescue me," Jesse said.

"Look, Jess," Ann answered. "Why don't we put a timeline on this thing. Let's say, forty. If no man rescues you by the time you're forty, we'll take it from a different angle. What do you say?"

"I'll be in a mental hospital by the time I'm forty."

Jesse was thirty-two. This was a realistic possibility.

"Jesse, if instead of being two women, you and I were a woman and a man, we would by lovers by now?"

"Yes." Jesse had to answer yes because it was so obviously true.

"So what's not there for you in us being two women? Is it something concrete about a man, or is it the idea of a man?"

"I don't think it's anything physical. I think it is the idea of a man. I want to know that my lover is a man. I need to be able to say that."

Things Invisible to See

Ann started to shake and covered her legs with a blanket so it wouldn't be so obvious. She felt like a child. She put her head on Jesse's shoulder feeling weak and ridiculous. Then they kissed. It felt so familiar. They'd been doing that for months. Each knew how the other kissed. Ann felt Jesse's hand on her waist and back and chest. Jesse reached her hand to Ann's bra. She'd done this before too. First tentatively, then more directly, she brushed her hands and face against Ann's breasts. Ann kissed her skin and licked it. She sucked her fingers, knowing those nails would have to be cut if Jesse were to ever put her fingers into Ann's body. She looked at Jesse's skin, at her acne scars and blackheads. She wanted to kiss her a hundred times. Then, as always, Jesse became disturbed, agitated. "I'm nervous again," she said. "Like, oh no—now I'm going to have to fuck."

Suddenly Ann remembered that their sexual life together was a piece of glass. She put on her shirt and went home. This was the middle of the night in New York City.

When Ann awoke the next morning from unsettling dreams, she saw that a new attitude had dawned with the new day. She felt accepting, not proud. She felt ready to face adjustment and compromise. She was ready for change. Even though she was fully awake her eyes had not adjusted to the morning. She reached for glasses but found them inadequate. Then she looked down and saw that she had a penis.

Surprisingly, she didn't panic. Ann's mind, even under normal circumstances, worked differently than the minds of many around her. She was able to think three thoughts at the same time, and as a result often suffered from headaches, disconnected conversation, and too many ideas. However, at this moment she had only two thoughts: "What is it going to be like to have a penis?" and "I will never be the same again."

It didn't behave the way most penises do. It rather seemed

to be trying to find its own way. It swayed a bit as she walked to the bathroom mirror, careful not to let her legs interfere, feeling off balance, as if she had an itch and couldn't scratch it. She tried to sit back on her hips, for she still had hips, and walk pelvis first, for she still had her pelvis. In fact, everything appeared to be the same except that she had no vagina. Except that she had a prick.

"I am a prick," she said to herself.

The first thing she needed to do was piss and that was fun, standing up seeing it hit the water, but it got all over the toilet seat and she had to clean up the yellow drops.

"I am a woman with a penis and I am still cleaning up piss."

This gave her a sense of historical consistency. Now it was time to get dressed.

She knew immediately that she didn't want to hide her penis from the world. Ann had never hidden anything else, no matter how controversial. There was nothing wrong with having a penis. Men had them and now she did too. She wasn't going to let her penis keep her from the rest of humanity. She chose a pair of button-up Levis and stuffed her penis into her pants where it bulged pretty obviously. Then she put on a t-shirt that showed off her breasts and her muscles and headed toward the F train to Shelley's house to meet her friend for lunch.

By the time Ann finished riding on the F train she had developed a fairly integrated view of her new self. She was a lesbian with a penis. She was not a man with breasts. She was a woman. This was not androgyny, she'd never liked that word. Women had always been whole to Ann, not half of something waiting to be completed.

They sat in Shelley's living room eating lunch. These were her most attentive friends, the ones who knew best how she lived. They sat around joking until Shelley finally asked, "What's that between your legs?"

"That's my penis," Ann said.

"Oh, so now you have a penis."

"I got it this morning. I woke up and it was there."

They didn't think much of Ann's humor usually, so the conversation moved on to other topics. Judith lit a joint. They got high and said funny things, but they did keep coming back to Ann's penis.

"What are you going to do with it?" Shelley asked.

"I don't know."

"If you really have a penis, why don't you show it to us?" Roberta said. She was always provocative.

Ann remained sitting in her chair but unbuttoned her jeans and pulled her penis out of her panties. She had balls too.

"Is that real?"

Roberta came over and put her face in Ann's crotch. She held Ann's penis in her hand. It just lay there.

"Yup, Ann's got a penis alright."

"Did you eat anything strange yesterday?" Judith asked.

"Maybe it's from masturbating," Roberta suggested, but they all knew that couldn't be true.

"Well, Ann, let me know if you need anything, but I have to say I'm glad we're not lovers anymore because I don't think I could handle this." Judith bit her lip.

"I'm sure you'd do fine," Ann replied in her usual charming way.

Ann put on her flaming electronic lipstick. It smudged accidentally, but she liked the effect. This was preparation for the big event. Ann was ready to have sex. Thanks to her lifelong habit of masturbating before she went to sleep, Ann had sufficiently experimented with erections and come. She'd seen enough men do it and knew how to do it for them, so she had no trouble doing it for herself. Sooner or later she would

connect with another person. Now was that time. She wore her t-shirt that said "Just visiting from another planet." Judith had given it to her and giggled, nervously.

The Central Park Ramble used to be a bird and wildlife sanctuary. Because it's hidden, and therefore foreboding, gay men use it to have sex, and that's where Ann wanted to be. Before she had a penis, Ann used to imagine sometimes while making love that she and her girlfriend were two gay men. Now that she had this penis, she felt open to different kinds of people and new ideas, too.

She saw a gay man walking through the park in his little gym suit. He had a nice tan like Ann did and a gold earring like she did too. His t-shirt also had writing on it. It said. "All American Boy." His ass stuck out like a mating call.

"Hi," she said.

"Hi," he said.

"Do you want to smoke a joint?" she asked very sweetly.

He looked around suspiciously.

"Don't worry, I'm gay too."

"OK honey, why not. There's nothing much happening anyway."

So, they sat down and smoked a couple of joints and laughed and told about the different boyfriends and girlfriends that they had had, and which ones had gone straight and which ones had broken their hearts. Then Ann produced two beers and they drank those and told about the hearts they had broken. It was hot and pretty in the park.

Ann mustered up all her courage and said, "I have a cock."

"You look pretty good for a mid-op," he said.

His name was Mike.

"No, I'm not a transsexual. I'm a lesbian with a penis. I know this is unusual, but would you suck my cock?"

Ann had always wanted to say "suck my cock" because it was one thing a lot of people had said to her and she never said

to anyone. Once she and her friends made little stickers that said "End Violence in the Lives of Women," which they stuck up all over the subway. Many mornings when she was riding to work, Ann would see that different people had written over them "suck my cock." It seemed like an appropriate response given the world in which we all live.

Mike thought this was out of the ordinary, but he prided himself on taking risks. So he decided "what the hell" and went down on her like an expert.

Well, it did feel nice. It didn't feel like floating in hot water, which is what Ann sometimes thought of when a woman made love to her with her mouth, but it did feel good. She started thinking about other things. She tried the two-gay-men image but it had lost its magic. Then she remembered Jesse. She saw them together in Jesse's apartment. Each in their usual spots.

"What's the matter, Annie? Your face is giving you away."

"This is such a bastardized version of how I'd like to be relating to you right now."

"Well," said Jesse. "What would it be like?"

"Oh, I'd be sitting here and you'd say, 'I'm ready' and I'd say, 'Ready for what?' and you'd say, 'I'm ready to make love to you Annie.' Then I'd say, 'Why don't we go to your bed?' and we would."

"Yes," Jesse said. "I would smell your smell, Annie. I would put my arms on your neck and down over your breasts. I would unbutton your shirt, Annie, and pull it off your shoulders. I would run my fingers down your neck and over your nipples. I would lick your breasts, Annie, I would run my tongue down your neck to your breasts."

Ann could feel Jesse's wild hair like the ocean passing over her chest. Jesse's mouth was on her nipples licking, her soft face against Ann's skin. She was licking, licking then sucking

harder and faster until Jesse clung to her breasts harder and harder.

"You taste just like my wife," Mike said after she came.

"What?"

Ann's heart was beating. The ocean was crashing in her ears.

"I said, you taste just like my wife, when you come I mean. You don't come sperm, you know, you come women's cum, like pussy."

"Oh thank God."

Ann was relieved.

Another morning Ann woke up and her fingers were all sticky. It was still hard. First she thought she'd had a wet dream, but when she turned on her reading lamp she saw blood all over her hands. Instinctively she put her fingers in her mouth. It was gooey, full of membrane and salty. It was her period. She guessed it had no other place to come out, so it flowed from under her fingernails. She spent the next three and a half days wearing black plastic gloves.

The feeling of her uterine lining coming out of her hands gave Ann some hope. After living with her penis for nearly a month, she was beginning to experience it as a loss, not an acquisition. She was grieving for her former self.

One interesting item was that Ann was suddenly in enormous sexual demand. More women than had ever wanted to make love with her wanted her now. But most of them didn't want anyone to know, so she said no.

There was one woman, though, to whom she said yes. Her name was Muriel. Muriel dreamed that she made love to a woman with a penis and it was called "glancing." So she looked high and low until she found Ann, who she believed had a rare and powerful gift and should be honored.

Things Invisible to See

Ann and Muriel became lovers and Ann learned many new things from this experience. She realized that when you meet a woman, you see the parts of her body that she's going to use to make love to you. You see her mouth and teeth and tongue and fingers. You see her fingers comb her hair, play the piano, wash the dishes, write a letter. You watch her mouth eat and whistle and quiver and scream and kiss. When she makes love to you she brings all this movement and activity with her into your body.

Ann liked this. With her penis, however, it wasn't the same. She had to keep it private. She also didn't like fucking Muriel very much. She missed the old way. Putting her penis into a woman's body was so confusing. Ann knew it wasn't making love "to" Muriel and it certainly wasn't Muriel making love "to" her. It was more like making love "from" Muriel and that just didn't sit right.

One day Ann told Muriel about Jesse.

"I give her everything within my capacity to give and she gives me everything within her capacity to give—only my capacity is larger than hers."

In response, Muriel took her to the Museum of Modern Art and pointed to a sculpture by Louise Bourgeois. Ann spent most of the afternoon in front of the large piece, an angry ocean of black penises which rose and crashed, carrying a little box house. The piece was called "Womanhouse." She looked at the penises, their little round heads, their black metal trunks, how they moved together to make waves, and she understood something completely new.

They got together the next day in a bar. As soon as she walked in Ann felt nauseous. She couldn't eat a thing. The smell of grease from Jesse's chicken dinner came in waves to Ann's side of the table. She kept her nose in the beer to cut the stench.

"You're dividing me against myself, Jesse."

Jesse offered her some chicken.

"No thanks, I really don't want any. Look, I can't keep making out with you on a couch because that's as far as you're willing to go before this turns into a lesbian relationship. It makes me feel like a nothing."

Ann didn't mention that she had a penis.

"Annie, I can't say I don't love being physical with you because it wouldn't be true."

"I know."

"I feel something ferocious when I smell you. I love kissing you. That's why it's got to stop. I didn't realize when I started this that I was going to want it so much."

"Why is that a problem?"

"Why is that a problem? Why is that a problem?"

Jesse was licking the skin off the bone with her fingers. Slivers of meat stuck out of her long fingernails. She didn't know the answer.

"Jesse, what would happen if someone offered you a woman with a penis?"

Jesse wasn't surprised by this question, because Ann often raised issues from new and interesting perspectives.

"It wouldn't surprise me."

"Why not?"

"Well, Annie, I've never told you this before, actually it's just a secret between me and my therapist, but I feel as though I do have a penis. It's a theoretical penis, in my head. I've got a penis in my head and it's all mine."

"You're right," Ann said. "You do have a penis in your head because you have been totally mind-fucked. You've got an eight-inch cock between your ears."

With that she left the restaurant and left Jesse with the bill.

Things Invisible to See

* * *

Soon Ann decided she wanted her clitoris back and she started to consult with doctors who did transsexual surgery. Since Ann had seen, tasted, and touched many clitorises in her short but full life, she knew that each one had its own unique way and wanted her own cunt back just the way it had always been. So, she called together every woman who had ever made love to her. There was her French professor from college, her brother's girlfriend, her cousin Clarisse, her best friend from high school, Judith, Claudette, Kate, and Jane and assorted others. They all came to a big party at Shelley's house where they got high and drank beer and ate lasagna and when they all felt fine, Ann put a giant piece of white paper on the wall. By committee, they reconstructed Ann's cunt from memory. Some people had been more attentive than others, but they were all willing to make the effort. After a few hours and a couple of arguments as to the exact color tone and how many wrinkles on the left side, they finished the blueprints. "Pussy prints," the figure skater from Iowa City called them.

The following Monday Ann went in for surgery reflecting on the time she had spent with her penis. When you're different, you really have to think about things. You have a lot of information about how the mainstream lives, but they don't know much about you. They also don't know that they don't know, which they don't. Ann wanted one thing, to be a whole woman again. She never wanted to be mutilated by being cut off from herself and she knew that would be a hard thing to overcome, but Ann was willing to try.

Angel Droppings
Kerry Bashford

1.

Janet Walker has never been to the Bahamas. She knows very little about them. She knows that it's warm there, that there are beaches and tourists and, she seems to recall, black people but that's about it.

Yet, two pages ago, Cecilia Van Der Post was to be found on a West Indian beach. When her editor at Playhouse Publications insisted that in Chapter Six, Cecilia simply had to be found on a West Indian beach, Janet Walker panicked. Two hours later, she left the travel agents' with a handful of brochures.

It is from these tracts that Ms. Van Der Post's Bahamas have been created. After another fraudulent paragraph of "sun scorched beaches" and "thunderous waves," Cecilia will look down the beach and see "an astonishingly attractive man emerging from the twilight, it would seem out of nowhere, as if an angel had fallen from the heavens."

2.

A meal is rarely as meaningful as when it is consumed a few short steps from death. Patrick lets this thought repeat in his mind as he mounts the stairs to the roof. His lunch time

encounters with peril are, in fact, brief and uneventful. Yet, Patrick finds it satisfying to leave the safe, predictable enclosure of the office and snatch a few moments of adventure on the roof of a twenty storey office block.

One day, he imagines he might even sit on the edge. This would give the occasion a hint of credible risk. But for now, he is content with remaining a respectful distance from the street.

3.

Around noon, every weekday, Janet Walker wanders to her window and watches a figure appear on the roof opposite her apartment. She has been intrigued by the man from the moment she first saw him and has devised an elaborate life for him. Some days, he intercepts signals from enemy satellites with a receiver hidden in his lunch box. Other days, he plans the murder he will commit as soon as he lures a victim to the roof.

Today, his life holds little possibility. Today, she must return to her typewriter. For now, Cecilia's life is elaborate enough.

4.

Patrick has just returned home from work. He has just watched a cup that he carelessly nudged off the kitchen counter fall like a feather to the floor. It is now 5:52 and six seconds, Eastern Standard Time. The problem is that it has been 5:52 and six seconds for the last ten seconds. The problem is also that Patrick has come home from a difficult day to find that the cat has left the remains of his canary on the living room floor. He is not in the mood to find that the universe is misbehaving as well.

5.

One hundred and thirty miles south of Patrick's house, in a town he is never likely to visit, an incident has just occurred

to a group of people he is never likely to meet. During an office party at the Institute of Seismology, the revelry is interrupted by a report from the adjoining room.

An earthquake had apparently just occurred in the city one hundred and thirty miles to the north. The earthquake was of such magnitude that the city would have been propelled into the Pacific Ocean. Workers grieved for lost relatives and friends, secretaries stumbled to their seats, scientists clambered under tables.

Soon, it will be discovered that no such catastrophe has occurred. Hands will be folded in prayers of thanks, glasses will be raised in expressions of relief, and the bearer of the message will be promptly fired.

6.

A few minutes before six, Eastern Standard Time, a violent power surge throws Janet Walker across her apartment. At the moment of the accident, she had barely finished reworking Chapter Three, in which Cecilia Van Der Post is horribly disfigured in an electrical fire that gutters her ancestral home and torches her entire family.

Janet is not just unnerved by this coincidence. She is distraught. Her typewriter has just come out of warranty.

7.

It is now a few moments before six. In retrospect, Patrick will not be able to say with any certainty whether it was the slippery tiles in the back yard that threw him to the ground or whether it was the sight of an angel hanging from his clothes line.

The angel, as he will soon learn, had been doing aerobatics. Patrick, as he will soon forget, had been doing laundry.

Patrick is not accustomed to having members of the

celestial host in his backyard. He is not entirely sure what he should do. At first he considers calling the authorities but no book he has ever read or film he has ever seen ever identified who the authorities are and what they might do if called upon to assist.

Suddenly, the creature stirs. The wings stretch. The head lifts. The eyes widen. The mouth opens.

"Holy Shit!"

8.

By then, it was too late for Cecilia to escape. She had thought that she was alone on the beach and had been so preoccupied by the sky seared by a simmering sunset ...

If in doubt, alliterate.

... that she failed to notice this man, this exquisite intruder, until he was almost at her feet. He stood there with a dog at his side ...

A labrador or a German shepherd. A german shepherd, I think, more noble.

... a German shepherd at his side, a strong aloof figure pressed against a blazing backdrop. As the sea lapped seductively at the shore, the dog lapped playfully at her feet ...

Janet, Janet, I think you need a good lie down.

... Cecilia pressed her scarred hands to her charred cheeks, afraid of offending this beautiful creature with her disfigurement. He did not shield his eyes from her twisted face. He did not turn away from her terrible burns. He simply stepped forward and fell over her foot.

9.

"Hello, hello, that's just wonderful. I make contact with a species that has spent the last few millennia wondering whether there is other intelligent life in the universe, whether there is in fact a god and when they actually find this to be true,

do you think they can put two words together in greeting?"

Patrick is not coping.

"Sorry but I have had better days. If it wasn't bad enough being assigned to this third rate rock, a few moments ago, I was hanging out with a few friends in an upper stratosphere and then I suddenly find myself hanging out with somebody's underpants?"

Patrick is not coping at all.

"Listen are you going to help me down or aren't you? You don't seem to realize the significance of this. You must be the first person in centuries to have met an angel. Haven't you always dreamed of something like this happening? Aren't there any questions that you're just dying to ask me?"

"Yes, how quickly can you leave?"

10.

Patrick is exhausted but sleep is the furthest thing from his mind. What does occupy his thoughts is a night in a year he had almost forgotten. It was the evening of the nativity play. He was on the stage, approaching the Virgin Mary in the garb of the angel Gabriel. At that moment, he tripped over the microphone cord and fell into the manger. The Virgin threw up her hands in fright. The baby Jesus bounced off the stage. The detached head of the doll landed in the lap of a screaming parishioner.

Later in the parking lot, his mother chastised him for this public sacrilege. She reminded him of the long hours she had laboured on his costume, the many hours she had spent creating a facsimilie from his Sunday School books. He had sat beside her as she worked, staring at the image of the angel, androgynous in a white robe, blonde curls and a bland smile. The creature that lies snoring beside him has no robe, no hair and certainly no smile. The angel does remain faithful to the artist's impression in one regard. There is no indication of gender and no sign of genitalia.

11.
Playhouse Publications
2/206 Main St.
Kingston, 2020

Dear Ms. Walker:

I have read chapter seven with great interest. Although I found the narrative quite satisfactory and the description of the Bahamas quite authentic, there is one small problem. You have described the male character as tall, tanned with "deep, dark eyes almost disguised by a shock of blonde hair." The problem is this—we need the character to have dark hair. Our research has indicated that heroes with dark features and hair coloring were particularly popular in the last financial year. As the action takes place in the Bahamas, which I believe is close to South America, it would be fitting that the character should be of Latin extraction, preferably with a name like Angelo or something suitably ethnic. I would appreciate your cooperation in this regard.

Yours faithfully,

James Stevens
COMMISSIONING EDITOR

12.
The angel lights a cigarette.
"You'll get cancer."
"Spare me, Patrick, I'm immortal."
"Well, I think it's appalling. You've lounged around my house for two days now, filling up ashtrays. Haven't you a higher purpose? What exactly is your mission here, anyway?"

"What mission? I was in the middle of a double somersault with a three-quarter twist and some how I screwed up my angle of entry and ended up belly flopping into your backyard."

"So you said. Well, forgive me, but you have been something of a disappointment."

"I've been something of a disappointment! Patrick, let me tell you, watching out for your welfare hasn't exactly been an intense experience. Since birth, the biggest risk you've taken has been changing brands of toothpaste. When you were a child, you didn't do challenging things like sticking cutlery into electrical sockets or playing with firearms."

"Sorry. If you're lucky perhaps in your next assignment you'll be looking after a mass murderer."

"Hey, there's an idea. You know how you always have lunch on the roof at work. Perhaps next time you could pack a rifle and drill a few pedestrians. You know, something like that. Make my life more interesting."

"I don't believe what I'm hearing. My guardian angel wants me to become a sniper."

"Sorry. Just a suggestion."

"So, have I always been a disappointment to you?"

"Well, no, there was a time when I held out some hope for you."

"Really? When was that?"

"When you finally decided you were gay."

"Exactly what was it you were hoping for?"

"Well, when you came to this startling revelation despite repeated hints from me ... Like, remember when Mr Johnson in the third grade kept on putting his hand on your knee? Well, that was my idea. Except it took years for the idea to sink in. And when it finally did, I thought great, the guy's gay, now we can start having some fun. Somewhere along the line he's bound to be bashed, arrested, do dangerous drugs, some

serious partying or if I'm lucky start hanging around public lavatories. But you, no way. You have absolutely no sense of adventure."

"So, what do you suggest I do?"

"You're not doing anything tonight. Why don't you go out for a change?"

"And leave you alone in my house? I'm not sure this is such a good idea."

"Who said anything about me staying home? I'm coming with you."

"You can't be serious."

"Of course I can. This will be my opportunity to do some field work. Anyway, what's the problem?"

"Well, how do we explain the wings? A congenital defect?"

"Costume party? Anyway, we're going to a gay bar, they wouldn't notice something like that there."

"I think they might notice two huge feathery appendages flapping in their faces."

"Don't worry. It'll be fine. What could be safer than a night out with your guardian angel?"

13.

Stop me if you've heard this one before. There's this angel, okay, and he walks into this gay bar, right. Anyway ...

14.

The angel lights a cigarette.

"Remind me to never go there again."

"I don't think I'll need to. The management will be more than happy to remind you of that."

"Well, I didn't see what the problem was."

"The problem was that you decked one of the barmen."

"But he made derogatory remarks about my wings. I don't see why I should tolerate that from a lower life form."

"And just when I was getting friendly with the guy in the corner."

"What ... the unemployed seismologist? Why would you want to waste your time with him?"

"I thought he was nice."

"Patrick, Patrick, one look at him and even I began to doubt the story of Creation."

"What do you mean?"

"Well, the man had no neck and I'm sure if you looked close enough, his knuckles would have shown sign of contact with the pavement."

"What? Who the hell do you think you are?"

"Your guardian angel. Show some respect. And pass the ashtray."

"If you're my guardian angel, what is it exactly that you do?"

"I don't know. I just hang around, making sure you don't step under a bus before your time."

"So, I'm going to step under a bus, am I?"

"Now, I didn't say that."

"But, you do know when I'm going to die, don't you?"

"Yes ... I am aware of the length of my contract. I wouldn't have taken the position otherwise."

"So, when do you finish the job?"

"I can't tell you that!"

"Well, at least tell me one thing, what's God like?"

"How in heaven's name would I know? Look, I'm a guardian angel, a shit kicker. I don't mix in those kind of circles. And would you please pass me the ashtray."

"No. Get it yourself."

"Patrick, I think it's time you started being nice to me."

"Give me one reason why I should."

Things Invisible to See

"Genesis, Chapter 9."

"Sorry?"

"Genesis, Chapter 9. You are, I take it, familiar with the sin of Sodom."

"Well, I have had the occasion to commit it a few times, yes."

"No, no, not that. These angels turn up in this city, right, and the townsfolk give them a hard time and it results in a riot. And then the place goes up in flames. You know, the sin of Sodom. Being inhospitable to angels."

"So, what are you trying to tell me?"

"Start treating me nice or the town's toast."

"Oh great, great, now I find out for the last two days I've been entertaining a pyromaniac from another dimension. If it wasn't bad enough you got me barred from the only gay bar in town. You've slept in my bed, stolen my sheets, kept me awake half the night with feathers in my face. And the only time I can truthfully say that I've slept with an absolute angel, it hasn't even got the decency to have a cock. I'm living with this free-loading, chain smoking, life-size fucking Christmas decoration. And another thing ... oh my god, what is that?"

15.

"Oh, look, look, the stars are so beautiful," Cecilia says, her face pressed against the telescope lens.

"Are they?" His voice sounds suddenly distant.

"Oh yes. Come and see for yourself."

"I can't."

"What do you mean you can't? Just come and have a look."

"I can't see."

"Of course, you can. You're not blind, are you?"

"Yes, in fact, I am."

Cecilia gasps, her cheeks stinging with shame. "Oh, I'm so sorry. I ... I ... didn't realize. Please forgive me."

"There's nothing to forgive ... Tell me once again. Tell me how the stars look tonight. You can be my eyes, Cecilia."

She turns and looks once again into the telescope. She cannot see the stars. She is blinded by her tears.

"Oh, they seem so wonderful, so close. It's like holding the heavens in your hands. It's like ... "

... a telescope, Janet, of course. Oh, but I couldn't ...

16.
" ... oh my god, what is that?"

"What?"

"That. That between your legs?"

"Well, Patrick, you complained that I was physically lacking, so I improvised. Don't you like it?"

"I must admit, it is impressive if not a little impractical."

"Why, what's wrong with it?"

"Well ... for a start, it's not supposed to hang any lower than your knees."

"Sorry. Artistic license ... how's that?"

"Better but still a little ambitious ... Now let's see if we can take it up a little higher ... yes, yes ... just a little bit more ... perfect. Now ... if we could just make the width a bit more proportionate ... no, no ... back, back ... lovely, yes, that will do nicely."

"You're enjoying this, aren't you?"

"Now, let me see ... how about making the left testicle hang lower than the right?"

"Whatever for?"

"I don't know. Authenticity, I guess."

"How's that?"

"Very nice, very nice ... now, just a few adjustments to the upper torso. Firstly, we can ditch the wings."

"No. Absolutely not."

"Come on. Just a few more suggestions."

"No."

"So, now that you've performed this extraordinary feat, what happens next?"

"I would have thought that was obvious. I haven't done this purely for self adornment, you know."

"You mean, you want to ... but isn't there be a commandment against that?"

"Well, last time it happened, it did rain for forty days and nights but things are a little more liberated these days."

"Are you sure we won't be interrupted by a bolt of lightning or something?"

"I'm sure we won't even create a turbulence."

"Have you done this before?"

"No, but I've been watching you for years. I think I can manage it. But Patrick, before we go any further, there's something I've always wanted to ask you."

"Yes?"

"Why do you always kiss with your eyes closed?"

Patrick is not really sure. However, it will be to his advantage half an hour later when, lying in the angel's arms, he fails to realize that he is floating five feet above the bed.

17.

Cecilia Van Der Post has a problem. During her stay in the Bahamas, she has fallen desperately in love with a man who is both incredibly gorgeous and incredibly sweet.

This is not the problem. A few months ago, Cecilia received third degree burns to her face. This is only part of the problem. The man in question is completely blind. The problem is that his blindness can be treated and his sight surgically restored, with a great deal of money.

Cecilia has a great deal of money. She can restore his sight

and risk losing him when he discovers her disfigurement. Or she can leave him in the dark and save her relationship and her money.

Janet Walker has a problem. She has just rented a telescope. However, the accompanying instructions are for a typewriter.

18.

Patrick is walking on air. He is on cloud nine. He is on top of the world. He is on top of the office building, sitting on the edge, dangling his feet above the traffic. In twenty minutes time, he is due to return to the office. In five hours time, he is due to return home.

He will never return to the office. He will never return home.

In a moment, he will be blinded by a flashing light from across the street.

19.

Now we're in business.

"Welcome to the world of telescopic viewing. See the stars as if they were across the street. See the many wonders of the heavens as if they were within your fingertips."

Okay, okay ... so, how does the fucking thing work? Let's see ... remove lens cap ... right, I see ... No, actually, I don't ... where's the bloody focus? No, but at least I know how to adjust the tripod ... oh, here we go ... so, where is he? Oh, there he is ... he's sitting on the edge ... he's looking right this way ... there seems to be a light in his eyes ... must be the reflection from the tele ... Jesusfuckingchristno!

20.

A fall.

An outstretched pair of wings.

An outstretched pair of arms.

A rescue.

21.

It is now 12:13 and six seconds, Eastern Standard Time. Janet Walker turns and throws her hands to her face and screams. She has not noticed the telescope, that she carelessly nudged off the tripod, fall like a feather to the floor.

22.

In the next few days, an unemployed seismologist will be reinstated with a full apology.

23.

Janet Walker is not coping.

"Yes, Miss Walker, so you say, but there have been no reports, no evidence of a man falling of a roof."

Janet Walker is not coping at all.

"You're not in the habit of playing pranks on the police, are you, Miss Walker?"

"No, officer. I must have made a mistake. I'm sorry to have wasted your time. I guess that will be all, then."

As they rise to leave, she catches the expression on their faces. It's the same expression she sees on the faces of her neighbors and on the face of the delicatessen owner.

"Mr Kouros, you didn't by any chance happen to see a dead body splattered on the pavement, did you?"

"Ah, no, Miss Janet, but if I do see one, I'll be sure to let you know. That'll be $5.20. Thanks. Have a nice day."

It's the same expression that she see on the faces of the pedestrians when, moments later, they watch her reaching into the trash can outside the shop.

24.

"You mean, you still love me?" Cecilia says, her bottom lip quivering in disbelief.

"Yes, my dear, how could I not love you? You have given me back my eyes and with my eyes I can see how beautiful you really are," he replies. As he lifts her trembling frame into his powerful arms and walks down the beach, Cecilia sobs into his left shoulder.

Suddenly, she feels like she has been borne aloft, like she is in mid-flight, like she is soaring into the sunset that softly caresses the beach.

25.
Playhouse Publications
2/206 Main St.
Kingston, 2020

Dear Ms. Walker:

I must say, in all frankness, that I am alarmed by the alterations that you have made to the final chapter. As you might recall, we decided that the character, Cecilia, would finance her boyfriend's operation. Yet, in the manuscript that you have sent me, I find that Cecilia has abandoned her boyfriend and the Bahamas and flown off to Switzerland for plastic surgery.

I'm afraid that this is not suitable. I take it your actions represent a dissatisfaction with company policy and have seen fit to terminate your contract with this company.

Yours faithfully,

James Stevens
COMMISSIONING EDITOR

26.

Janet lights a cigarette.

"Honey, it's so good to have you home."

"Janet, are you okay, you look dreadful."

"It's been a hard week that's all. I'll tell you about it sometime."

"What's that you're playing with?"

"Just something I found in the trash downstairs."

"Don't tell me things have gotten so bad you're rifling through garbage."

"No, it just caught my eye."

"So lovely and soft and white. Must have come from a fucking huge bird."

"Mmm."

"So how's the book going?"

"It's finished."

"Really, can I have a look at it?"

"Sure. Here it is."

"Thanks ... Hey, what's this 'Cecilia' shit? Darlin', how could you name such an appalling character after me?"

"Well, at least you were assured of being constantly in my thoughts."

"I'm not convinced. So, what did the publishers say?"

"They turned it down."

"But why?"

"Let's just say that I expressed 'dissatisfaction with company policy.'"

"So there go the holiday plans, ay?"

"What holiday plans?"

"Oh, I just noticed all those travel brochures on the table."

"Oh, right ... yes, it's a shame. I've never been to the Bahamas."

"I'm sure you'll find a way."
"Only if I sprout wings."

Reunion
Brian M. Thomsen

I lost all feeling from the waist down, weeks, maybe months, ago.

" ... and this is the old-timer of the ward. How are you doing today, Percy?"

Giles is one of the good ones. He doesn't really know that I'm still here, that I haven't already slipped off to the la-la-land of the great beyond. He still treats me like a human being, and not just some withered old husk.

I wish we had met before this place. Before ...

"This is Max. He'll be filling in while I'm away at my time-share."

I remember Fire Island in July.

"Can he hear us? He doesn't even blink."

"Does it matter? I'd like to think that his suffering is over, but if he can still hear us, I'd like to think that he still deserves some respect and courteous conversation. Now roll him over onto his side. Careful, those bedsores look mean. Sorry, Percy."

"Should we change the sheets as well?"

"No, the doctor wants to examine him first. A new doctor is going to look you over, Percy. Doctor Arnold is summering in Spain, and won't be back 'til September; the lucky old troll. Don't you just hate him?"

I remember Spain, and I remember France, and Italy, and

England. So many places, so many years. I remember Camelot and Arthur and Bors and the quest.

The Grail.

I remember it all, I think.

It's a bit of a jumble and things seem slightly out of order and I don't know how long it's been. There are gaps. The doctor said the lesions could cause amnesia, aphasia, and dementia, and he was partially right on all accounts. Too much to remember. Too much life.

I can't even remember how long I've been lying in this bed.

So many lives.

Too many goodbyes.

I think I still remember the first one, the last time I saw Bors ...

"But Perceval, we must return to Arthur. We must," said Bors, pleading for me to accompany him.

"You can if you want to. There's more to the world than just Camelot now."

"But we have been chosen. We found the Grail and must share its blessings with others. It is as Galahad instructed," he implored.

"Galahad is dead."

"No, you know better than that," he argued. "He has experienced the Rapture and has joined God in heaven. We are immortal now, and when our mission is over, we will one day join them."

"You spend your hard-earned immortality your way, and I'll mine. There are more earthbound raptures I plan to experience."

"But what should I tell the others?" he begged, the noble knight Bors now reduced to tears.

"Tell them I went with Galahad, or that I'm in a monastery somewhere, or that I'm dead. Tell them whatever you want ... or better yet, come with me. Join me in an eternity of experience."

"It would be sinful. This is not why the Grail chose us."

"The Grail did not choose us. We found it. Come with me. We could live like kings."

"Farewell old friend," he said sadly. "Go with God. I shall miss you."

I never saw Bors again. History and legend say that he eventually joined Galahad in the hereafter, or at least so the scholars think.

Bors was pure. His only sin was when he lied to the court about my fate.

I'm sure he was forgiven. He led a good life.

I carry the sins of several lifetimes.

"Moisten his lips. It helps to keep the skin from cracking."

"Jeez, I hope I never get this bad. How old is he?"

"Don't know. He's been on the ward since '88."

"Damn. Five years. I know I couldn't take it. Why doesn't someone just put this withered old husk out of his misery."

"Hush, show some respect. He didn't mean that, Percy."

"For chrissakes, Giles, he can't hear us."

"You don't know that."

Don't be too hard on him, Giles. He's right. This withered old husk would have been better off dead years ago.

Long dead.

But, I'm not.

It was about thirty years after parting with Bors that I realized that I wasn't getting any older. The plagues of Europe were claiming young and old. I was immune.

I thought I was lucky.

I made a habit to move on every ten years or so to avoid making any of the locals suspicious. After all, I didn't want to waste my hard-earned long life finding out what it felt like to be burnt at the stake for witchcraft.

No sense in wasting it.

War was another matter.

I had always been a soldier, a warrior. A warrior has to fight and protect. Normandy, Constantinople, Salzburg, Petersburg. The places all run together.

I took my chances and survived.

War brought back that sense of comradeship that had been missing since I left the Round Table.

So many lives, so many deaths.

Mostly war relieved the boredom.

I remember Martin. We fought the Armada together, I think.

We gave each other comfort on those long nights at sea.

"So, my love, what are you going to do when the war's over?"

"What do you mean when the war is over?" he'd say. "It won't be over in our lifetimes, I'll tell you that."

"But what if it was?"

"I don't know, probably go back to my father's farm, marry, and raise a new crop of soldiers for the Queen. What about you?"

"I have no family left."

"Too bad," he offered, and then, smiling, added, "you could come home with me. Father has plenty of land. You could marry my cousin. She's not really that bad off. We could all be one happy family."

He leaned over and kissed me.

"I don't think so. Settling down on a farm is not my cup

of grog, if you know what I mean."

"Then I'll join you," he replied. "Two merry gents on the open road. Soldiers for hire for fame and fortune."

I took him in my arms, and as lovers we passed the night away.

He died the following week when we sank the Armada.

He was what we call an acceptable casualty.

He didn't suffer long.

"Here, let me get that sun out of your eyes. I'll pull down the shade."

Bless you, Giles.

"That new doctor is a real honey. Must be fresh out of med school or something. You notice they keep making them younger and younger."

Youth and appearance aren't all they're cracked up to be.

"I could never have been a doctor. It takes too much time. You could never find me in a classroom when there was a sun to warm my buns or a dancer calling my name. You're only young once. Right, Percy?"

I remember having fun.

"I guess that's why I'm a nurse's aide. It's hard work, but the hours are cool, and besides, where else could I meet interesting guys like you?"

Enjoy while you can, Giles. The clock is ticking for everyone.

"And try not to let Max bother you. He doesn't mean to hurt your feelings. Max is a veteran and his head sort of got messed up during Desert Storm. Takes a lot out of a guy, war does."

That's why I gave up after a century and a half.

Korea, Vietnam, Palestine. After World War II, I just didn't have the heart anymore. I just gave up soldiering. There had to be better ways to fight boredom.

Maybe I'd just grown too tired of the pain and suffering.

Things began to loosen up a bit too. For a while, I hung with Ginsberg and his crowd, then I ran a club on Bleecker. Dylan played there. Then came, Stonewall, liberation and

dancing in the streets.

Sex without questions, camaraderie without commitment.

Who needed anything else?

Well ... Bobby did.

"Now don't take that tone of voice with me."

I had never seem him so angry before. We had been together for nine months and this war was our first argument.

"I don't see what the big deal is," he said with that cute little pout that first attracted me to him. "I mean, it's just Sunday Mass."

"You told me you weren't religious."

"But, it's a gay church, the Church of the Beloved Disciple."

"I don't have time to just sit around and be called a sinner by some holier-than-thou mama's boy."

"It's not like that. The priest is gay, and he's young, and he's ... "

"Oh, I see," he answered. "You have the hots for him."

"No, that's not it. I just thought that maybe it was time we sort of got serious about ourselves."

"Serious?"

"You know, maybe get married."

I had been Bobby's first and only live-in lover. He wanted more than I could give him.

"I don't think so, " I said, turned and walked out. I didn't come back for a week.

Bobby was gone ... but that was for the best because I had brought home David. No, not David. He was the one in France, or Germany.

I can't remember anymore.

I thought I loved Bobby, but ...

What's happening?

Damn this disease. I'm losing it all!

What good is living forever, if you have to live like this?

All of the faces are interchangeable.

There has to be more than this.

"I've got to go, Percy. Max will look in on you after the doctor leaves."

No, Giles, don't leave me, too.

I don't want to forget you.

I want to die!

The room seemed to get brighter. I heard someone's footsteps approaching the bed. It must be the doctor.

Please put me out of my misery.

I couldn't believe it. The doctor was beautiful, full of vigor and health. I didn't even notice that for the first time in four years, I could see.

I recognized him.

He said, "Perceval, it's been a long time. Remember me. I'm Grail. Come home."

I smiled, and felt myself leaving to join Galahad and Bors.

"Shit. Giles leaves, and his favorite old codger dies. Why do I have to be the one to tell him ... "

Shayna Maidel
Laura Antoniou

Kiva sighed as she took the freedom rings from around her throat and hung them from the hook on the back of the closet door.

"It's not going to be that bad," Shari consoled from across the room. "It's only for a few days. And really, I've wanted to meet your family anyway."

"As my roommate," Kiva groused.

"As your special friend. When you're ready to come out, I'll be ready too." Shari was as patient as ever, her dark, sapphire eyes showing nothing but acceptance, security, and love. It never took long for those eyes to make Kiva smile, and she eventually did, her lips tight in a sharp grin.

"Well, wait until you experience the High Holy Days at Temple Hillel," Kiva teased. "Every stereotype of Jewish culture, right there in front of you, and half of them coming from my relatives. Women in fur coats, trying to make matches while comparing the cost of cars, weddings, and jewelry."

"I just wish I could bring my *talis*."

"Me too, baby. But I don't think Rabbi Feldman will be very up on women in *tallit*. And I don't expect he'll have some

Things Invisible to See

interesting interpretation on the *vidui*, and I don't think we'll be hearing a woman sing the *Kol Nidre*, either."

Their regular synagogue was a very liberal congregation, with a heavy gay and lesbian membership. Shari, since her conversion, was a much better Jew then Kiva when it came to observing the customs. Yet, because of Shari's fervor, Kiva had rediscovered the beauty and serenity of the Sabbath, and the comfort of the seasons and their celebrations. Time could easily get to be abstract without those reliable markers.

"We'll make do, sweetie," Shari said. "*Bubeleh*." She giggled.

"Don't start with me," Kiva warned. With another long suffering sigh, she pulled a dark skirt out of the closet and began to fold it. "Just don't start. I'll sic my mama on you, and she'll have you married and pregnant before *Sukkot*."

"Oh! *Kayn aynhoreh* on that!" In a fit of giggles, Shari almost fell off the bed. When she recovered, she noticed that Kiva hadn't joined in or offered a pithy comment. Instead, the darker woman was holding an old gray wool shawl, embroidered with fine stitching and worn around the edges. She had it bunched up under her nose, breathing in the scent of old perfume and smoke and piety.

"I wish you could have met her," Kiva said, breaking the silence.

"I wish I had."

Kiva folded the shawl carefully and put it in her suitcase. Maybe this year, she would wear it in front of the rest of the family, and solve the mystery of what Baba Chanah had done with it before she died.

But then, maybe she wouldn't. Kiva drew in more barren air and compressed her body to expel it, falling into the rhythm as she continued to pack. She was a little out of practice. Baba Chanah had told her not to allow these things to fall away, but it was so easy to forget. Especially when she had the headache

142

of a family reunion after all these years. And during the Days of Awe, of course. The fast was going to make her very touchy. All this, she had explained to Shari months ago, but Shari was firm. It was time for Kiva to go home, even for a visit, and time that she met the family. It was only fair—Kiva got to meet Shari's parents last year, during Christmas, when they had to deal with both their daughter's conversion and her new lover.

But fair doesn't mean bubkes when you have a family like mine, Kiva thought. And without Chanahleh there to smooth things over. . .

There were definitely times when lacking the ability to cry was a blessing.

"I've come to tell you a story, Akivaleh," Baba Chanah said as she slipped into Kiva's bedroom. Kiva pulled her head off the pillow and smirked.

"Baba, I'm eighteen years old. Don't you think that's a little grown up for bedtime stories? And what are you doing up so late?"

"You don't think an old woman like me hears things, like young women sneaking into the house at three in the morning?" Baba Chanah humphed in her elegant, knowing way and sat down on the edge of the bed.

Unlike her sisters, she had not grown rounded in her age, staying slender and almost a little bit fragile, her pale skin tight over her long fingered hands. She was always a small woman, but strong, and when the sisters gathered in family emergencies, it was always Chanah who was consulted and heeded. Kiva's mother had once told her that Chanah had always taken care of the entire family, men or no, and always would.

"I'm sorry I woke you," Kiva said immediately. She meant it.

"Tcha, tcha, I don't need all this sleep. I need to tell you a

story. Now, will you be quite and listen to your old Baba, or talk, talk, all night?"

Kiva sat up and drew her legs under her. If Baba Chanah wanted to tell her something this much, it must be important. She looked into the older woman's sharp eyes and wondered if Baba Chanah felt she was going to die. She was never ill, never weak. But she was much older then she looked . . . Kiva bit her lip to hold back the wave of pain that swept through her and took Chanah's hand.

"Is it about the family?" she asked. "Is it about you?"

"Yes, of course!" Chanah patted Kiva's hand reassuringly. "It's time you were told about Michal."

"And this couldn't wait until morning?"

"Tcha! It's morning enough! Now listen:

Back in the old country, under the Tsars, our family lived in a village where nothing stands now, in a place where people do not remember that a Jew was ever there. And Michal, the girl with the strong name and a temper to match, was the oldest daughter of Akiva, for whom you were named, and who was the finest weaver for miles and miles.

"You never say anything about the men, Baba Chanah."

"Ah, men. They tell their own tales. These tales are ours, Akivaleh. Now, listen!"

As I was saying; Michal was the eldest of three daughters and two sons. There are men for you, all right? And this was back in the days where we Jews lived only by the whim of the Tsar—one day, we are valuable, and the next we are nothing. There might be peace for a year, for three, or five, but then the Cossacks would stir up the filthy peasants who hated us and they would burn and steal and drive us away from our homes. They would cut down men in the street and take the young

girls and do as they wished to them. They burned down our synagogues and spat upon the learned men and the Torah. And there was nothing to do, no place to go! There was no police precinct to complain to, because the police were the peasants, ready to take what was ours. We had no, no—civil rights?—not like here in *goldeneh medina*.

For many years, my mother's village was quiet. A little beating here, a little fire there, some ruffians breaking windows and stealing chickens, that was all.

Now, also from this village was a loose woman, a *kurveh* —

"Baba Chanah!"

"Well, she was! You're not a child, you can hear such talk."

"Mama would die if she heard you say that!"

"Your Mama, dear heart, should be so lucky that she gets a story like this one from me. Are you going to listen now?"

"Yes, Baba."

—this woman who had a reputation, nu? But more then that, she had a profession, and she didn't come to the synagogue, and no one spoke to her. Except for Michal, who had been her friend in their childhood and never forgot that, even when this woman turned her back on our ways and went to ply her trade among the *goyim*. And not a few of our men as well, I might add! But they never talk about that, only that she was shtupping the *goyim* for rubles. Never mind the giggles, Akivaleh, just listen!

It happens that one day, Michal goes into the fields to the secret place where she meets her old friend, and instead of gossip and young women's thoughts and dreams, they share terrible news. This outcast, this woman, had heard (don't ask how) that men were coming to this village, soon, tomorrow maybe! They were going to do this pogrom, do you know what that was? Of course you do, you're a good girl, a good scholar.

145

They were going to burn the village and chase all the Jews out, maybe even kill them.

And now, Michal knew. But there she was, with her younger brothers and sisters, her mama, and the whole village to think of, what could she do? She was only a girl. If she warned them, they would not defend themselves—there were no shops to go buy guns, and our people, sadly, were not great fighters in those days. Chachemin, yes, but Lions of Judea, no. They could only run away, and hide, and hope that the troubles would be over soon.

Michal did what she thought was right; she ran home as quickly as her legs could carry her, through the fields and down the roads, and to all she passed, she cried, "The Cossacks are coming! The Cossacks—

"What, what's so funny? This is a serious story I'm telling!"

"I'm sorry, Baba. Please, go on."

And the word spread through the town. Many people put their candlesticks and holy items under boards in the floors of stables and in their houses. They hid their valuables—what little they had—and they sent many of their daughters on wagons to another town to the east, where there was no trouble that day. But Michal's mama would not separate her family—together they would stay, until the troubles were over. Carefully, they took up their shawls and the smaller children, and some milk and bread and cholent in an old iron pot, and they went off into the woods, where no one knew the trails. Akiva (for whom you are named) was a wise woman to do this, but foolish as well. They left the morning of the pogrom, and slipped into the trees and vanished, a family together.

When the animals came the following day, they did the things they are known to do, and worse. They smashed

windows and they smashed people. They carried off furniture and books and chickens and children, the girls for—hurting—and the boys to go into the army. And they burned down not only the synagogue, but the three shops and the mill and the spinning house where all the women of the village went. And when they discovered that many people were missing, they became enraged and set out into the fields and onto the roads, and yes, into the forest, to look for them.

They did not like being outsmarted, these Cossacks and their peasant slaves. Now, they wanted to kill as many Jews as possible, to teach them a lesson.

Deep in the woods, as dusk fell and no one from the village came to look for them, Akiva became worried and sent Michal back along their trail to try and find out what had happened. Michal didn't have to search long to realize that the woods were full of drunken peasants looking for the escaped Jews! She hurried back to her mother and her brothers and sisters, and took two children up in her arms. Leading the way, she brought them further and further into the woods, never losing the sounds of these terrible men coming after them. It was a nightmare, one shadow on another, strange cries and noises, and so many kinder to look after. Soon, they all became tired, and Michal had them take shelter near a stream. As they drank their fill, Michal looked at her mama and said, "I must go and get help."

Akiva didn't argue, only kissed her daughter and sent her on her way. You might ask, what help was there? As I said, there was no police, no FBI, no men to come save them. And this Michal knew also, yet she thought that there was one chance.

Through the woods she went, now to the north, now to the east, now to the west—each way, she looked and listened, and kept moving—always ahead of the searching men, always watching that some drunken momzer doesn't come and catch her.

And then suddenly, she sees a clearing. And in that clearing is a house, built in the old way, with logs and straw on the roof, and round windows without glass. There is no path leading to the heavy door, because that house doesn't sit still for much time in one place. But there were three large rocks by the door, because the house didn't sit on the ground. No, on both sides of the house were big, fat legs. The legs of a chicken!

"You like laughing at old women?"

"Baba! You're mixing Russian folktales with Yiddish ones!"

"Tcha! This is a story in Russia, yes? And she is being chased by Russians, right?"

"You didn't tell me this was a fairy tale."

"Because it is not a fairy tale, Miss Smart Mouth. Are you going to listen or not?"

"All right, Baba Chanah. So, she meets Baba Yaga."

No, not Baba Yaga, as though there is only one. One of the Baba Yagas, perhaps a young one, perhaps an old one. To her eyes, as she climbed the stones and reached for the door and it opened by itself, to her eyes, Baba Yaga is a *baba*, a little grandmother of a woman, with bad teeth, and round black eyes like saucers and hair like a bird's nest. Baba Yaga reached out for Michal with one huge hand like a shovel and brings her into the hut on chicken legs and sits her down by the fire and gives her a nice cup of tea from a kettle that sings old Volga songs. Michal takes the tea and sees that her chair is made of bones, but she drinks the tea and said, 'Hello, Grandmother. Peace be unto you.'

You see, even being chased by those *momzerim*, she was still polite.

And Baba Yaga laughed in the way of old women, and sat down in a chair piled high with the skins of unclean beasts and picked her crooked teeth and nodded. 'Greetings, child of the

Chosen People. I have never received a visit from your folk before!'

'And I have never met one of your folk before,' said Michal.

'What is it you wish, Daughter of Sorrows? A charm to win the heart of the Rabbi's son? A potion to rid a woman of an ill-gotten babe? A cow that gives golden milk, or the horn of Cheslav the Wicked, which brings the dead back to life once during a battle and once during a wedding?'

Now Michal shuddered to hear of such things, because she was a good girl. She said, 'No, Grandmother, I have no need of such things, thank you. But I am in need of something to save my family.' And she explained about her mother and brothers and sisters hiding in the woods with the Cossacks and the peasants getting nearer.

'My magic can only help one person at a time,' said the old witch, rubbing her bony hands together. 'Tell me what I can give to you so that you might save them instead.'

Michal thought and thought, but couldn't come up with the answer. All she could think of was asking for some great weapon out of the past, but she was a young woman, she knew nothing about any weapon save the Ark of the Covenant, which she would not even mention before this *goyisher* magic woman. And in despair, she cried, 'I wish I had the power—the strength and cunning to protect my mother and all of my family from harm, forever!'

And Baba Yaga laughed again and spun in her chair and cracked her knuckles like gunshots. She sprang up and leaned over Michal, her breath like spoiled meat, and said, 'By your God, I swear that I will give you this power in exchange for a kiss and an oath!'

'I will not swear before God to do anything without knowing what it is,' Michal said wisely.

'You will have the power you seek forever,' promised the

old witch. 'But you must consume what is forbidden to your people in order to do so!'

Michal's stomach turned at the thought of eating pig. (For that was what she thought the old women meant.) But to save her family? Yes, this she would do.

"I swear that I will consume as you direct if this power is true,' she said.

'Then come for your kiss, Daughter of the Book!'

And Michal closed her eyes and leaned forward. But instead of kissing her on the forehead (as her mama did), or on the cheeks (like Russians did) or on the lips (as lovers did), Baba Yaga kissed Michal on the neck.

After that, Michal could hardly remember what happened. She saw herself putting the teacup down and thanking the old woman for her gift. She remembered walking out of the hut and patting one of the fat chicken legs absently as she turned to the south. She knew it was night, but she could see as clear as day. And although she knew that there were still men running through the forest looking for her and her family, she was no longer afraid.

When she came upon one, who was carrying an old sword and a pistol and a bottle, she almost ran away. And as he came to her, unsteady and filthy, grinning like a wolf, she wanted to fall to the ground and cry and shake.

But instead, she waited for him, her entire body full of something, she didn't know what. Not until he touched her did she move.

His neck was broken in a blink of an eye!

Yes, Michal, the daughter of the weaverwoman, had taken a grown man up and broken his neck—snap!—like a dry branch. And instead of letting him fall, she caught him, and pulled him to her, because like Baba Yaga, she wanted to give him a kiss. But not on the forehead, or the cheeks, or the

mouth. Michal kissed him on the throat, and took into her the most forbidden trayf!

"Are you saying that Baba Yaga made Michal into a vampire?"

"Are you going to listen to the rest of the story, or ask questions?"

"Baba Chanah—why do you have to tell me this in the middle of the night?"

"Shush and you'll learn."

Michal was terrified of course. She had heard legends of creatures that drank blood, but they were things of the Christians, the goyim, not of her people. (Well, there's Lilith, but she's a demon, so she doesn't count. Besides, she really wasn't Jewish.) Michal wanted to run away at once and kill herself, but she knew that her family was depending on her. So, she dropped the body of the man who would have raped and killed her, and went in search of her mama.

During that long night, Michal did what she had to do to keep her family safe. And when the dawn came, she roused them and took them back to their village, without explaining what had happened to her or how it was that they were never found. 'It was surely God's will,' she kept saying.

But when they got back to the village, matters had become even worse! For all the Jews were being forced to leave, at once, and they no longer had a house to return to, nor mule nor chickens. They had to join another family as almost beggars, and go onto the road alone in the world, after a night of horror.

"But Baba, the sun was up."

"The sun shouldn't be up in the daytime?"

"But Michal was a vampire! Didn't she have to sleep in a coffin or something?"

"*Gevalt!* Didn't she have enough *tsuris*, without this Dracula nonsense? Obviously, the vampires in Russia are different than the Romanian ones, what can I say? Oh, Michal didn't like it out in the sun, but it was a fashion to wear a shawl in those days, even if you were a pretty, young, unmarried woman, a nice *shayna maidle* like you."

"What about crosses?"

"She was Jewish, Akivaleh, what do crosses have to do with her? That's *goyisher mishegoss.*"

"OK, OK. So, they're on the road, fleeing the village."

That night, Michal slips away, and goes into another part of the woods, off the side of the road. Before long, what with going this way and that way, and this way and that way, she finds her way to the hut with the chicken feet underneath. This time, Baba Yaga is outside, picking mushrooms.

'You must undo this gift,' Michal said right off.

'Oh, but you swore,' the old witch said back, taking a large pink mushroom and munching. 'Have I not given you the power to keep your family safe, forever? And is not the price that you must eat a forbidden thing? Or drink it!"

Michal wanted to say that she was wrong for asking for the gift, but when she thought about how many families back in the village that were missing people, girls and boys gone forever, and she knew that no bargain she made to save her family could be a bad one. She was resigned to live with it—but forever?

'Before Hashem, it would be an *averah* to live more years then Moshe,' she said finally. 'I beg you to limit my life to 119 years only. Surely that will be long enough.'

Baba Yaga considered as she munched and munched. 'Forever is forever, Daughter of the Hebrews, as you well know. But I will give you this; before your 120th year, should you find a daughter of your mother's blood who will accept your

place, you may die a true death and be judged as your God wills. But if you wait for one day past the start of the 120th year, you shall stay as you are forever, and be cut off from your people when your Messiah comes!'

"And if there are no girl children of my blood?"

The old witch cackled. "When there are no daughters, there are no babies! But I will allow this—if there are no girl children to pass this gift on to, then surely it will pass away."

Michal bowed her head. She knew she would get no better then that. And she returned to her family and stayed with them and guided them to safety, eventually, in Poland.

"A lot good that did," Kiva said bitterly. "Think of what you had to do to get the family out of there!"

"Well, I was only doing what Michal told me to do before she died, *alecha ha-shalom*. When I had to became the guardian of the family." And Baba Chanah sighed and patted Kiva's hand. "And now, I'm thinking that 119 years is a long time for a woman to walk the earth. Eighty one was enough for Michal, and I'm thinking that eighty-seven years is long enough for me. And Akivaleh—you are the only daughter of my blood."

Kiva eyed her old aunt with tired skepticism. "Baba — none of this makes any sense, you know. You're only talking about two generations going back to pre-revolution Russia. And you're sixty-seven, not eighty-seven."

"And this is so, *bubeleh*—according to the records in this country. We age slowly, we Sovetski women. Especially the cursed ones." She sighed and patted her niece's hand absently. "I am the only daughter of Michal's youngest sister, Leah. So many died in Poland. I was our protector, but only of those of our blood—so wives, husbands, they were taken—it was our blessing and my curse that we were able to survive, some of us, and come here to be safe again."

"Wait. I'm losing track here. You're not my aunt?"

"I'm your grandmother, Akivaleh."

"Does mama know?"

"Of course she does! What child doesn't know her own mother!"

"But—why lie about it?"

"That was my idea—when Baba Michal finally went to her rest, I thought we could change the records and make it seem like I had no daughters. I could just join my child with her cousins, and say that they were my sisters. Perhaps the curse would end there! But blood tells, and your Mama was supposed to be the one I asked to become our next strong woman. But Akivaleh—you know your Mama, my sweet Leah, my tender Lily. Nice, she is. Bright, oh, she's bright as a button! And very kind, full of charity! But strong? Strong, she's not. So, anyway, here we are. And Akivaleh—you might be the one to end this forever! We don't need guardians anymore, in this new country. We have a nice family—all boys! And, honestly, I don't think you're planning on having any babies, are you?"

"Baba Chanah!" Kiva blushed and then rapidly paled. "What—what do you mean?"

"I mean that you're a nice young woman who's not interested in men, nu? And to think I'd be happy that my own grand-daughter is a *faygeleh*! But, that's what you get for having children. In this case, it's a blessing from God, I'm sure. You'll be the guardian, and when your time runs out, the bargain with Baba Yaga will be over, and we will be free." She brushed her hands briskly together in her "That was easy!" gesture and smiled.

Kiva lowered her gaze at her newly discovered grandmother and chewed her lip. "So, you're a vampire."

"Yes!"

"And you want to make me one, because you think I'm a lesbian. And when I do become a vampire, you can die. After

that, I'll live until I'm 120 years old and then, because there won't be any more women of your blood in the family, I'll die."

"Yes!"

"Baba Chanah," Kiva said softly, "have you ever heard of Prozac?

It was a long night for both of them.

"Kiva! Kiva, sweetie, over here! There's my baby!"

Kiva sighed and shifted the garment carrier on her shoulder. She pointed at the waving figure covered in fur and mouthed the word "Mom" to Shari.

"I guessed," Shari said, smiling. They nodded and waved as they made their way through the checkpoint and toward the baggage claim area where the excited woman and two beaming men stood waiting.

"Kiva, Kiva, look at you! My little bubeleh, so thin, so pale! Look at her, Henry, she's thin as a stick! Are you starving in your fancy schmancy condo in Chicago?" Lily Birnbaum held her daughter at arm's length and then drew her in for a flurry of kisses. "Oh, it's so good to see you, my baby, my poor skinny baby!"

"It's a co-op, ma," Kiva sighed. "Ma—Ma, it's OK, I'm fine!" She laughed and kissed her mother gently on the cheek. "You know, I'm not alone—this is Shari, my roommate."

Shari darted forward and shook hands with Lily. "It's great to meet you, Mrs. Birnbaum. Kiva's told me all sorts of things about you."

"It's good to meet you too, Shari, welcome to New York. Well, come on, let's get these poor girls someplace warm— Kiva, you're as cold as ice! I've got some nice chicken soup for you—your favorite, with the noodles, just like when you were little! Did she tell you how she made us always put the noodles

in the soup instead of matzah, Shari! Oh, how she liked her noodles!"

Meeting the men was a brief clutch of hands, and the girls were swept into the car and onto the roads in a flurry of nostalgia. During the ride, Kiva smiled and clutched Shari's hand carefully, and tried to remember to breathe.

"You didn't tell me about the noodles," Shari whispered accusingly.

The house was full, not only of people, but of scents, rich, heavy scents of long-simmered soup, pungent aromas that made your mouth water, like the garlic-touched drizzle that spoke of fat, green pickles, aged in barrels. In preparation for the fast, lunch was catered from the local corner deli. In addition to Lily's soup, there were hills of burgundy colored corned beef, peppery pastrami, pale roast turkey, slow cooked brisket. And the hills led up to a veritable mountain of potato salad and cole slaw, and were surrounded by islands of potato and kasha knishes. Tributaries of sour and half sour pickles led you to bowls of pickled tomatoes, stuffed derma, kasha salad with bow-tie noodles, and then finally to a lake of chopped liver, wide and deep enough for the skewered herring—not the cream sauce one, but one rich with marinated onions—to swim in, if they were in any shape to swim.

Men were everywhere. Shari was introduced to Uncle-this, and Uncle-that, and this cousin and that cousin. She had always understood that Kiva was the only girl in her generation, but never really though of how isolating that could be. Wives were present, yes, and even one girlfriend for one of the younger boys. But no sisters, other then the three who led this clan. No girl cousins. When she did spot another 20-something girl, chatting at the other end of the room, she asked who that was.

"My Uncle Mike married a divorced woman after his divorce," Kiva explained, politely turning down an offer of a taste of chopped liver, nicely spread for her on a cracker. "That's Trudy, her daughter by her first marriage. No blood there. Unfortunately for Mike, no Jew, either. Trudy was baptized, and although Aunt Eileen did convert to marry Mike, Trudy hasn't yet. Gee, let's move away from the food again, OK?"

They had discussed the fast before. Last year, the day long fast for the atonement of the sins of the Jewish people was meaningless to Kiva, who didn't eat much anyway. Oh, she could, if she wanted to—put some mass in her mouth, chew and swallow it. But it was rarely worth the cramps as her body tried to figure out what to do with this foreign matter. It also wasn't very palatable any more, no matter how she used to love it. No, in order for the fast to be meaningful, she had to abstain from what really served as her diet for at least a week.

Now the only trick was to hide this special fast from the rest of her family for the two days before Yom Kippur.

"Eat, *bubeleh*, eat!" That was Aunt Sarah, now known to Kiva as not her mother's sister, but her cousin.

"I had some in the kitchen," Kiva gamely lied, patting her flat stomach. It had been like this for hours. She eyed Shari with a different kind of hunger, and the two women surreptitiously touched. Shari's warmth, her vitality, her sheer force of life made Kiva hunger in ways that her body could not process. From this desire too, she was abstaining. It was a vacant hope against hopes that some sacrifice would serve to open the proper gates this time. She sighed and turned down an offer of some more chopped liver.

"Your roommate, she's not seeing anyone, not engaged?" Sarah whispered, passing the liver off to someone else. "Two nice girls like you! Listen, you go to temple, I'll introduce you to my friend Paula's son, Harry, he's a graduate of Yale! I'm sure one of you will get lucky!"

* * *

That night, Shari slipped into Kiva's bed, Kiva hearing every move as her lover eased back the sheets and tiptoed across the room. They were sharing the guest room, the one with one single bed and a folding cot that smelled of mothballs. They had considered moving them together, but decided not to tempt fate.

"I miss you," Shari whispered unnecessarily as Kiva gathered her into an embrace. "Maybe you were right, this is too hard. I'm so sorry, sweetheart, I didn't realize there'd be so many people here—and that we'd never get any chance to be alone—"

"Shhh, it's OK," Kiva consoled, letting her lips touch Shari's forehead. "It's almost over. Tomorrow starts the fast, and we'll be heading home right after it's over." They touched, slowly, their hands exploring, cool and warm, soft and hard, until Shari moaned and broke away.

"This is the hardest for me," she said, turning away. "I want you so much it hurts."

Kiva smiled her thin smile and touched Shari's back with one cool finger. "*Aishet kayyil. . .*" she murmured. A woman of valor ...

"... I have found. Her worth is far beyond that of rubies," Shari responded automatically. She turned halfway to kiss that finger, went back to her cot. Finally, the two women rested, each in her own way.

It was still daylight when they entered the temple, surrounded by well-dressed men and women, some of the men carrying decorated *tallis* bags, others looking vaguely lost. In her white blouse, with Baba Chana's shawl around her shoulders, Kiva

looked more pale than ever, and Lily had agonized over it all through the ride and into the actual temple.

"You shouldn't fast when you're sick," she lectured, eyes whipping back and forth to greet friends and rarely seen acquaintants. "The rabbi said so, last year."

"I'm fine," Kiva insisted. In fact, she did feel a little weak. But that was the point, wasn't it? The daylight shining through the windows gave her a pounding headache—she practically had to let Shari lead her to a seat and settle her. She tried to ignore the steady stream of humanity that passed her by, their pulsating heat, the rich scent of their bodies, the sound of their heartbeats echoing against the walls. When she saw the ushers herding people to their seats and the white-clad cantors ascend the bima, she almost felt like signing. It took a while to figure out how to do it, though, so she passed.

It was so familiar, not only to her, but to the memories bound by blood which lived inside of her. The relief that the Days of Awe were almost about to close, the anxieties of communal sin about to be washed away by communal repentance—all the burdens of humanity against humanity examined and stripped and held up for judgment. And now, on this holy of holies, the burden of humanity's crimes against the Ineffable. Not so much crimes of blasphemy and law breaking—but that of the making of vows which should not have been made.

The shortest cantor was the one with the biggest voice. As he pulled his pristine kittle in place around his rotund body, the entire congregation stirred and then stilled.

"Kol Nidre!" he sang, his voice quavering in that beautiful, haunting melody which compelled silence and attention. He was surrounded by two other men, holding Torahs, for this was not a prayer as much as it was a legal statement.

Shari had learned that much in her religious studies. The Kol Nidre asked that forgiveness be granted for vows made and

not fulfilled, and that any vow made falsely or under duress will be considered null and void. These vows could not have been made specifically to other people—they had to be vows before or to God. There were all sorts of theories about where the *Kol Nidre* came from, and why it was part of the ceremonies of Yom Kippur, but it had occurred to Shari that it might have real meaning for Kiva.

"Who knows?" she had said, urging consideration of her idea. "At worst, you'll be hungry for a while. At best ..."

Kiva didn't think about what might happen for the best. She cleared her mind and allowed the words of the *Kol Nidre* to penetrate her, fill her, and as it was repeated two more times, she swayed with its passionate rhythm and resonance. Slowly, the sun began to set and the evening services continued, just a hint about the marathon of prayers and reflection which would come the next day.

The afternoon sun was merciless as the millionth repetition of the al chet had Kiva staggering to her feet and beating her chest with genuine anguish. This list of community sins, cried out in the plural, as the entire congregation confessed to them, was a central part of the Yom Kippur daytime services. It was even repeated within the solitary prayers. She dimly realized that many members of her family were shocked, not only by her appearance, but by this apparent religious fervor. To Lily, religion was fine, a good thing to have—but not in abundance. Luckily, Shari situated herself between them and Kiva, and made it difficult for any of them to reach over and ask what was going on.

Shari gives me strength, Kiva thought, sinking back down into her seat. I need her so much! She glanced at the swelling body of the woman in the row in front of them, and then reeled back a little and closed her eyes. The pulsing heat of her,

the hypnotizing scent, it was worse than being tempted with food. Food didn't fulfill your soul—food didn't give you the purity of oneness, that moment when a heartbeat becomes yours.

Just a few more hours, she thought, clenching her fists tightly. Then, I'll slip away and . . . or maybe not! Maybe this will end it all—the gates of heaven will open, and this injustice will be over! God will see that a deal made by a frightened girl with a crazy old witch should never have gone this far!

A tiny part of her mind stubbornly avoided the issue of what kind of God would allow this sort of thing to happen to begin with.

The service droned on, through the story of Jonah, through still more recitations of the al chet, and then, finally, the late afternoon saw the part of the ceremony called Ne'ilah, the Closing, representing the closing of heaven's gates, open for only so long.

Souls gathered in that temple, earnest prayers of release and relief, mingled with mumbled echoes of bad Hebrew tinged with annoying hunger pangs, thirst, and caffeine and nicotine withdrawal symptoms.

Kiva's withdrawal was making her itchy—her mouth and stomach ached, her head pounded. She needed to get out, and soon. But still, she prayed and sent her prayers into the setting of the sun, toward those gates which could surely send her case directly to the Creator, the Originator, to her Shekinah, the female essence of God. Hear me! she begged, not even realizing that she had fallen back into her seat.

When she felt Shari's hand on her shoulder, she started and almost leapt up. "Come on, honey, everyone's outside!"

Kiva licked her tongue across the top edges of her mouth and this time did execute a perfect sigh. Her lips were cracked,

and there was a unique, sharp agony buried deep in her jaw that tingled and pounded at the same time. Shari was looking at her with compassion, guilt and worry written all over her face. "It's time to go," she said softy. There was nothing else to say.

Kiva got to her feet and stretched. Food or no, it was night, and she was stronger at night. Carefully, she made her way down the stairs, into the back seat of her mother's Buick, where she waved off the panicked suggestions that she needed medical attention.

"Food!" Lily declared, throwing the car into gear. "She needs some nice, hot food! Chicken soup, with noodles, we have some at home in the fridge."

The very thought made Kiva's stomach lurch—or, what passed for such a reaction these days. The heavy, cloying smell of chicken fat, the pale golden color, the thin liquid, the high temperature—she closed her eyes and gripped Shari's hand, wrapping her fingers in icicles. Time was running out. If she didn't find a way to get out of the house, she would start losing it. That much she knew—her limitations had made themselves clear many times before. On two occasions, it was Shari who had saved her—Shari, with her beautiful, unselfish, unwavering love, Shari, who held her up and never, ever doubted or condemned her—Shari, whose pulse seemed so loud, drowning out the engine, the wind, the sounds of Kiva's aching soul.

Past the front door, she burst upstairs, Shari in close pursuit. Shari's "We'll be down soon!" echoed like jackhammers in her ears, and the startled cries and tsks of the relations were like the retorts of gunshots. Once in the room, checking the window, no, the fall wouldn't be that bad, she could hit the ground running. What a damn shame old Michal hadn't bargained better; the ability to become a bat or a wolf would be nice at moments like this. She threw the window

open and groaned as her body shuddered in a great spasm of hunger/hurt.

Instantly, Shari's arms were around her. "Don't, don't," Shari murmured, her heat wrapped around Kiva from behind. "Lover, love, stay, don't leave me. God, I want you so much, Akiva ..." Little kisses, sweet as a Rosh Hashanah apple, dripping with the honey of her tongue—Kiva turned in the embrace and wrapped her arms around her lover, unable to resist.

Their hands were everywhere at once, sweeping over their backs, curling over arms, twisting in hair. Their skirts rode against each other, and slid up, as their thighs crushed together, their bodies melded. Always like this after a period of abstinence, but worse now, because Kiva was lost in hunger, lost in the bitterness of a bargain left intact, a price so heavy it couldn't be spoken of.

"I can't do this to you again," she whispered, groaning, into Shari's ear. She nibbled on that earlobe, sucking it, a tease that made her teeth ache. Even as she spoke, she felt the shift in her mouth, and the preparation of her body to receive what would sustain her. "Three times, isn't that what they say? Let me go, I can't—I can't—"

"I'm not afraid," Shari whispered back. "I want you, now I want you in me, lover, I want all of you." She pressed her own short, grinding teeth against Kiva's throat, and Kiva shuddered and whimpered in sympathetic agony. The sweeping power of her body's response made her growl, and forced the final change, that inner—click—that told her she was ready to feed. She grasped Shari's hair in one hand and swept the other fingers across her chest, tearing pearl buttons open, revealing Shari's beautiful breasts, nipples taut with excitement.

"I love you," Kiva growled. And she bent forward, scent and heat and need driving her, until she could feel the touch of needle to flesh, feel the sweet heaviness of the impression, taste

the heaviness of the skin's own sheen—and then the door opened.

"Kivaleh! What is going on in here? You don't answer— *Gevalt!*" Lily Birnbaum stood in the doorway, still clutching a mug of her bracing chicken soup, her mouth open, and her eyes sharp. Next to her was Aunt Sarah, and then behind her was Aunt Reba. The triptych of their astonishment might have been amusing had it been caught at that moment and gone no further.

Kiva and Shari, caught in the act, stared back at the three old women at the door. They were still entangled, their skirts hiked up past their thighs, Shari's blouse gaping open, Kiva's rumpled and loose. And worse—far worse for Kiva, who swayed as she realized what was on her lips, she had done more than tease Shari's flesh—a little trickle from one successful puncture was stark against the white of her throat and her blouse. A drop—a single, cursed drop!—was shooting through her mouth, screaming for company.

"Close the door!" Lily snapped, stepping in. Still, her grip on the mug was unwavering—not for nothing had she managed Passover Seders and High Holy Day meals for over thirty years! Her "sisters" stepped in as well, and were busy shaking their heads in amazement.

"And just what is going on here?" Lily demanded, her voice just hitting the lower range of her scale.

Shari grabbed the sides of her blouse and shrieked as she realized that her throat was a bit messy. She turned away, blushing and shoving her skirt down over her upper thighs again. Kiva drew herself up, hard to do when she was so dizzy and one of her shoes had fallen off. The pounding of her hunger and the pain from her disappointment had made her bold. How dare her not-strong-enough mother barge in on them like this? And why did she care what this ungrateful family thought about her anyway? To hell with being the

guardian, to hell with it all! She had been about to have amazingly tasty sex with the woman she loved more than she had loved life, and she couldn't even do that!

"I'm a vampire, mom!" she shouted, baring her still extended—and now truly agonizingly hurting teeth. "Just like Baba Chanah was, and Michal before her! To save this stupid family from the Russians, from the Nazis, from those pathetic skinhead creeps that attacked cousin Nate when he was a kid! That's right, a stick my teeth in someone's neck and drink their blood vampire! And you're driving me crazy with your 'eat this, drink that, you're so skinny and pale'—dammit, I'm undead! We're not supposed to look like the very picture of health!"

Aunt Sarah made tsking sounds as she shook her head. "So, that's what Chanah did!"

Aunt Reba nodded. "That old fool, *alecha ha-shalom*. She couldn't tell us? What did she think we'd do, tell the world?"

"Always with the mysteries," agreed Sarah with a sigh.

Shari turned back, her breasts recontained and the trickle now smudged into a pinkish smear on her neck. She looked at an equally confused Kiva and then back at the three women at the door. "You—knew?"

"Of course we knew, what are we, idiots? Children? You think we don't know what's what in our own houses?" Lily asked indignantly. "Am I some stupid yutz who doesn't even know what her mama is doing? Apparently so, because here I don't know what my own daughter is doing! Akiva, why did you do such a thing to this nice girl, your roommate? Don't you know, this is only for *mamzers*, the scum outside? What did mama tell you, nothing at all? What a way to treat such a *shayna maidle*, and to do this on a Holy Day, besides!"

"I'm not—but mom—" Kiva stumbled over her words and sat down, missing the bed entirely and sliding to the floor.

She looked up at Shari for help, advice, anything, and Shari pressed her lips together and nodded.

"Kiva wasn't hurting me, Mrs. Birnbaum," she said carefully. "I wanted her to, um, do what she was doing. I've done it before. You see, we're more than good friends—we're lovers. I don't mind when Kiva takes a little blood from me— she can have it all, if she wants." She looked down at her befuddled and starving lover fondly and then back at the relatives. "I love your daughter, Mrs. Birnbaum."

"Lesbians?" Lily's fingers loosened, and all that good soup spilled over the worn shag carpeting, the cup bouncing harmlessly aside. "You're a *faygeleh?*" Her voice scaled up two more octaves, and the sisters behind her began 'tsk-ing' again. "I don't believe it—go raise children! This is how they treat you—they run off and become homosexual!" She threw her hands up for good dramatic effect and shook them accusingly at the sky. "Curses aren't enough, you have to do this? Go raise children!"

With that mighty wish aimed at the Almighty, Lily Birnbaum stalked to the door and threw it open. "So, be a lesbian! If that's what you want! Don't give a thought to your mama, who loves you! I'll just go back and cook some more now, don't pay any mind to me!"

"She knows about—?' Kiva waved her hand limply over her mouth. "She knows?"

"She'll get over it, this lesbian thing," Sarah counseled, picking up the mug. "Oy, what a mess. One of you girls will clean this up, OK? It's OK to call you girls, right? Of course right. Just don't go marching with those drag-boys, yes? You stay at home and just keep out of trouble. And don't worry about the family. You come down later, when—you're feeling better."

The two young women nodded, in shock, and Sarah took

a breath to start advising them some more, but caught an elbow from her sister.

"Don't talk, go," Reba snapped, pushing Sarah out the door. "Lesbians!" the girls could hear her say, as the door swung. "And such nice girls, too!"

Absent Friends
Martha Soukup

It was a mistake getting the tree. Douglas's hands were scraped and sore, and his joints ached from spending too much time wrestling with the thing in the damp, steady wind. Ten minutes just to get it up the stairs to his second-floor apartment.

Ah, well, but an Iowa winter would surely kill him. That, or his parents' cutting concern. Better to take his chances with San Francisco, and loneliness, and Mrs. Aguilar downstairs.

On cue, she started with the broomstick, banging it on her ceiling. Bang, bang. Bang, bang. Douglas had expected it. He had provoked her by dragging a heavy Christmas tree up past her door at nine at night. He had provoked her with the noise of his grunts as he wrestled it up the stairs, and with the scattered pine needles he was too exhausted to sweep off the stairs. He always provoked her, with his friends, his hours, his clothes, his inability to understand Spanish, his pallor and thinness. His existence.

The first hadn't troubled her for some time, and the last shouldn't trouble her much longer.

He sat very still, waiting. If she didn't use the broomstick for more than a few seconds, she usually didn't go on to call

the cops. The tree lay on its side across from his worn sofa, filling a third of the space in his living room. Bedroom. Room. He couldn't put it up tonight, or she would call the cops. By tomorrow it would be half-dead. "Sorry," he told it.

The tree was silent. It was a good neighbor.

Douglas risked getting up and going to the kitchen for a hit of oxygen. He walked carefully in stocking feet, but he could hear the floor creak. Damn. He put the mask over his nose and mouth, turned the valve, took a few deep breaths. He felt a little less dizzy. Had he eaten today? His volunteer would be pissed at him if he hadn't made a dent in his larder next time she came by. Tough love, that's what she was into. Douglas had liked his previous volunteer better, but Ray had got sick, and had to quit. Maybe now Douglas's new volunteer was visiting Ray's house, too. Douglas didn't want to call him. He might call and find out—he might get bad news.

He couldn't put up the tree now, and he couldn't fall asleep for hours, probably not before three or four. He took a jar of crunchy peanut butter and a half-full bag of pretzel sticks and went back into the main room, pushing his feet along without lifting them. The floor creaked.

"Damn it!" Douglas said. He was just sure tonight she'd call the cops.

It was Christmas Eve.

The cops were always nice; they always seemed to guess about his illness; they always left again after talking to Mrs. Aguilar for a time and him for a time, not saying they thought she was crazy, but showing it in their eyes. And pity for him. But it was embarrassing, it rattled him, and he had enough trouble sleeping at night. She'd call tonight, of course she would, because it was just his damn luck.

Don't think about it. He'd worry himself sick. Couldn't afford to. Wouldn't. He sat and unscrewed the jar, the lid rasping hollowly, and jammed a pretzel stick in the peanut

butter. The pretzel, when he bit into it, was stale. He'd left the bag open. His feeble excuse for an appetite left him, but he finished the pretzel. There, Margaret, I've eaten, are you happy? he thought. There's half an ounce less I'll have lost at my next checkup.

Oh, hell, even Margaret with all her stubborn volunteer concern wouldn't be thinking about him tonight, wrapped in the bosom of her family in Christmas bliss.

Fine. Enough. He leaned forward in his unfolded futon sofabed, one of two pieces of furniture in this room, to the coffee table. He felt a little dizzy as he reached for the lower shelf. The scent of dying pine in the room was too strong. He grasped for his photo album, found it, and opened it in his lap.

There was a file label stuck to the first page: "Christmas— 1958-1981." The page was empty. The next ten pages were empty, front and back. The film over each page showed marks where it had once held down snapshots. Douglas could remember a few. There was a picture of him at two in his grandmother's lap; she had died when he was four. There was one of him at twelve with a blue, adult-size bike. One of him at five in a cowboy suit. Now he knew friends of friends who decked out in cowboy paraphernalia every night they went out, but he didn't think his parents would think that cute. It made him think of himself as a little kid at Christmas, playing with his new plastic six-shooters: not his idea of sexy.

Those photos were gone. He'd ripped them up and thrown them out last year, when his sister said she couldn't possibly come visit. She had to worry about her small children, and whatever the doctors said, how could you be sure? And his parents had supported her. So much for Christmases past. They didn't want him now, he didn't need them then.

Past the blank pages was the label "Auld Lang Syne." These pictures were still there. He wasn't related to anyone in them. They were in no good order: faded pictures of grade-school

friends lay side by side with photographs taken only a few years before.

There was Jerry. He was dead. There was Patrick. He was dead. There was Rob. Douglas pursed his lips, considering. He didn't know if Rob was dead. He hadn't seen him in three or four years. Safest to assume he was. There were George and Carlos. Carlos was dead and George had gone home to Mississippi to die. Mississippi had to be a worse place to die than Iowa. Douglas was lucky.

Except he wouldn't go home to Iowa.

"Home? Screw it," Patrick had said. What was it, six years ago? He'd had an enormous party, tinsel and presents and mistletoe, in his flat on Noe, the place that was the envy of most of them, right near the heart of the Castro. Douglas had been living in the Sunset district then. He liked going home to a quiet neighborhood. "This is home and this is family. We can make our own traditions and screw anyone who doesn't want us in theirs." Patrick had had a few.

Who else was at that party? He couldn't remember. That was before any of the gang was sick. A life away. Many lives. All his old Christmases were gone. New Christmases might never come. This could be it. The ultimate, final extent of his Christmas cheer.

Suddenly furious, he threw the album against the wall. Pages came loose and scattered on the floor. Pounding started up beneath his feet.

Douglas sat breathing hard, fists clenched. He wanted to go down and confront the woman. Shout at her. Give her what for. Who was he kidding, though? She could knock him over with one blow, overweight woman of fifty that she was. Pathetic.

There was a rap on the door. Douglas started. Mrs. Aguilar? She preferred to act as though he didn't exist, assaulting his floor or calling the police without ever speaking to him. He

stayed still. The pounding had stopped downstairs. The rapping came again from the door.

She had to have run up the stairs. Did she think yelling at him in Spanish would do any good? Maybe she was going to hit him with that broom.

He got uncomfortably to his feet and went to the door. He would speak slowly and maybe she would understand. "Ma'am," he said, opening the door, "please, it's Christmas Eve."

"Ma'am?" said the man at his door. Douglas blinked at him. "Excuse me, but I think I'm as macho as anyone you know, fella."

"Rob?" Carrying a bottle of burgundy. "You're not dead."

Rob gave him an incredulous look. "Well, thanks, Dougy. You're looking good too. Are you going to let me in?"

Embarrassment fought with old irritation at the unwanted nickname, with nervous relief at seeing an old friend alive, with the knowledge he was not looking good. Douglas gave up on trying to make his mouth work and stepped back from the doorway.

"Hey, a picture show," said Rob. He walked over to the wreckage of the photo album, bootheels clicking on the wooden floor.

"Um," said Douglas. Rob took off his heavy leather jacket and tossed it at the coffee table. It skidded off and thumped on the floor, zippers jingling. "You have to be careful here. About noise."

"Pal," said Rob, "you don't have to tell me what I have to do."

"It's the downstairs neighbor, she's sort of sensitive and she gets upset. She can't sleep. If there's any noise."

"There's traffic and people playing their radios out there, Dougy, she's going to get upset because someone walks on your floor? Not on Christmas Eve, pal. This is a party."

Douglas sat carefully on the futon bed, hoping Rob would follow his lead and stop pacing the floor. "What are you doing here, Rob? Where have you been? It's been years."

Rob shrugged. "Hanging out with people." He circled the room, examining the old posters taped to the walls, glancing at the prostrate tree.

"Not anyone I've been hanging out with."

"The looks of things, you haven't been hanging with anyone, Dougy. Hot parties in clubs all over the city, and you sit at home Christmas Eve. Is the dust half an inch thick in here or is it just your mood rubbing off on everything?"

He went past Douglas into the kitchen. The click of his boots on the linoleum was high and sharp. Douglas winced. Rob came back into the living room with two glasses filled with wine. "Good god, man, you've got no two clean glasses the same. Is this why you never invited any of the gang over to your old place? I always thought it was because you were afraid of what your nice straight neighbors would think."

"Jesus, Rob, did you look me up to insult me?"

"Not me, Doug." Rob's voice softened. "I'm just here to spend Christmas Eve." He handed Douglas a root-beer mug. "Look, some wine for you. A toast."

Douglas's wrists ached, holding up the heavy mug nearly topped off with dark red wine. He raised it silently in both hands and let Rob clink his

juice glass against it.

"To friends," Rob said.

"Absent friends," Douglas said.

"Absent, hell, what good is that?" Rob said. He took a big gulp from the juice glass. "Let's invite 'em over."

"Rob—"

"How long has it been since we all got together? I ain't seen you in ages, just for one."

Didn't he know they were all dead? "Rob, you can't."

"Can and did," Rob said. "Ran into an old high-school buddy of yours. It's what made me think of coming over to start out with, when we found out we knew you in common. He's on his way. Had further to come."

"Who?"

"Billy McElroy." Douglas vaguely remembered a skinny blond kid he thought was Billy. "You know he told me he never knew you were gay? What a missed opportunity."

"What, you mean?"

"You didn't know either?" Rob shook his head. "Typical. Well, here's your big chance. So romantic, reunited across the years—"

Douglas was losing patience. "You never change."

Rob stopped and looked at him. "Not anymore," he said. He looked like he would say something else. "Wait, there's the door." He trotted across the room, his steps echoing like gunshots from the walls. This time maybe it *was* Mrs. Aguilar, and Rob would talk to her and make things so much worse. Douglas drank several long swallows of wine.

"Billy, man, glad you could make it!"

"I wasn't doing anything else. I'm glad to be here. That is, if Doug even remembers who I am—"

"You bet he does. The one that got away. All he can talk about, poor sap. Come in, come in!"

Rob escorted the newcomer inside, arm around his shoulder. Billy looked much as Douglas would have expected him to, thicker around the middle and thinner on the top. A little uncomfortable. He was shy, back in school. Billy shook free of Rob's arm, removed his jacket, and draped it quietly across the coffee table.

"Let me get you a drink, Billy," Rob said. "I'm sure I can find a Flintstone glass or something."

Douglas put his mug down and stood up to shake hands. "Um, hi, Billy. Long time."

"Yeah," said Billy. He looked around, and finally sat awkwardly on the coffee table. "Nice tree."

"I should have picked a smaller one." Douglas shrugged, self-conscious. "It's too big for me."

"Thought you liked 'em that way, Dougy boy!" Rob shouted from the kitchen.

"Are you just going to leave it lying there?" Billy asked.

"I have this downstairs neighbor," he said. "If there's any noise at night she goes ballistic." It sounded stupider every time he explained it. It was better than saying he was too weak and tired to put up a damn Christmas tree, though. He took up his mug and drank half the remaining wine.

"Yeah, okay," said Billy.

"So, um, what have you been doing the last—eighteen years? Jeez, is it eighteen years?"

"I guess it is. Well, I went to college in Illinois. Northwestern. Studied engineering."

"And since then, what, you've been an engineer? What have you been up to?"

"Nothing, really." Billy looked like he didn't want to talk about it. That was all right. Douglas knew very well about not wanting to be pushed.

Rob came back from the kitchen and handed Billy a tall iced-tea glass. "Cheers," he said. He poured more wine into Douglas's mug.

"To friends less absent than before," said Rob. He and Billy clinked glasses and smiled at each other. Douglas wondered just how good friends the two were. "It's too damn quiet in here," Rob said. "Could drive a man crazy. Let's have some music, for god's sake!"

"Wait, Rob, come on—"

"You got any Christmas music?" Rob was squatting down by the short piles of CDs stacked in the corner behind the boombox Douglas used for his stereo. "No, no, no, no—your

taste in music is still boring, pal, by the way—nothing Christmasy here at all. Where's your spirit, Dougy?"

"Gee, I'm sorry, Robby," Douglas said. "I didn't prepare properly for this party. Thoughtless of me."

"You ought to put this tree up," Billy said. He sounded worried. He rustled its branches, examining it. "It's getting dry already. Dying. And it's a fire hazard."

"No problem," said Rob. His bootheels made war on the floor as he went over to where his jacket lay on the floor. He pulled a blank-labeled cassette out of the inside breast pocket. "You wouldn't have seen this. It's the Christmas compilation album I waited all my life for. Sisters of Mercy doing 'Silver Bells'— really, I'm doing you such a favor." Three strides and the cassette was in the boombox. The first bars of "White Christmas" floated glumly across the room. It sounded like Lou Reed. Then it sounded very loudly like Lou Reed, as Rob cranked the volume all the way. "There's Christmas for you!"

"Let's put the tree up, okay?" said Billy. "Really, okay?"

"Dance first," said Rob. He grabbed Billy by the hand and swung him into the small clear space in the middle of the room. The creaking of the floor was just audible over the music booming through the apartment.

"Guys—"

"Okay, it's not the most danceable tune on the album," Rob shouted. "Next one works a lot better. Come on, we don't need to divide by partners for this, Dougy, get off your butt and enjoy yourself a little!"

Billy was dancing with his eyes shut, brow furrowed in concentration, head thrown forward, back. He was completely off the beat. His sneakers thudded more quietly than Rob's boots, but the floor was groaning.

"Great tune, but you really can't dance to it," Rob shouted. "Just a second!" He bent over the boombox. The music shut off as he hit Fast-Forward. Billy's solo shuffling was still loud,

unaccompanied. There was no broomstick against his floor. She must have called the cops. Probably half the cops in the precinct were bearing down on him, pissed at having their Christmas disturbed.

Rob hit Play with a loud click and the boombox screamed with electric guitar. Douglas couldn't recognize the tune over the distortion and the riffs. "All right!" Rob shouted. He leapt into the air and crashed to the floor doing air-guitar. Billy increased his pace to a near-flamenco.

"Stop it!" Nothing changed. Douglas screamed, "*Stop* it!"

Rob stopped. Billy stopped. The music stopped.

"What the hell are you *doing* here? Are you just here to make what's left of my life hell?"

"Not us," said Rob.

"My neighbor hates me, you're going to get the cops called on me, maybe I'll be evicted, this could be my last goddamn Christmas and what are you doing to me?"

"Spending Christmas," Rob said.

"Jesus, don't you see it? I'm dying, you moron. You're spending your goddamn Christmas with a goddamn dead man."

"You?" Rob sounded amused.

"Did you ever hear of rest in peace? Would you get the hell out of here?"

"Everyone isn't here yet."

"You should put the tree up," Billy said. "You've got to trim off the bottom so it doesn't die so soon. I don't think you should wait any more."

"I don't give a damn about the tree. I hurt. I have nausea and I can't breathe right sometimes and you are pissing the hell out of me. Go away. Go away!"

"We have no place else, Douglas," said Rob. "For a so-called dead man you're not so swift on the uptake. You should

at least give everyone else a chance to come by and have Christmas."

Billy went to the door and opened it. "I don't know these guys," he said.

"Jerry," said Rob. "Patrick. Carlos. George here?"

"Not yet," Carlos said. "He's a tough one."

"How are you doing, Douglas?" Jerry asked. The last time Douglas had seen him, he was skeletal, enmeshed in tubing, blotched with K/S. Five years ago. Now Jerry's thick hair was beginning to gray and there were more wrinkles around his eyes. He looked older.

Rob smirked. "Oh, he thinks he's dead already."

"There's a difference, Douglas. Trust me, you can tell," said Jerry.

"Do you have any of that wine?" Patrick asked Rob.

"In the kitchen," Rob said. "Help yourself. I'm turning the music back on." Electric guitar filled the room again, somewhat less deafeningly. Rob hadn't touched the boombox.

"Go away," Douglas said. "You're not real. Leave me alone. All of you." He sat heavily on his futon. It came to him that, beneath the wild improvisation, the tune was "I'll Be Home for Christmas". "Who the hell is playing that?"

"Hendrix," said Rob. He shrugged. "I waited all my life to hear Hendrix do Christmas. Had to wait for your life."

"Never understood why you were so into that guy," Jerry said.

"You're dead? Billy, you're dead?" Billy smiled faintly. "It?"

"Oh, no, that's the part I hate," Billy said. "I was a virgin. Wiped out by a semi truck. I was nineteen. I barely knew who I was yet; I was just figuring myself out. You're a lucky guy, Doug."

"Is that what this delirium is about?" He was furious. "My subconscious telling me where there's life, there's hope? Buck up, take your AZT, tomorrow there's a cure and true love is

around the corner? Well, screw that. Tomorrow I could be in intensive care, and I never found true love, and I don't need a bunch of party animals from beyond the veil telling me pie in the sky!"

"Screw you," said Patrick, coming from the kitchen with a coffee mug of wine. "Who said this is anything about you, Douglas? What about us? Where the hell do we exist except in you? Our loving families? Give me a break. You go gentle, but if you're taking me with you I'm gonna fight, man."

Douglas blinked. His anger had spooled itself out in one burst and now he didn't know what to say.

"Hey," said Carlos. "We're the guests here, guys, be nice. Come on, Douglas, sit back down." His hand on Douglas's arm felt strong and real.

"If this is really your last Christmas, Douglas, how are you gonna spend it?" said Jerry. "Pretending for your neighbor's sake you're already dead?"

"Can we put the tree up?" Billy asked. "Let's put the tree up."

Douglas looked around at all of them. Hendrix faded into Sisters of Mercy. "It's really drying out, isn't it?" he said.

"Yeah, but it'll last a while longer if you get the bottom sawed off. You have a saw?"

"In the kitchen," Douglas said. "Bottom drawer next to the stove." Billy turned to get it. "Hey, Billy?"

"Yeah?"

"If—it happened—when you were nineteen, how come you look like my age?"

"It's 1993, Doug," Billy said. "How old should I get to be? I didn't come here to be nineteen forever."

Douglas nodded. "Right-hand side of the stove."

* * *

Officer Yi sighed as he climbed the stairs of the old Mission district building. He was too damn old to still be working Christmas Eves. His partner, Kelley, behind him, had heard about this building. "This dizzy old woman calls on this poor asshole all the time, Jim," he'd told Yi in the car. "Claims he's, I dunno, bowling with elephants up there. Every one noted as unsubstantiated when the cops got there. One night she called three times. I think she just hates his ass." Better than a domestic dispute, though. You never knew who might wave a gun in your face when you went to one of those.

He knocked loudly on the door. Get it over with and find out what the next call was. Finish the shift, then get about two hours of sleep before his kids woke him so they could tear into their stockings.

"George?" said a voice on the other side of the door. It opened. A very thin man in pajamas stood looking at him. He was pale, though there was color high in his cheeks. Another poor jerk with AIDS, for sure.

The man smiled crookedly and held up a teacup filled with wine. Behind him, in the corner of a small studio room, a scraggly, undecorated Christmas tree tilted at a precarious angle in its stand. A boombox hissed white noise.

"Oh. You're alive." He handed Yi the cup of wine. "Come in and help me get this tree straight, would you?"

Yi looked at his partner. Looney-tunes, Kelley mouthed. Yi smiled. "What the hey, it's Christmas." It seemed like something to do. The three of them went into the apartment to fix the tree.

Still Life With Woman and Apple
Lesléa Newman

You have been wandering around Gal's Gallery for barely an hour, yet museum fatigue has already set in. There is a stiffness about your neck and shoulders. Your feet are dragging as if through mud, and your eyes are glazed over as though you have been up all night watching television. You park yourself on a hard bench in front of a painting: Still Life With Woman and Apple. You stare at the woman sitting on a maroon couch, one arm resting along the back of it, one leg crossed over the other, gazing at an apple on a small white dish in front of her. Just for fun, you decide her name is Lilith.

From the way Lilith is looking at the apple before her, you know she is thinking about sex. Lilith thinks about sex all the time. Sex sex sex sex sex. Lilith thinks sex once a day keeps the doctor away. Lilith greets you on the street by pinching your ass and asking, "Getting any?" when a simple, "Hi, how are you?" would do. Lilith's philosophy is, straight people think we do it all the time, so why disappoint them? Lilith says if they're going to scream insults at us and throw rocks at us and take

away our jobs, our houses, our children, and our lives because of who we have sex with, we better make sure we're having a damn good time to make it all worthwhile.

There's a clock over Lilith's head. Both hands have stopped at the twelve. It is always midnight in Lilith's world, never noon. She is always dressed in black leather from head to toe: boots, pants, and a jacket with lots of zippers, all of them unzipped.

You know this is Lilith's cruising outfit. Lilith can sniff out the new dyke in town just as sure as a cat can sniff out the one catnip plant in a garden of weeds. You imagine her knocking at your door just as you finish unpacking your last carton of books, or right as you are placing the last cast iron frying pan on its hook in your new kitchen. She has left her Honda purring in your driveway, and invites you out for a ride. Reminds you to hold on tight as she takes you up the mountain to a secluded spot under a full moon and a sky speckled with stars. She teases you with a midnight picnic: "Want a hunk?" she'll offer, holding out a wedge of bread. "Do you like cherries?" she'll ask, extending a fistful of fruit. After the meal, she'll lie back on the grass, her hands under her head. "I'm so hot!" she'll exclaim, stripping off her boots, pants, and jacket. All she'll have on underneath is a black leather G-string and a tiny rose tattooed on the left cheek of her ass. Her body gleams in the moonlight. "Aren't you hot?" she'll inquire. You try not to let on that you are sweating profusely. Museums are always so stuffy. Stifling. No air. You can scarcely breathe. You loosen your collar. Unbutton your shirt. Shed your clothes as gracefully as a snake sliding out of its skin.

You approach the painting and place your foot on the bottom of the frame for a leg up. You hoist yourself into the portrait and stare at Lilith. She has not moved. She is still gazing at the apple in front of her. Her eyes reveal her hunger. She is

starving. Ravenous. Famished. She has been staring at that apple for a very long time.

Just for fun, you decide your name is Eve. You lift the apple from its small white dish, and take the first bite. You chew voraciously until it is gone. Devoured. A part of you. You take another bite, and then another and then others until the apple disappears completely. The apple is now contained by you. The apple has now become a part of you. It is time for you to become the apple. You lie down on the table. Lilith has not moved. She is still still. She stares at you. At your red rosy cheeks, your breasts like two apples, the long stem of your neck, the apple blossoms of your hair. She is hungry. It is midnight. You have never been so still in your entire life. You know you are delicious. You wait for Lilith to take her first bite. You will gladly wait forever.

The Vision of Men
Michelle Sagara West

To live in the future was, of course, impossible, but to live by it was as necessary to Jonathan Seaton as breathing, as much a part of his life as the unconscious motor control of legs and arms and lungs are to most men.

It had started when he was fifteen. Not five, although it would have made him a much different child, and not thirty, when he might have understood how best to use the wisdom that such knowledge granted. At fifteen, an awkward, rebellious fifteen, a rational, logical, scientific fifteen. Sometimes he wondered what had become of that boy, whose faded idealism shone now only through old photographs and letters and the faces of those men and women who had only known him in that youth.

Sometimes he wondered.

But sometimes he knew. What idealism, after all, could survive the truth that came in flashing, coloured vision, at the centre of any crystal, coloured or clear, that had a heart? What love could survive the certain knowledge that the lover of his dreams, who promised him forever and more, would within the course of a few short months tell him that Robert Stanton was far more attractive, and better in bed, than he?

He could not tell them, of course; they'd laugh, or worse—they'd think him crazy, seriously crazy, and have him locked up. He knew, now, that the means to lock him up existed in books, in novels, in hysterical memories of women—why was it so often women?—who had been locked up by tyrannical husbands and a medical system run by men decades before he was born. But then, his imagination was as clear to him, perhaps stronger, than the visions which frightened him—and at fifteen and sixteen and seventeen, he had not understood how true each vision would inevitably become.

His father's death had sealed his belief.

Other deaths—death was always the clearest—followed, but his father's death was the only death he had ever tried to prevent. The only one. And it had done what? Caused a fight with his father, a terrible, scornful angry match, a burning thing that had, at its heart, the power to cut Jonathan again and again, even at the remove of decades. Maybe that argument had caused the heart attack. Maybe not.

But his father died, just the same. And because he'd tried so hard to have his father do something to avoid the inevitable, the last words he'd had with his father were angry ones. His mother was more forgiving, but she changed, too—because she'd understood that Jonathan had known, that his knowing was true, and that frightened her more than anything else he'd ever done in his life, even his small scrape with drugs in a world where drugs had not yet become the only public enemy.

He did not speak to her much anymore, although he sent her a card at her birthday, one at Christmas. Christmas was a tradition that had roots in a youth in which Christmas itself was magic. He needed neither mother nor tradition now, but tradition itself was a hard thing to break without the impetus of anger. So he continued.

He wouldn't have to continue for long. In a year, two years at most—for he knew the age of her face well enough, if not

the year that framed it—she would be dead, a withered thing, drained of youth and beauty and purpose by her husband's death, his absence, a life that she could never quite control enough to find happiness in.

She didn't know or ask for this vision, of course.

Jonathan's vision was more important to him than anything that he owned, that he might own.

He learned to use it, when he might, for guidance: to see where money might be gained or lost—although answers of this nature were thin and hard to apprehend—or to see where the course he had chosen might lead him. He discovered that until he stepped foot on a path, until he'd written the prologue to the story and sometimes the first chapter, the crystal would not reveal anything to him at all.

But revelation, once he had begun, would come. Sometimes it would come unlooked for, and sometimes it would come unwanted. When he was twenty-one, and involved with the man to whom and for whom he would have sacrificed everything, he had been blindingly happy. Giddy, silly, obsessive, his world had collapsed to a point, and that point had been Aidan.

Two months after he met Aidan, he'd come home in the darkness, turned on the lights to the apartment he visited only barely enough to call 'home', and stumbled into his special room. The lights had burned and flickered against the far wall, catching the hearts of each and every crystal, large or small, that adorned it, demanding his attention, forcing him to look inward, and inward again, to see what his future with Aidan would be.

To see that there wouldn't be one.

That had taught him.

Never to get too involved. To let the answer come before the rest could.

But even having learned that lesson, in that moment he

did what he'd not done since his father died: he destroyed them all, these harbingers of doom, these destroyers of happiness, these terrible, terrible judges.

One month later, he had collected them again, bitterly, hopelessly adorning his walls like a half-crazed interior decorator. He drunk a bit, comforted himself with things meaningless and banal, spent time with friends, although he had few enough of them. He survived.

He was older than twenty-one now, older than thirty-one even, though he had not yet crossed forty; he hung in limbo between his mid-life and the life that stretched before him. The only death that he did not see clearly was his own, although the lack of insight brought him no comfort; he waited, expecting that visions of that death would come eventually, when the story that started his end began. He had learned not to second guess endings, or beginnings, for as he got older they became less clear.

But he noticed, one day, that the endings that he knew of, those endings that waited completion, were few. It did not worry him at first, for the visions did not come at his command, although oft-times they would repeat themselves at his request, once seen. But as the months passed, the stories played themselves out, one by one. A death. A birth. Another break-up. A move.

And no more were waiting.

Jonathan thought, at first, it was because he had done so little that was new, had begun no new stories to await the outcomes of. His work consumed much of his time, and it was not a type of work which brought him in contact with new faces, new voices. The lack of visions unsettled him, but he told himself to wait, and he did wait, and there was no reward in waiting, not this time.

Nearly twenty-five years.

Twenty-five years of being special, of being somehow guided through life—of having the map that no one else had, a crutch he could rely on while everyone else bumped blindly into one another as they groped their way along the paths that led to their own unseen futures. He could hear them crying or cursing or whimpering, could see them huddling together as if it were better than being alone.

He hated it.

And he hated it more when he found himself drawn, in fear and uncertainty, to join them.

He met Ian in a library, of all places.

Jonathan had visited both of the bars that he sometimes frequented, had eaten alone at the four restaurants in which he felt comfortable, had browsed through countless isles of bookstores, old and new, seeking something that might catch his interest: a new face, a hint of conversation, a friendly expression.

The library was where he went to when he desired the peace of a book that bore no weight of ownership, in a place where books were like walls.

Card catalogues had been replaced by computer catalogues and a system of magnetic strips, that was only facilitated by people. It was probably more efficient, but he wasn't overly fond of computers; they seemed to him an extension of the harsh logic, the cool rationality which denied his existence.

Or rather, which denied the existence of what he *had* been. Now was nothing special: human, depressed, directionless. One of the many.

The circumstances of that first meeting with Ian were not auspicious; they were, in fact, irritating—it had been a long,

unproductive day for Jonathan. He had gone to the library and bypassed the catalogue system entirely because he chose not to seek new knowledge that night, new literary vistas; he wanted that rarest of reads, the one well-travelled. Comfort.

He turned the corner, and collided with a taller man. More than height Jonathan didn't immediately notice; he didn't want the bother of an extended apology, and instead muttered one that sounded, even to his ears, rather more like an ungracious curse.

The man said something that was stronger and clearer, and he ignored it to the best of his ability, although the words worked their way into his brain, as words will, and as he found the shelf he sought—which was too close to the man in question—he realized that those words were a gracious apology.

This made Jonathan feel smaller, and he hated that, so he didn't acknowledge the man.

And then, on this winter day with skies too grey and ground too wet to be even remotely pleasing, this stranger who stood in the isles of his library, at a moment when he wanted to share his life and his time with no one, reached out, just as Jonathan did, and pulled a book off the shelf with a gentle tug at the top of its spine.

It was, of course, the book Jonathan had come for.

The man was halfway down the isle before Jonathan could separate his outrage from his voice enough to speak calmly. Mostly calmly.

He said, "Excuse me, sir, but that's my book."

Hardly an auspicious start.

The man turned around, and Jonathan saw that he had dark eyes, a full face, lips that were hooked into a quirky half-grin—in this case, almost bemusement. Not the kind of face that he usually found compelling, and he was certain that, had

it not been attached to the man who had taken this book, he wouldn't now. "Pardon?"

"That book—that's my book." But the words trailed off as he realized how stupid they sounded, how childish. Except that he wanted that book. "Look—I'm sorry. I came all the way across town in this weather just to get that book. You were—you were—you looked like you were just browsing, and I thought—"

"Yes?"

"Well, there must be a different book you'd rather look at."

The man looked down at the book, looked up again at Jonathan, and then smiled. "I'm really curious," he said, as he took a step toward Jonathan, "what makes this particular book so interesting, but I have the suspicion that I'd only be disappointed. It couldn't possibly as interesting as that to anyone who wasn't you. Here."

Jonathan took the book, met the smile, and stood there in a momentary stupor, wondering what had just happened.

They met again when the library closed. Not by plan—or at least, not by Jonathan's—but by a casual sort of accident occasioned by librarians who were tired enough to want to go home and short-tempered enough, just, to shoo out the patrons who hadn't taken the hint the first three times they made closing announcements.

Or who'd been so immersed in their reading that they just hadn't heard.

Jonathan had hunched his shoulders, shoved his gloveless hand into pockets stretched by such poor use, and put his shoes into the first furrow of slush he could find. Someone fell into step behind him—someone who'd had the sense to wear

boots, to wear gloves, to wear a coat that was heavy enough to withstand the cooling weather.

He wasn't much surprised when this unlooked-for companion spoke and he recognized the voice.

"I'm Ian," the man from the library said. "Ian Bain."

"Jonathan. Jonathan Seaton."

"Are you driving?"

"No. I don't own a car. Don't need one."

"I'm driving. Can I give you a lift somewhere?"

He started to say no, but his shoes had already started to let the water into his socks, and he didn't feel particularly stoic, so he muttered what he hoped was a good-natured acceptance.

Ian Bain didn't really say much else. He asked directions, and Jonathan obligingly answered, but that was all. Ian was in all possible ways unobtrusive, and perhaps because of that— only because of that, Jonathan ended up inviting him up to his apartment, and indirectly into his life.

They were both busy men, and older; they had a schedule of life that didn't permit for the craziness, the excess, that Jonathan had once called love. What they built, they built slowly, as if unaware that they were building anything at all.

For his part, Jonathan was willing enough to make that careful effort, for it occurred to him as the days stretched into weeks, that this was a new thing, and that, having embarked upon it, the heart of his life might once again open its vista with images and certainty, the landscape of the future.

But not yet, not yet; they were silent and still, like glass, like any other man-made object that had no heart.

"What are these, Jon?"

No one called him Jon; no one had since his father had died so many years past. But he couldn't quite make himself tell

Ian that, and the nickname Jon took on a not-quite-comfortable familiarity, an echo of an older—a younger—self. He called Ian by his name because shortened names had always struck him as an artificial convention. Besides which, Ian didn't much lend itself to diminutives.

He was in the kitchen—because Ian was, in the end, a poor cook, and Jonathan had little patience for eating out—and Ian was, or had been, curled up with a newspaper in the living room.

But the moment he'd heard Ian's too-distant voice, Jonathan had known Ian had moved. His fingers turned white around the knife's handle as he froze in mid-slice of onion. Then blade clinked against the glass cutting board as time returned to the kitchen; Jonathan finished that motion and then pried his fingers free. He wasn't Bluebeard, after all; there were no rooms that had been specifically denied his visitor.

Visitor?

He wiped his hands on the apron, untied it, put it aside. As if he could see—and he couldn't—that this might not be a two word answer.

"Jon?"

He moved toward the living room, but froze just inside of the open door.

Was this it? he wondered. Would they fight about this? About the room, about what was in it? Would he laugh? Would Jonathan even be able to tell him the truth, some semblance of the truth?

They had not argued yet, not once; the earliest weeks of a relationship were always the most forgiving, and that glow rarely vanished quickly for him. It was the day-to-day that tarnished the shine, and Ian and Jonathan were both adept at avoiding the day-to-day in the lives that otherwise enmeshed them.

By now Jonathan should have seen something. He should

have at least seen the end, seen the how of it or the why, slices of his life in a cross section as clean as the onion's on the counter. But there was nothing.

He stepped over the threshold into that room, taking a breath, steadying himself.

Ian's back was toward him; his face was to the wall, to the shelves upon which sat all the crystal balls that Jonathan had amassed over the years, in the almost two decades since Aidan's passing.

"Jon?"

"Here," he said quietly.

Ian turned. "What are they?"

"Those?" He shrugged, wondering if the movement looked as unnatural as it felt. "Glass globes. I—I collect them."

"Oh." Ian reached out, cupped one of the smallest crystals in the palm of his hands. Jonathan stiffened at his back; Ian didn't notice. "It's heavy," he said.

"It's solid."

Silence. Ian forced a laugh. "They look like crystal balls."

"And I'm the gypsy woman, and this is the dark wagon?"

"Yeah, well."

Be careful, Jonathan wanted to say, but he bit the words back. He didn't want to scare Ian, not yet; he found that he enjoyed the company, fraught as it was with uncertainty.

"You ever wonder what life would be like if you were that gypsy woman?" Ian asked.

"Myopic," Jonathan said.

Ian laughed obligingly. "All right. So you aren't that gypsy woman, and you don't have to live in a tent or a wagon, and you don't have to be forced into tacky clothing, poor make-up, and a fake accent.

"But haven't you wondered what it would be like, to see the future, to be able to see it?"

"No."

Ian laughed again. "Jon, sometimes you are the least imaginative man I think I've ever met."

"Have you?"

"Wondered? Often." Ian slid the ball back into the four-footed pedestal he'd lifted it from moments ago. "But in the end, I don't think I'd much like it."

"Oh?"

"Sure. I mean, what if I pick up a crystal ball, look into its depths, and find out I have cancer? AIDS? Something that gives me six months to live. Or worse, what if I find out that I'm going to get hit by a car. Killed by a car. Or some random mugger."

"You wouldn't see your own death."

Ian didn't appear to hear him.

"I'd like to say that I'd live my life the way I live it now. That I'd live up to the responsibilities I've taken on, that I wouldn't lose it, go berserk, figure I'd got nothing left to lose anyway. But I don't know for certain that I wouldn't. Death does funny things to a person."

"But what if—" He knew he shouldn't ask. "What if you knew you were never going to see your own death? Would you do it then?"

"Do what? See the future?" He shoved his hands into his pocket. "What kinds of things? Stock market numbers? Which businesses make it big and which ones die inexplicable deaths? Winning lottery numbers?"

Jonathan rolled his eyes. "I'm going to finish dinner. You go on with your dreams of wealth beyond avarice."

Ian's response bothered Jonathan.

He hated to admit that it bothered him, because he couldn't tell Ian why: that in a few words, Ian had dismissed the core of what made Jonathan Seaton special, of what had

always made him special. There was a time when the vision had not graced his life, and he struggled to remember it more clearly; it eluded him.

In the darkness of breath and silence, so did sleep.

"But what if," he said, "you could see the future?"

Ian's reply was a rustle of sheets, a turning against the night sky that the uncurtained windows let in.

"I mean it," he continued. "Not lotteries, not things like that. What if you could see what would happen in your ... personal life?"

"Personal life?"

"What if you could see when your mother was going to die."

"She's already dead, Jon."

He'd known that, and forgotten in his careless urge to ask a slightly less pointed question. His cheeks burned, the sight hidden from Ian. Drop it, he thought, but he couldn't quite. "What if—"

"What what?"

"What if you knew when I was going to leave you?"

"Well," Ian said, propping himself up on an elbow, which was a familiar enough movement Jonathan could almost see it, "if you did leave me, I'd probably get a lot more sleep."

"I'm serious."

"I'm not. Oh all right, all right. Did I say you had no imagination?" He took a breath, close enough to Jonathan's ear he could feel the tickle of its passage. "It's been a long time since I've been afraid of that particular thing."

"Endings?"

"Endings."

"Why?"

"Are you afraid?"

Jonathan shrugged. "Everything ends."

Ian laughed. "You say that as if you mean it, but if you

meant it, you wouldn't be so anxious to have an answer to that question." He shifted, the sheets rustling. "And yet, my answer is that. Everything ends. When I was a lot younger—a lot younger—my life hung in the romantic balance. Love was more important to my existence than the rest of existence combined. And I didn't have a life. I had a string of 'destined encounters' and a great desire to be special. That was it. Same as billions of other people the world over. I had a sense of what love should be, and I never let it be what it was.

"Love is a different creature with different people. But it's not based on fear, Jon."

"I'm not asking you to be afraid, I'm asking you if you wouldn't choose to know how something ends."

"But you are asking me to be afraid," Ian said, reaching in the darkness for Jonathan's hand. "Because to be that focused on the way things would end, I'd have to think of the end, be aware of it, desire to be prepared for it, anaesthetized to it. I'd have to want to 'protect' myself from pain."

Jonathan pulled his hand away. Sullen, he sat in the darkness that wasn't quite dark enough.

Ian hadn't known him for that long, but he knew him well enough. "Jon, I'm not laughing at you. I'm giving you an honest answer. If I knew for certain that things were going to end, it's the end I'd think of. Not the beginning, which I love— 'Excuse me, but that's my book.' Not the now—the right now, if you'd give me back your hand. Just the end. And the thing I learned the hard way is this: worry about the end, and it's already happened."

"But that's not true."

"How many people can know how things end, and not somehow try to prepare themselves for it? If you think you can, you're a better man than I am. Now, can you turn out the lights and come to bed?"

"But the lights aren't on."

"Jon, sometimes you are the most literal man I've ever met. Stop thinking so hard and get some sleep."

It didn't happen all at once; they were both too old for that. But in a slow, quiet way, roots sank and grew deep; two men whose lives were very much established and real came, after some time, to believe that they could blend those lives together.

That had been Ian's idea, of course, and he had asked for it in the same way he asked for anything; he sat down, cup of coffee in one hand, Jonathan's hand in the other, and simply asked.

And Jonathan's heart—he could think that word, although he couldn't bring himself to say it, it had so much cloying sentiment attached to it otherwise—did something so profoundly painful and electric he thought it was failing him.

"I'm too old for this," he'd said.

Ian laughed. Ian laughed a lot, a low, quiet laugh that was as calm as he was, as affectionate.

"I haven't lived with anyone since I left home."

"And you've never wanted to?"

"Once."

"Didn't work out?"

"No."

"Messy?"

"Yes." They never spoke about each other's past. They avoided comparison, the appearance of comparison.

"Well, this is working out, it's not messy, I'm not your mother, and I want to live with you." He put the coffee cup down and caught Jonathan's flailing free hand. "If you don't want to give up the life that you have, tell me."

"I—"

"I won't believe it, of course, but tell me anyway."

Nonplused, Jonathan gathered air with his half-open mouth, waiting. Then he said, "Yes." Just yes.

And for the first time in many months, when he walked by his special room, he reached out and firmly closed the door. Because he thought, *this time, for sure,* and he didn't want to know how it would end. No, that wasn't quite true. He didn't want to know that it would end. He wanted to float for just one evening, to feel dizzy, to feel as if—as if the future was boundless, open, a place to be explored.

Jonathan woke in the middle of the night.

He was afraid, of course, and the fear was as old as he was: he was looking into the face of loss, because he knew, now, that he had something to lose. He'd made that mistake before, and vowed that he wouldn't make it again.

Light edged the doorway, and it was a moment before Jonathan realized he'd forgotten to shut the hall light off. He rose; Ian wasn't snoring, but only barely. The city never became completely dark; he could make out the rise and fall of Ian's chest in the darkness, could take a moment to be comforted by the rhythm. Ian was steadfastness defined.

He could be trusted.

Jonathan's hands were cold as he pushed the door open and made his way from the room he dreamed in to the room that he saw truth in. Where he hadn't seen truth for months, almost a year.

He stopped at the door, pressed his forehead against it, pressed his lips together. He stood there as if praying, although he wasn't certain for what.

He wasn't a young man. He wasn't a fool. What had he been thinking, to come so close to this again, only to lose it? He had to know.

He opened the door.

Or started to; a hand reached out and pulled it shut. Ian's hand.

"Come back to bed, Jon."

Almost terrified, Jonathan Seaton looked down at the back of the hand whose palm covered his. He felt like a child, one caught just before some petty crime had been committed.

"You don't need to do this."

"I don't—I don't know what you mean."

"You should."

Silence.

"Jon, you are such a terrible liar, I don't know how you survived to get to be as old as you are."

"But you were asleep!"

"And you weren't. Come on."

"I don't believe you can read the future in those little balls."

"Then why did you stop me?"

Light crested the window sill; light followed the words.

"Because it's perfectly clear to me that you think you can."

Jonathan was embarrassed, but the embarrassment didn't reach below the skin; neither did the momentary fear that had gripped him the way Ian had gripped his hand. He felt numb, numb with waiting; Ian was a stranger to him.

"You don't have to tell me anything," Ian said, when the silence had gone on and on, an awkwardness that Jonathan didn't know how to begin to fill. "You don't have to explain it.

"If you're afraid that I won't love you anymore—" That word, that precious word, "you're more of an idiot than you were the first day I met you. I knew it the first time I saw the wall. Did some of my own checking. You spent a fortune on those things."

"Yes."

"You're known as something of an odd collector. I even

went into Madame Mystic's on Fourth Street. She knows you by name. Three of them." He shook his head. "Madame Mystic, for god's sake!"

Jonathan had the grace to flush.

"Whatever it is you think you see, you don't need to see it. Are you afraid of me?"

He was so afraid, he couldn't answer; he didn't think he could draw breath.

"Jon, are you afraid of me?"

"Yes."

Silence. "Why?"

"I—I don't know."

"Don't you?"

"Why don't you think I'm crazy?"

"I do think you're crazy."

"Then why are you still here?"

"Because you're more than just crazy." Ian smiled, that odd quirky slow smile of his. "And you still haven't answered the question."

So Jonathan answered it, because he'd been living with the fear for almost a year now, and he suddenly thought, in a moment of giddiness and stupidity, that if he spoke the words, the fear might leave him. He said, "I don't know whether or not you'll leave me."

"I don't know whether or not you'll leave me, either." Ian laughed. "You never doubt yourself, do you?"

"No."

"No, of course not. You're the victim, not the villain." Ian rose. "I want some coffee. I want some breakfast. I want some goddamn sleep, but I'll settle for the first two. With company."

The streets of the city were a chilly backdrop. Ian wore sensible boots and a long, thick coat. A scarf. A hat. Jonathan wore shoes that leaked. That much at least was normal.

"You don't understand. I'm—I don't want to just give you everything if I don't even know that you'll stay. You've seen it as often as I have: these things don't last. You'll find someone younger, or—"

"Things don't last by accident," Ian said. "They don't last by caprice of stupid fate."

"You don't understand."

"You keep saying that. What don't I understand?"

"I can—I could—see the future. I've known, I've always known how things will end."

"Well maybe, little idiot, that's why they've always ended."

Nonplused, Jonathan fell silent. The whole day bore an aura of unreality so strong he kept pinching himself, stubbing his toe, biting the inside of his cheek, in an attempt to jar himself back to reality. Nothing helped.

Breakfast passed. They each drifted to work, then back together, as if for the moment the lives that they both valued and nurtured had been left to fend for themselves.

But Jonathan didn't go into his room before Ian arrived; it was as if, having once sealed it with both knowledge and affection, it had become something they should only unseal together. He was afraid, and he did not know how to be unafraid, except to let Ian go, to push him away—and that, of course, was the one thing that he did not want.

"What if," Ian said, "as you like what-if's so much—what if you look into one of these crystal balls and you don't see an end?"

"I've always seen an end."

"Very careful. What if there isn't one?"

"I don't know. You'd be—you'd be safe, I guess. You'd be—we'd be—"

Ian laughed. They were, neither of them, given to adolescent declarations. But the laughter ebbed into the too-

close walls of the apartment. "What if the end you saw was my death?"

He was stricken at the thought, for it had occurred to him before. "I——" He stood, restive. "I've seen a lot of death. My mother's, probably next year."

Ian was silent.

"My father's, when I was seventeen. A friend's, when I was thirty-five. Three friends, that year, like stalks of harvest wheat." He lifted his chin, unselfconscious. "I did what I could to help them, when I knew what was coming. Two of them—two of them were too afraid to tell anyone; I knew, but not because they were honest. But because I knew, I could help them.

"It isn't all bad, Ian."

Ian rose. There wasn't much he could say to that.

And of course, a loss for words wasn't particularly a problem for him. "If you saw my death, would you do as much?

"No, don't answer. I don't want to be your object of sympathy, or worse, pity. I don't want you to be some sort of angel of mercy."

"Are you dying?" Jonathan asked softly.

"We all are, one way or another. But no, that I know of, I'm healthy."

"Would you tell me, if you were?"

"If you promised not to try to read that future in those little balls and chains of yours, yes, I'd promise."

Jonathan stood, as still as crystal, as frozen in place as the lattice which made it solid. To speak was so agonizing; he was not a young man, to be uncertain with words, but he was uncertain, and it galled him.

Freed him.

"Would you—would you promise to tell me, if you—if what you felt changed? Would you tell me, would you promise

to tell me, if you met someone else? Would you tell me before you started something, before you—"

"If you don't already know the answer to that question, you can't ask it," Ian said. "Jonathan, Jon, trust is always a risk—but love is like god. If you don't have faith in it, trust in it, it isn't real."

"You don't believe in god," Jonathan said faintly.

"No. But I do believe in love. I can reassure you. I can tell you that yes, I give you my word that if I ever stop loving you, I'll tell you. But if you don't trust me, if you don't know that you can, what comfort can you take from just the words?

"Jon—love isn't an accident. It isn't an act of god. We make choices. We don't get 'struck' by commitment, we make a commitment. And if there's an end that we don't want to meet, we face it, and we plan around it; we know each other well enough to know weaknesses and strengths.

"But if you want to just look for an end—any end—on high, then you can make that come true with just as much ease. More. It's always easier to break something than it is to make it."

"Ian, when I saw my father's death," Jonathan said, from a great distance, "I did everything in my power to stop it from happening. Everything. And he died just as I saw it."

Ian didn't blink an eye.

"Love and death aren't the same thing. How did he die?"

So blunt. "Heart attack."

"And you think, somehow, that you should have been able to stop this?"

"We had—I'd seen it, for god's sake!"

"And you think a heart attack is the same as a love affair? No wonder you've had problems."

"Wait—where are you going?"

"I'm going to get some coffee. What you have here could almost be … instant." He smiled, although the smile seemed

strained to Jonathan's eyes. "I'm not going anywhere in the larger sense, Jon; you'll have to do better than that."

I don't want to be hurt.

 I don't want to be hurt.

 I don't want to be hurt.

 And what hurts?

 Loss.

 And why does loss hurt?

 Because it's unexpected. Because it's raw. Because.

 And how does knowing how things end make it easier?

 Because I don't get attached. I don't get involved. I don't give so much of myself away that I don't know how to get it back.

 You sound like an angst-ridden teenager.

 Well, that's honesty for you.

The door stood between Jonathan and the answer that he felt certain lay within. What could it hurt, to know? How was ignorance better than knowledge?

 "What did you say?"

 "I said, 'How could it hurt, to know? Why do you value ignorance over knowledge?'"

 "If this were a scientific endeavour—and I'll admit a healthy dose of biology is involved—I'd say, go for the knowledge. But I'm not a corpse yet, Jon, and I don't want to be dissected. If you want distance and safety—"

 "I don't."

 "You do. Look, there is a rationale to emotion. There is a logic, a reason, a cause and effect. But it's delicate. If we were sensible, we wouldn't give a damn about fidelity. We'd sleep with whoever we liked, and we'd base are lives on things that meant more than sex, more than physical activity. We're not sensible, not that way.

 "If you know that it's over, then it's already over. It's the

possibility, the range of the future, that gives us hope, room to grow in, room to change if change is what we need to do.

"Give in, play that crazy game of yours, and I've already lost you, you've already lost me. You've made that decision before we've even started."

Together, they pulled away from that door.

"Is this what it's like?"

"I don't know. What?"

"Is this what normal people live with?"

"Yes."

"But they're not all afraid."

"Bullshit. They're all afraid. We're all afraid. With time and experience, fear fades. Trust grows. Or breaks. Fear is natural, Jon."

"But I hate it."

Ian laughed. "Stop letting someone else write your endings, Jon. Write 'em in your own style. And please, let me get some sleep."

They began to search for a place to live together; it was probably the hardest thing they'd ever done. Their sense of space was both idiosyncratic and rather individual, and only by dint of will and desire to compromise did they at last find a condominium that they could afford and be comfortable in. It had height—a bit too much for Jonathan's taste, certainly not enough for Ian's—and it was open, with few walls between rooms. Fewer barriers than Jonathan was wont to surround himself with.

Bank loans were easy, lawyers easy, paperwork easy. Arguments about how exactly their new home was to be renovated were less pretty, but the home itself didn't suffer.

They bought furniture together, because so little of what they did have could co-exist.

They planned their move.

And all the while, the room was closed, and Jonathan did not venture across the threshold; he did not so much as open the door.

Ian moved three days ahead of Jonathan, and left most of his life in boxes.

Jonathan packed slowly, finding the flotsam and jetsam of nearly forty years of life in the nooks and crannies of a desk, a bedside table, a closet—hints of the past in photographs. For the first time in his adult life, the past was more real to him than the future, and he looked at it through eyes that were tinted, everywhere, by Ian.

Dishes went first; they could figure out what to keep and what to donate to some worthwhile charity when they had pooled the whole of their resources. Cups were washed and packed with care—he had no intention of getting rid of those; they could argue until they were both blue in the face—and most of his clothing. He unplugged the television, the VCR, the stereo equipment, boxed shelf after shelf of books.

Put away, in fact, his entire life except for the contents of that one room.

But when the apartment was empty, except for that one door, he stopped; the silence was thick and numbing. If crystal had a voice, that voice was softly, insistently, filling the whole of the apartment his packing had made bare.

He had made a mistake, and he realized it only now: the whole of his life, save that part which had defined so much of it, had been put aside, boxed up, closed away. What remained was the room, and its contents.

The call of it, the desire.

His hand was on the door before he stopped.

Be clear, he could hear Ian saying. *Understand what it is you're choosing.*

Not knowledge, of course. But life with, or life without, Ian.

I can't just leave them here. They have to be dealt with.

Yes, of course; they were a responsibility. Jonathan Seaton was very good at saying good-bye. He opened the door, half-expecting to feel the weight of a hand that was now almost more familiar to him than his own. But nothing stopped the handle from turning; nothing stopped the door from opening.

There, against the wall, resting on stands of various quality, they sat, clear in their accusation. It had become almost easy to live without them; as he stepped across the threshold of this special room, this almost hallowed space, he understood that he had been living in a dream, a youthful dream.

He was not a young man.

He was not a fool.

What are you afraid of?

He took a step. Another step. Heard the door creak at his back. Something, he thought, would have to be done with these. Ian wouldn't want them, wouldn't live with them. Something—

He reached out, as if he were reaching out for Ian, the movement was that natural and that automatic. Instead of warm flesh, he touched cool glass, rounded surface, something hard and ungiving.

Except that the crystal had never been ungiving.

Trust.

Faith.

Hope.

How... religious. How almost quaint.

Jonathan Seaton felt at home, and at complete ease as he lifted the best of the crystals that remained. Not the best he'd

owned; close his eyes and he could still hear the refrain of that particular loss, had heard it before it happened. All of his life had been informed by loss, by knowing loss.

He had protected himself by knowing it.

His whole life was in boxes outside of this room, waiting on him; waiting for him to take the biggest risk he had ever taken. To take it blind.

Everyone lives with fear, Jon.

But not Jonathan. Not anymore. Not since he turned twenty-two.

He closed his eyes, bowed his head. He had so much to be afraid of now. So much, and he felt that the answer to the weight of that fear was here; he could lift the burden and be free.

Lift it...

And be free.

He was so very tired of wondering how things would end, when they would end. An answer, any answer, had to be easier than this.

He felt the surface of the globe with his hands, felt its weight. Felt the flat, hard contours of the life that had been chosen for him when choice was a thing that he'd understood so poorly.

Felt a sharp pang of fear.

Pressing his lids tightly together, biting his lip, he lifted the world between his hands—

and sent it, scattering in shards, between his feet. He wanted to look. He knew it. He wanted to open his eyes and have done. Perhaps—perhaps there wouldn't be an answer; perhaps if he just looked, once, the crystal would tell him nothing and the choice would be made for him.

As all choices had been.

Blindly, because he didn't truly need to see, he reached for another. Perhaps just one glance—

And he dropped it, as well, less certainly. And a third. A fourth. But the fifth, his hands curled round convulsively.

"This is what I was," he said.

"I know," Ian replied. "I'm sorry."

Ian. Ian was here. "Help me."

"Don't open your eyes, if you're afraid of what you'll see," Ian said softly, his voice drawing nearer and nearer to Jonathan's back.

"Help me," Jonathan whispered again.

"You only had to ask. You only ever had to ask."

"I know. But it's easier to make a choice than to—"

"It's a start."

He heard the crash of glass, of crystal.

Blind, afraid, determined, Jonathan reached out to the shelves in front of him, and found his sixth, his seventh.

"Do people live like this?"

"Yes. This is how they live. In the now. The future comes out of that, only out of that." He felt Ian's hands on his face, his cheeks, felt his thumbs gently touch either eyelid. "We're probably going to lose your rental deposit for this."

Jonathan Seaton opened his eyes.

Saw Ian's eyes, so close they were like small, clear globes with pupils for hearts.

At their centre, at either centre, glowing and undistorted, he could see himself, his face framed by Ian's hands. And for just a moment, he felt the fear recede, he felt a certainty take root and grow.

Acknowledgments

Almost any book, and an anthology in particular, benefits from generous advice and support of many people who assist in their individual ways. I am grateful to everyone who helped make this project a reality, but especially to the following:

To Cecilia Tan, for having faith in me and this project (and for her inexhaustible patience with me during the process of putting this book together!)

To Mel Odom, for the gorgeous cover illustration.

To Michael Bronski, Marta Grabien, Keith Kahla, Richard Labonté, Michael Lassell, Bruce Holland Rogers, Steven Saylor, and Eve Tetzlaff for enthusiasm, moral support, suggestions, and advice at various stages.

And, of course, to my wonderful contributors, for writing such visionary and illuminating stories that inspired me to do this book

About the Editor

Lawrence Schimel is the author of The Drag Queen of Elfland (The Ultra Violet Library) and the editor of more than twenty anthologies, including Switch Hitters: Lesbians Write Gay Male Erotica, Gay Men Write Lesbian Erotica (with Carol Queen; Cleis Press), The Mammoth Book of Gay Erotica (Carroll & Graf), Tarot Fantastic (DAW Books), Camelot Fantastic (DAW Books), and the forthcoming The Erotic Writer's Market Guide 1999 (Circlet Press), among others. His stories, poems, and essays have been included in more than one hundred anthologies, among them Best Gay Erotica 1997 and 1998, The Mammoth Book of Gay Short Stories, Gay Love Poetry, The Random House Book of Science Fiction Short Stories, and The Random House Treasury of Light Verse. He has also contributed to numerous periodicals, from the Saturday Evening Post to Physics Today to Gay Scotland. He lives in New York City, in one small room with many, many books.

About the Authors

Laura Antoniou is best known as the author of the Marketplace Trilogy—The Marketplace, The Slave, and The Trainer. She is also author of the novel The Catalyst, and the editor of Leatherwomen volumes 1-3, Some Women, No Other Tribute, By Her Subdued, and Looking For Mr. Preston, among other anthologies (all published by Masquerade Books). She lives in Flushing, Queens.

Kerry Bashford was editor of Pink Ink and Kink and Campaign magazine and is now producer for the Microsoft Internet site, Sydney Sidewalk. His stories have appeared in various anthologies, including The Mammoth Book of Gay Erotica (Carroll &

Graf), *Boy Meets Boy* (St. Martin's Press), *Hard* (Blackwattle Press), and others. He lives in Sydney, Australia.

Rand B. Lee—son of Manfred Lee, who was half the byline Ellery Queen—has written short stories for The *Magazine of Fantasy & Science Fiction, Asimov's Science Fiction Magazine,* and *The Year's Best Science Fiction,* among other publications. He lives in Albuquerque, New Mexico.

Lesléa Newman is probably best-known for her controversial picture book *Heather Has Two Mommies* (Alyson Wonderland) but is also the author or editor of over twenty five other books, including the novels *Good Enough to Eat* (Firebrand) and *Fat Chance* (Clarion), the short story collections *A Letter to Harvey Milk* (Firebrand) and *Secrets* (New Victoria), the nonfiction collection *Out of the Closet and Nothing to Wear* (Alyson), the poetry collections *Love Me Like You Mean It* (Her Books) and *Just Looking For My Shoes* (Back Door Press), and the anthologies *The Femme Mystique* (Alyson) and *My Lover Is A Woman* (Ballantine), among others. Selections from her newest collection of poems, *Still Life With Buddy* (Pride Publications), earned her a 1997 Poetry Fellowship from the National Endowment for the Arts. She lives in Northampton, MA.

Sarah Schulman is the author of seven novels: Shimmer (Avon), *Rat Bohemia* (Dutton), *Empathy* (Dutton), *After Dolores* (Dutton), *People In Trouble* (Dutton), *The Sophie Horowitz Story* (Naiad), and *Girls, Visions, and Everything* (Seal Press) as well as two nonfiction books: *My American History: Lesbian and Gay Life During the Reagan/Bush Years* (Routledge) and *Stagestruck: Theater, AIDS, and Marketing* (Duke University). She is the recipient of many awards and prizes, including the Ferro-Grumley Award, the Anderson Prize, a Revson Fellowship, and the Word Project for

AIDS/Gregory Kolovakos Memorial Award, among others. She lives in New York City.

Martha Soukup is the author of the short story collection *The Arbitrary Placement of Walls* (DreamHaven Books). Her story "A Defense of the Social Contracts" won the Nebula Award, and her short story "Over the Long Haul" was filmed by Danny Glover as the short film, "Override," which aired on Showtime. She lives in San Francisco.

Nancy Springer is the author of more than thirty books, including the adult novels *Larque on the Wing* (Avon), *Fair Peril* (Avon), and *The Book of Suns* (Pocket); the young adult novels *Looking for Jamie Bridger* (Dial), *Toughing It* (Harcourt Brace), *The Boy On A Black Horse* (Atheneum), and *I Am Mordred* (Philomel); and the poetry collections *Stardark Songs* (W. Paul Ganley) and *The Music of Their Hooves* (Boyd's Mill Press); among others. She has twice won the Edgar Award, and is also the winner of the Tiptree Award, among other honors. She lives in Dallastown, PA.

Brian M. Thomsen is author of the novels *Once Around the Realms* (TSR) and *The Mage In The Iron Mask* (TSR), and editor of *Mob Magic* (DAW), *The Reel Thing* (DAW), and other anthologies. He lives in Brooklyn.

Michelle Sagara West is the author of the novels *The Broken Crown, The Shining Court, The Uncrowned King, Hunter's Oath,* and *Hunter's Death* (all published by DAW Books), among others. She lives in Toronto.